The Wanton Green

Gordon MacLellan and Susan Cross

contemporary pagan writings on place

The fold stands empty in the drowned field,
And crows are fatted with the murrion flock;
The nine men's morris is fill'd up with mud,
And the quaint mazes in the wanton green
For lack of tread are undistinguishable:

Titania's speech,
Midsummer Night's Dream,
William Shakespeare

ISBN 978-1-906958-29-9

Acknowledgements

♦ to those heroic folks who have contributed to *The Wanton Green*, sharing their experiences, offering inspirations and enduring endless editorial tweaking

♦ and many thanks to Mike Parker for first dropping Titania and her Wanton Green into the pools of our deliberations

♦ and still more thanks Damian Hughes for the magnificent cover image and to Marlo Broekmans for the smiling face of flowers on the title page

Disclaimer
The editors and publisher would like to affirm the obvious that throughout *The Wanton Green*, opinions expressed and practices pursued are the authors'. Their inclusion here should provoke thought and discussion but in no way should be taken as a stance by the editors, the publisher or even the author, advocating any particular practice. We would only recommend that the reader should approach their own practice with respect for the places they live in or visit, for other living spirits on this Earth and for themselves as part of that dynamic whole.

Published by
Mandrake of Oxford
PO Box 250
OXFORD
OX1 1AP (UK)

Contents

Introduction,
Gordon MacLellan and Susan Cross .. 5

Foreword,
Graham Harvey ... 8

"She said: 'You have to lose your way'",
Maria van Daalen ... 13

Personal journeys, intimate connections

1. *Fumbling in the landscape,*
 Runic John .. 14

2. *Finding the space, finding the words,*
 Rufus Harrington .. 17

3. *Stone in my bones,*
 Sarah Males .. 20

4. *A Heathen in place: working with Mugwort,*
 Robert Wallis ... 24

By river, well and sea

5. *Wild, wild water,*
 Lou Hart ... 38

6. *Facing the waves,*
 Gordon MacLellan ... 51

7. *The dragon waters of place: a journey to the source,*
 Susan Greenwood .. 55

Exploring - mud on your boots, mud on your hands

8. *Catching the Rainbow Lizard,*
 Maria van Daalen ... 66

9. *The rite to roam,*
 Julian Vayne .. 68

10. *Places of Power,*
 Jan Fries .. 78

11. *Natural magic is art,*
 Greg Humphries .. 90

Step back and consider

12. *Pagan Ecology: on our perception of nature, ancestry and home,*
 Emma Restall Orr ... 95

13. *Because we have no imagination,*
 Susan Cross .. 108

14. *The crossroads of perception,*
 Shani Oates ... 112

Where are the wild places?

15. *Devon, Faeries and me,*
 Woody Fox ... 125

16. *Lud's Church,*
 Gordon MacLellan ... 133

17. *Places of spirit and spirits of place: of Fairy
 and other folk, and my Cumbrian bones,*
 Melissa Montgomery .. 138

18. *A life in the woods: protest site paganism,*
 Adrian Harris .. 146

19. *We first met in the north,*
 Barry Patterson .. 159

Urban wildness

20. *Museum or Mausoleum,*
 Mogg Morgan .. 167

21. *Hills of the ancestors, townscapes of artisans,*
 Jenny Blain ... 173

22. *Smoke and mirrors,*
 Stephen Grasso .. 187

23. *America,*
 Maria van Daalen ... 206

24. *Standing at the crossroads* ... 211

25. *Meet the authors and photo credits* 214

A word at the beginning

Gordon MacLellan and Susan Cross

At first: provocation

I had been sitting through (yet another) well-intentioned but essentially saccharine "interfaith and environment" conference. Sitting there, wondering what I would contribute beyond being the wild-card, the barefoot, painted-toenail weirdo at the end of the dais. Asking myself what was it, why was it, that I thought British Pagans could contribute to these discussions…

So I listened, and bristled appropriately, and spoke up on behalf of trees and hills, grubby backyards and window-boxes and realised that I was tired of listening to ownership. It may be blatant "ownership", it may be couched as "stewardship" or "custodianship", but the language one hears in so many environmental debates is of management, is of humans making the decisions. "This world is our world. We own it. It was given to us."

Pagans speak of communion and partnership and recognise a symbiosis where we are simply part of the whole and certainly not the most important part of it all. We have grown into this world, evolved out of its earth and stone, flesh and blood. Proponents of Deep Ecology, permaculture or atheist scientists may use similar terms but perhaps we Pagans add a dimension of shared consciousness. Pagans live in a world that watches us, comments upon us, and is quite likely to turn round and slap us.

A Pagan world is not one of tree-worshipping huggers of fluffy bunnies. We do hug our trees and respect them, but we don't worship them and our bunnies are likely to donkey-kick the over-enthusiastic witch then hop off to make wild rabbit babies in a burrow. A Pagan experience of the world is of connection, of being bound to this spectacular, rich and

changing planet. Pagans live passionate lives, celebrate a wanton world where our "wanton" is wild, free, unbridled, sensuous; a deep, curling flow in the heart and spirit of who we are: a spiral, a wave, very rarely a spear-shaft straight line. Our wanton connections lie everywhere – from far-off hills to those urban window-boxes: we breathe and share our breath with the world around us. We aim to move with the ways of the world, to be part of it, to recognise our impact upon it, for good or for ill, and to celebrate the richness of that connection. That became my question behind this book: *how to communicate that connection, the richness that we experience, maybe the despair that we meet?*

So I talked very fast to Susan, my fellow editor, and to Mogg from Mandrake of Oxford and started smiling in a crocodile way at contacts around the (mostly) British Pagan world. We were looking for people from different disciplines who question their practice, testing the boundaries of their teachings and experience, who are prepared to step out of the known and comfortable and discuss their personal experiences of life in the Wanton Green.

Like Titania, we feel the estrangement, the confusion and despair of the mazes clogged up with mud and in this first *Wanton Green* volume we offer reflections on living with a passionate world and some ideas for stepping out yourself, into that waiting, vibrant richness - Gordon MacLellan

And then:

So, how do you tell the story of a pattern or find a start in the waves on the shore? This introduction may well be your entry point to this collection, but I am writing it looking back. I am on the brink of leaving the Wanton Green project, setting it free to find its way into your, and other, hands, minds and spirits. It has enriched the pattern of my life: I hope it does yours.

I don't know why Gordon asked me to join him in this Wanton work nor how I knew so clearly that it was an invitation to accept instantly and completely and explore what that commitment meant afterwards.

Gordon knew almost all of these contributors, I knew one or two personally, some I had heard speak or read their books, others I had never heard of. So I came to know them though what they said in answer to that question of connection and passion. The pieces came in gradually and, to start with, each stood alone, individual. As more arrived, the cross connections began, and the shared voice emerged. Each was like a root, sometimes tentative, always purposeful, seeking, probing, and questing. Together, they were like a taproot driving, over and over, in different words and imagery, into depth and mystery.

Working on this has been a joy. And I had no idea how much work would be involved. Or how generously people would give of their time and of themselves. We asked people to take a step outside their teachings, traditions and disciplines. So this is not simply an account of what Druids do, or how Heathens practice, Wiccan teachings or academic research. This is practitioners speaking for themselves. Several people told us this was a new challenge for them, but all responded in lively, sometimes surprising ways.

I have been an asker of questions, in this process, questions that I hope will help this book be more readable for people who have not yet encountered contemporary paganism or concepts of magick and Faerie. For you, there may be challenges here. In truth, there are challenges in these pages for almost everyone. We have tried to weed out jargon but throughout we have felt our primary commitment was to the voice of the writer. One early reader asked me to define magick; I wittered unhelpfully and theoretically for too long about different definitions and said very little that satisfied me. Eventually I got to the correct answer and asked whose piece he was reading. Our contributors are powerful voices, well equipped to speak for themselves.

So read on with an open mind and ask each writer what they mean. I suspect that if you read carefully and imaginatively, taking pauses for reflection now and then, it will be clear. And if that suggestion sounds like some of the practices recommended deeper within these pages, that's well and good. Enjoy.

- Susan Cross

Foreword

Graham Harvey

"What is your favourite colour?" might not seem the most urgent or profound question that you will ever be asked. However, those who have seen Monty Python's *Quest for the Holy Grail* (Gilliam and Jones 2002 [1975]) will remember it as the decisive question asked of King Arthur and his Grail knights at the Bridge of Death. Failure to name his own favourite colour proved fatal to Sir Galahad (who had instead parroted Lancelot's reply). *Wanton Green* is not about favourite colours. But it is about the preferences, affections, relationships, rituals and responses that make the authors who they are, inform their understandings of the world (quite literally), and prompt their further acts towards living places and communities. It is not only a book about senses of place, feelings of belonging, or romantic longings to be somewhere. Far more than that, it is about the absolute centrality of belonging. Radically, it contests the idea that humans are separate from "nature" or "the environment". It insists that our bodies and all our senses, feelings, emotions and thoughts, are rooted in our relationships to places and the other beings with whom we co-inhabit places, the world and the cosmos.

Ecology, the story of the world, is not about somewhere else. Nor can it only speak about animals, plants and other beings — it cannot leave us out. We humans are members of place-communities. Ecology is about those who dwell in places, and those who shape and affect places. This includes us. It cannot properly ignore us. Sometimes it is almost all and only about us, especially now that we have had such dramatic and widespread effects in our world. The chapters that follow arise from the preferences and experiences of particular authors. Their cumulative effect is the rising of a powerful wave of recognition, celebration and active engagement with the world. We are subtly invited or provocatively propelled to honour the places of our dwelling and our influence. Especially when in a celebratory

mood, these might include our homes and their immediate surroundings, or those places where we step aside from the demands of human-focused living to seek presence within and among the wider, larger, more diverse community of earth-dwellers. Particular places matter to us, they manufacture us from their matter, and our bodies are part of their intertwined relationships and busy communities. Our connections to place(s) are not accidental. And all of this is true whether or not we like the places where we are right now.

For all that the chapters that follow present places that the authors deem significant and usually worthy of joyful celebration, they do not ignore the dirty, messy and tangled realities that sometimes, at least, include our disconnections, dislikes and discomfort in some places. To know your favourite colour and the place where you feel most alive does not mean the rejection of all other colours and places. Knowing such things, such everyday but often entirely overlooked things, such simple but rarely celebrated things, is also knowing yourself.

Belonging is vitally important to people's health and well being. Knowing where you belong strengthens various senses that aid an ability to thrive and contribute to the wider community (human and other than human). Senses of security and familiarity that derive from knowing your place nurture the soil in which you can put down roots to draw sustenance. Even when you travel away from the place of your belonging, knowing where it is, knowing its relation to your present location, can also maintain your sense of self, of identity, of being. Perhaps knowing where you belong begins with having a sense of home. But it is also related to knowing where you are – how the place where you lie, sit, stand or walk at any particular moment relates to other places. Home and abroad may both be defined by their relationship to "here". Orientation may literally refer to facing east, the direction in which we (seem to) see the sun, moon, planets and stars rise, but its purpose is to understand the relation of one's current location to other places from which one has come and to which one will go. Thus orientation serves as a literal and metaphorical reference to locating oneself in relation to others. Knowing where you stand, in a particular place, in a position that connects and separates you from others (and by both connecting and separating you, relates you), fills in acres of your otherwise only implicit knowledge of yourself. Orientation also helps you decide where to move next, which path to follow, which connection to enrich. By moving in and through place, you perform yourself as a person in relationship, a person with a place and a role. The shape of your standing and your movement is unique but never disconnected. To acknowledge this, and

so much more, is to find ways to reconsider the ways in which we humans have been misbehaving in the world for some time now. Those who continue to act as if they do not belong not only see reality falsely but they act badly towards everyone else (human or other-than-human).

In *Report from a Wild Country*, Debbie Rose offers a disturbing understanding of "wild country" in a summary of a conversation between herself and Daly Pulkara, one of the Aboriginal Australians who she credits with teaching her with considerable generosity (2004). For Daly, "wild country" is "a place where the life of the country [is] falling down into the gullies and washing away with the rains". The erosion of soil (and all that the soil had previously supported) is the result of the "wild" unrestrained and greedy abuse of people who named themselves "settlers" but really deserve the epithet "takers" (Quinn 1992). In contrast, Daly spoke of "quiet country" where "all the care of generations of people is evident to those who know how to see it" (Rose 2004: 5). Greater familiarity with Rose's work with Aboriginal Australians enriches understanding of this important contrast by bringing all the multi-species inhabitants of places into the drama. The "generations of people" who had previously cared for what are now "wild places", damaged places, eroded places, disappeared places, dead places, included a great variety of species. Indeed, Rose writes elsewhere of the responsibilities shared by all dwellers in places to care for the well-being of all other co-inhabitants (Rose 2004). Places are communities. Like all communities they can be damaged by anti-social behaviour. When humans imagine that our species alone is "social" (as is implied in the academic distinction between "natural sciences" and "social sciences") it is reasonable to expect what Daly Pulkara calls "wild" or truly anti-social behaviour. Naming one's shared places, owning one's shared belonging, celebrating one's shared dwelling — all these overlapping challenges to what seems normal in modernity (anomie, disconnection, disenchantment, disenfranchisement and disease) are what the chapters that follow explore. In their own way, as relevant to their place in the scheme of things, the authors indicate something about what it means to them to belong both to place and to a society and/or era that can make such belonging seem eccentric or romantic at best.

Shakespeare's Titania lists the 'lack of tread' which makes the 'quaint mazes in the wanton green … indistinguishable' as one more sign of wrong in the world. Confusion and disaster result from not knowing where one is, that one is a member of a place-community and a citizen of this world. More, not knowing how to tread in that place — and hence in all other places — has been utterly destructive. Heraclitus may or may not

have been correct that it is impossible to step into the same river twice, but places are made of and by those who move one foot, hoof, claw, root or fin in relation to another. Humans, animals, plants, birds, insects, microbes and other species co-create the communities / places in which they move together or in relation to one another. The dynamic dances of minerals and weather systems contribute to the rhythms of belonged-in places, ecologies, homes. But violent and destructive steps have also shaped our world. Forgetting their indigeneity, European colonialists assaulted other place-communities — genocide and ecocide have been vigorously pursued. The ongoing capitalist over-consumption of the world is a failure to belong within a world that does, after all, have limits and boundaries. By failing to celebrate their own dwelling and bodily participation in multi-species place-communities, Europeans (and their modernist descendents) have conned themselves into imagining other weird separations such as those some claim to exist between mind and bodies. They have deluded themselves that others' cries of pain are insignificant background noise that communicates nothing of value. These are examples of some symptoms of the extraordinary idea that humans are separate from the world. Like Galahad at the Bridge of Death, giving the wrong answer to questions about the

relationship between humanity and the world has led to deaths. But now it is not the life or death of the fictional Quest knight or any mere individual that is at stake. We have entered an era of mass extinction that will radically alter our planet home, forever silencing many of the voices of place-dwelling creatures, species by species.

Only rapid and dramatic steps back into the wanton green to rejoin the maze dance of the still vibrant multi-species place-communities can give us hope. Perhaps only our rapid and dramatic re-entry to the "deep world's gift economy" (Grimes 2006) will gain us partners in that dance. And perhaps we might only learn the steps of that dance if we begin with deceptively simple questions like "what is your favourite colour?" and "where do you most like walking?". The chapters that follow are not *about* this in any heavily didactic and depressing way. They are, rather, evocative and provocative presentations of how each author values and celebrates particular places. They are celebrations of belonging, of preferences, of self-discovery. In such celebrations we catch ourselves enchanted again by a gloriously alive and spectacularly fragile world. Each chapter is likely to send you back to places of importance for you. The book is likely to send you into the world you have never left and have always lived in as a dancing partner. Only now, if you have not seen it before, you may see the place where

you can take the first of many steps into the maze of the wanton green.

References

Gilliam, Terry, and Terry Jones. 2002 [1975]. *Monty Python and the Holy Grail*. DVD CDR14164.

Grimes Ronald. 2006. "Performance is Currency in the Deep World's Gift Economy: An Incantatory Riff for a Global Medicine Show, Interdisciplinary Studies" in *Literature and Environment* 9(1): 149-64.

Rose, Deborah B., 1992, *Dingo Makes Us Human: Life and Land in an Australian Aboriginal Culture*, Cambridge: Cambridge University Press.

Rose, Deborah B.,, 2004. *Report from a Wild Country: Ethics for decolonisation*, Sydney: University of Sydney Press.

Quinn, Daniel, 1992. *Ishmael*, New York: Bantam.

She said.
"You have to lose your way"

She said: 'You have to lose your way.
And then, when you are at the crossroads,
Bow down, and like the children play.'

So I sat down, and flattened with
my hand the chunks of soil, and dust
settled itself, and covered it.

I had to write my name, I knew,
but drawing lines itself had left
and all I touched were: drops of dew

were touching me. Morning: today,
the movement's music must be lost
and movement makes itself the way.

Maria van Daalen, from ASK THE RIVER,
a series of poems, 1996

Fumbling in the Landscape

Runic John

Not too long ago a childhood friend I hadn't heard from in years got in touch to say that he had been walking near the river we used to play in together as children and was horrified to see that Grasshopper Island had completely disappeared and he was wondering if I was aware of its disappearance!

Strangely enough, I too had been revisiting that path a couple of weeks before and I had to tell him that I too had been shocked to find our illustrious and joyful island was now nothing but dark swirling waters.

As children, Grasshopper Island was a magical and wondrous place, where, once we had climbed the great cliffs that surrounded the main approach to the island and had managed to navigate the treacherous rapids that separated the island from the mainland, we were totally isolated from the rest of the world. Here, in the sweltering summer sun, to the background songs of ten thousand grasshoppers (which gave Grasshopper Island its name) we would spend blissful hour upon hour adventuring. Amongst numerous other achievements, we discovered the fossilised remains of the earliest life that had inhabited the island and unearthed the fossilised footprints of an unknown (at that time) species of dinosaur, we found the site of the ancient city that once occupied the island and discovered the graves and lost treasures of the long overthrown royal dynasty that ruled there. We mapped the Island from end to end.

These were great achievements indeed, especially when you realise that Grasshopper Island was in reality an area of un-submerged scrubland in the middle of the River Irwell overlooked by an industrial estate, where local residents regularly dumped their rubbish rather than take it to the local tip. Its cliffs were the concrete river walls that separated the river from the cars and lorries parked outside the "Cash and Carry Warehouse". If I remember rightly, much of our treasure that didn't come from local residents' dustbin overspill had either been dumped on the island by the "Cash and Carry" or had washed downstream, often from the many mills and factories it shared its water with (deep dirty brown waters that on occasion changed to red, blue and yellow depending on what the factories upstream had poured into it that day).

I was brought up and spent all of my childhood days in the Rossendale Valley in East Lancashire, a beautiful place set in the foothills of the Pennines, surrounded by great hills and rugged barren moorland. I grew up at a time when the delights and distractions of Facebook, i-pad and X-box had not even been thought of. I'm sure we would have loved them if we had had them, but we didn't, so we had to fashion our own entertainment. Most of my time was spent outside in the hills or on the moors and for years the only gadgets my friends and I carried around with us were "primitive technology" in the shape of our

"special sticks" or staffs as we might call them today.

The landscape of Rossendale became both our playground and, without knowing it, our classroom. Here we established our land. We built our homes under the great rocks that jutted from the cliffs that overlooked the one road that swerved its way through the valley. Building walls with the branches we collected from the nearby woodland, thatching them with leaves and great sods of earth to keep out the rain and (in many cases) snow. We fashioned weapons from whatever we could find around us, swords of wood and stone-tipped spears. We grew in knowledge of the plants in our valley and used them to cook and make clothes. Often we were called to protect our tribe from invaders and with painted faces we fought valiantly side by side for the common good. We relived the great battles of the past and single-headedly we halted the invasion of the Rossendale Valley by the Roman hordes. We tended the land around our village and we lived a happy life within our tribe; albeit after school and at weekends!

We didn't really spend much time analysing or even thinking about what we were doing. When you are a child you simply do the things that you find interesting or fun, devoid of any adult need of function or some kind of meaning to give validity to your actions. What we did simply came naturally

to us; we followed the flow of our actions without ever stopping to question, analyse or ask why … it was fun so we did it!

As I've grown older and with the gift of hindsight, I have come to understand how important these first childhood fumblings in nature were to my life and, more specifically, to me as a Heathen. My childhood "play" to me today takes on a deeper relevance than it could ever have had as a child. This time that I spent within nature was not something learned from a book. In many ways it simply flowed from us, as though it was knowledge that was already within us, as though we were doing things that somehow we already knew how to do.

With retrospect, looking back today over this childhood time spent with nature I can see clearly that, even though I was not in the least aware of the fact at the time, this was a period of deep reconnection with the land itself and with my ancestors. Eventually, this would lead to my reconnection with my ancestral spirituality when I consciously discovered the Heathen path around the age of eleven or twelve. This event that now seems like one more step on an already unfolding path, a natural progression. Just as a seed is planted in the earth and is nurtured by the land until it blossoms, I feel that as a child I too was planted within the landscape and nurtured by the land to become the Heathen I am today.

Finding the space, finding the words; The Charge of the Horned God

Rufus Harrington

In the early 1990s, while a member of the Bricket Wood Coven, I was stirred up to perform a magical quest, to seek a vision of the Horned God. I was living at the time in Hampstead Garden Suburb, thanks to the kind generosity of Fredrick Lamond, who has supported and helped many people in the Craft in his own private way. His house has a lovely garden backing onto woods. For three days, I fasted and meditated daily, both in the garden and in the woods. In my meditation, I deliberately evoked every memory and experience I had had of working with the God. I evoked thoughts and images, emotions and every experience I could remember of being invoked upon in Craft circles in many previous years. Then I just relaxed, tuning into the natural world around me, sinking into the experience of nature, of the sun shinning through the trees, of warm grass and earth. I felt warm sunlight on my arms, now brown from the time spent outside. At night I relaxed into the starlight, warm evenings carrying me as I drifted in reverie, sometimes sitting, sometimes walking.

By the third day, my body had passed the hunger stage and this was no longer a distraction. I drank water and was not uncomfortable. I did not spend every minute of every day in meditation, I approached the quest

in a most relaxed way. In the circumstance, I didn't have to worry about anything, there were no significant distractions, I could slip away from the everyday world and focus my attention in this particular way, knowing I wasn't going to be disturbed. All these factors are very important.

On the third day, in the afternoon, sitting in meditation at the end of the garden, the vision of the Horned God began to open before my inner sight. I was carried to what felt a great height, out into the stars and beyond sensing a presence, the God of the universe. It was as though I was held in the? God's hand, yet flying beyond the horizon of space and time. I had entered a timeless, sacred space and then I heard words, kindly spoken echoing across the horizon of eternity. I began to write, my pad and paper were beside me, and as though taking dictation, wrote down the Charge of the Horned God.

As I wrote, I experienced the Charge, not as a set of words but as a gateway, as a set of words with a resonance which lock together in a particular way to create a particular effect. To this day when I use this charge I am carried back to the point of vision from where it comes and a power flows from that place into whatever ritual I am performing. I have used this Charge in healing work and many large Craft gatherings where I have been called upon to take the part of the Horned God. Many people have afterwards described how the words had a particular effect upon then and their own visions triggered by this Charge. I often use this Charge when I initiate. It takes me to a place of sacred power, it helps me to make a connection between the initiate and the sacred realm, "it opens the ways between day and the night between the realm of men and the Gods".

My experience of this Charge continues to grow and deepen, it is a statement of faith, a connection with power a hope for human kind. It speaks of love and guidance and destiny of an intelligence that has our best interests at heart. It teaches us to be brave and to trust our path and to have courage. It speaks of a freedom beyond the chains that perhaps our fears impose upon us. The charge calls us to awaken to walk the path of destiny, to answer the call of the Horned God, who yearns for us and loves us.
Blessed Be.

THE CHARGE OF THE HORNED GOD

For I am the Horned flame
And born before the night,
And from the beginning of all time
Know that I have loved you.
From your beginning in the oceans,
And in your destiny beyond the stars,
I have been with you always.
And as I have known you,
I have loved you.
And as I called,
You have followed.
Fear not, for I am with you.
Know not, for I am wisdom.
Yearn not, for I am silence.
For I am the ancient Lord of the trees;
And your children have always known me.
And in the dark places of the night,
And in the silence between stars,
There you will always find me.
For I am the master
and the opener of the gates;
And I open the ways
between day and the night,
Between the realms of men and the gods.
So walk in the darkness, for I am with you.
Trust your way, for it is sacred.
Tread lightly, for all is well.
The shadows are but the measure of your fear.
Crack the mirror and see the light.
Throw off your chains and put on wings;
For in my love is freedom.
For I love you,

I yearn for you,
I call to you.
For I am the cry and the call of the darkness;
I am the Horned One, Lord of the trees.
Remember me well,
For I have always loved you.

Stone
in
my
Bones

Sarah Males

How do I tell you how I relate to the land? Where do I begin? With the past, with myself or with a vision of the future? How do I speak of my affair with the earth, the stone and the water that holds me like a child? Of the elemental forces at work within me and around me? An earthly resonance. A shock, a resounding rushing of blood through my veins as energy flows through, around, in me and without me? Of my knowledge that my future lies inextricably entwined with this place?

When I speak of place I am referring to the larger world, to everything, each part, place and particle of existence. Those traces that skim the surface of physical being, that speak truths of past, present and future. Place that is more than just physical, place that sings with both harmony and discordant voices, a cacophony of communication from distant spheres or whispers of half formed utterances from those that are yet to come.

How did this happen? How did I reach this place of enormity, this vast and infinite space with which I feel deeply within my very being? Again and again I reconsider this change in my perceptions, for I was not born to this way of being. Or I was not born able to immediately recognise this relationship, whilst I suspect this is in some way an innate aspect of our nature and an aspect that has been pummelled out of us through centuries of attempts to control and exploit the natural world. For whatever reason, this understanding was not easily and immediately accessible to me.

As a child, I believed in magical beings, in dragons and trolls, unicorns and other fantastic creatures. This was an unquestioning assumption of the truth in such tales, a "knowing" rather than a received or informed position. A fascination with mystery and a joy in the uncertainty of the spirited world meant that I knew these things existed, something that comforted me in my exchanges with the mundane reality of daily life. In my early adult years, I was gripped by a gloomy existentialism, reinforced by my university study of philosophy, a syllabus entirely dominated by contemporary european thought. This left me in a bleak and isolated place with a huge and disconsolate sense of disconnection from people and place.

The emphasis on rationalism and empirical truth allowed little room for the magic to be found in nature. A deductive methodology reduced experience to mathematical equations and problematic analysis. I started to walk. I went out into the world, encountering life beyond theory, an experiential involvement with nature.

A profound recognition awakened my senses, as the landscape opened to reveal its power and authority. I was shocked and stunned by this experience. Reeling from this, I stood in awe of my earthly keeper. This was more than a sense of protection though. It was a strong, forceful recognition of being part of the whole, a deep and new understanding of my place in the world. A sense of dynamic forces working within, around and beyond my own existence. This experience was deeply emotional, profoundly shifting my way of being and my way of relating to the world. This felt like becoming alive, a birthing of spirit, a bringing into being of deep meaning and flowing understanding of my place in the universe. I knew that nothing would ever be the same again. No longer was I to be dominated by the mundane, numbing existence that had been my daily reality.

Looking back, I can still remember the intense feeling of discovery, of excitement and of anticipation. I am reluctant to describe this as a "revelation" although it is difficult to find another word that describes the fundamental shift in my spiritual awareness. The experience had transcended all previous understanding of my place in the physical world and had rendered many familiar concepts useless in the face of such magnitude. Learning to walk in a different way, stepping tentatively into a new awareness of being part of a greater living being. Action became tinged with excitement and an eager desire to flex these new muscles. A faltering and fumbling, a sense of movement creating ripples and echoes through time, touching the past and reaching towards the future. The extending of limbs into rock, the edges of nature, trailing touch, linking with spirits in stone and earth. I had

discovered a new deeply sensual relationship imbued with passion, yearning and emotional resonance. New ways of speaking, touching, moving and feeling gave me the language to communicate beyond common words. A profound love affair, this felt like meeting a new lover, forging a new relationship and dancing to an earthly rhythm. Over many years, this relationship has strengthened, familiarity seasoned with changes, ebbing and flowing with the cycles of nature.

I can walk through many landscapes; I can feel the earth beneath my feet, the water rushing between my toes. But nowhere do I feel more at one than in this limestone cradle that is my current home. I constantly return to the dales, to rifts worn by water streaming towards the river, towards the sea. At Lathkil Dale, in the Peak District, I visit the mouth of the resurgence where water will follow its course above or belowground depending on the seasons. At Monks Dale I pick my way through rocks, trees and summer vegetation, a damp and earthy experience. In Deepdale, I shelter in Thurst House Cave overlooking the flower scattered slopes below. The dales are many and varied offering deep, sheltered routes contrasting with open, grazed farmland pathways. On higher ground at Minninglow there are chambered tombs, slabs of limestone marking burial sites from the Neolithic period. Geology describes this as the "Derbyshire Dome" formed around 350 million years ago

during the carboniferous period. A length of time almost inconceivable in relation to our understanding of time, in terms of our fleeting, but needy existence. That fact in itself supports and encourages my spiritual ties to this place.

I exist in the crevices, the clefts, the fissures in the stones, the damp and mossy places that hold the promise of secrets and mysteries. The stone of the white peak speaks to me of coral seas, of water and stone bound together in an unfolding, eternal connection. The water creeps, runs and flows eternally through this porous rock holding an uninterrupted connection through time and place. I feel the movement of history, of millions of years, time extending over space, bringing into being of new life and encompassing the old. The carbon traces of particles of life in most minute detail or the significant fossils of sea lilies and shellfish caught in time. The rocks that surround me shine with shades of grey, tinges and traces of mineral deposits holding me in their gaze.

These are wild places, places where the limestone bedrock tears through the surface exposing me to thousands of years of life. The spinal ridge of Chrome Hill presents me with the dragon writhing within, a life form of ageless beauty and eternally long drawn out movements before my very eyes. To climb the dragon's back is to ride the movement of time and I shudder in recognition of such magnit-

ude. The wind rushes through and around me here, has blown throughout, an ancient reminder of nature in spirit and ethereal transition. My responsibility to the earth is inscribed on my body, is spoken in words and demands action from me.

Now I can return to philosophy, to an investigation of phenomenology, a need to understand that "knowing how we know" is rooted in daily existence and a need to interact with and respond to my place in this world. As we face an uncertain earthly future, a time when we recognise the dangers inherent in our lifestyle, our dependency on earthly resources creates a demand that we review our ways of being in the world. To make explicit a sense of "connectedness" contributes to the development of an ecological phenom-enology, a theory of knowledge that is rooted within the environment and a belief that nature exists in, of and for itself, rather than as a resource available for exploitation. My passionate relationship with the environment brings with it desperate feelings of urgency regarding the protection of resources for the continuance of our whole eco-system. This is not to do with conserving resources for future human generations to continue to exploit, this is a fierce and visceral belief, written in my body, that we are of this earth. The magic in my daily existence is earthly, a knowing that is ecological in origin, rooted in stone and water.

A Heathen in Place: working with Mugwort as an ally

Robert J. Wallis

A journey: introducing Mugwort

I'm walking past an unkept verge on my way home from the train station, having commuted to the city, and a raggedy plant catches my eye. It is Mugwort, *Artemisia vulgaris*, outwardly an unassuming plant but, as I now know, with hidden, extraordinary qualities. The encounter is a markedly special one, albeit in a very ordinary place, at the end of a very typical day - and I smile at the fact. I offer a discrete salute to Mugwort and whisper a respectful greeting in Old English:

> Gemyne ðu mucgwyrt hwæt thu ameldodest
>
> hwæt þu renadest æt regenmelde
>
> una þu hattest yldost wyrta

Continuing on my way, I spot a young Sparrowhawk circling above the woods near my home, something I've not seen before. While I would not be so arrogant as to think this sighting was 'meant for me', for Wyrd's pattern is not so fatefully reliable, I recognise the beauty of the moment and offer the bird a 'waes thu hael'. Arriving at the cottage, I unload my pile of essays for marking and, with a very welcome tankard of cider in my hand, offer the first draught in a libation to the house wight[1] : I sign the hammer of Thunor over the brew, then spill some of the liquid over a large flint offering-stone near the front door, which produces a satisfactory fizz.

A proposal: a Heathen in place

I open my essay with this personal narrative for three reasons: first, to

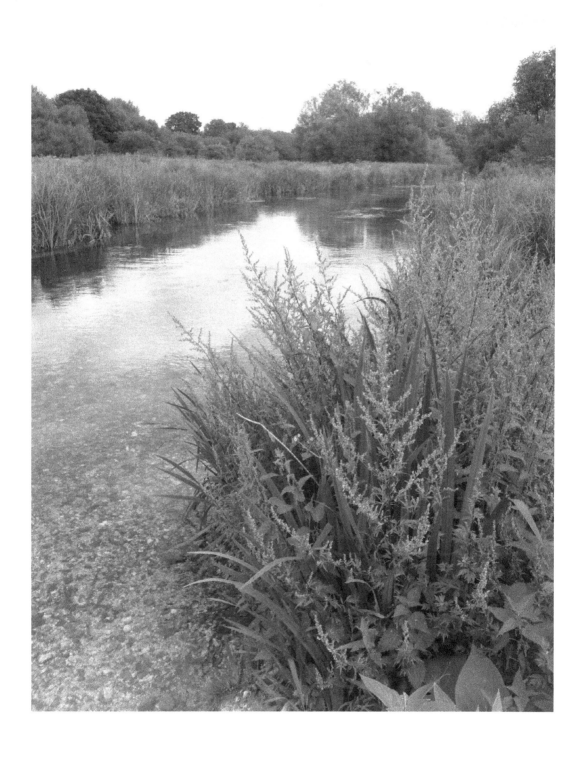

MUGWORT, SITUATED IN PLACE AS A TYPICAL WAYSIDE HERB, UNASSUMING BUT 'GRACING' VERGES

introduce you to Mugwort, a plant ally I am going to treat in detail; second, to make the point that my Heathenry begins at home and is something that permeates every aspect of my daily life; and third, because all of this is firmly rooted in my relationships with places – both local and further afield. For me, this is both ordinary and extraordinary, at the same time, what I might term a Wodenic paradox[2]. Of course I take my Heathenry with me wherever I go: to work in London, to the picnic spot in the woods that we cycled to last weekend, when on pilgrimage to sacred sites some distance away from home, such as Danebury Hillfort, Avebury stone circles, and further afield yet - last Summer, to the rock art site of Ekeberg and Viking burial mounds at Borre, near Oslo. But in my heart, my Heathenry begins at home and in place, for the place that I am in, this land, is at the centre of my ontology and epistemology, and shapes who I am. My Heathenry is inseparable from the place(s) in which my life unfolds, and in many of these places, I encounter Mugwort.

A little context: on Mugwort's lore

Armstrong suggests that Mugwort 'is not pretty, nor even conspicuous, and it is remarkable that it should ever have attained to fame and sanctity'[3]. Grigson agrees: 'It is tempting to call [it] a scruffy, mean plant, as one sees it along the roads at the end of summer, and to ask why such a species ever became so distinguished'[4]. While she is not

much to look at (Figure 1) – no colourful flowers or leaves, no fruit to speak of, or noteworthy scent, Mugwort does have agreeable, feathery leaves, with pleasing grey down on the underside, and when bruised gently, the leaves smell of aniseed. While her unassuming demeanour means she may often be overlooked, she is recognised in the lore, not only in England but over great distances, as a special plant. Mugwort is described by some as the '*Mater Herbarum*, or Mother of Herbs'[5], the 'female herb *par excellence*'[6], and there are fine late thirteenth century carvings of Mugwort in the Lady Chapel at Exeter Cathedral (Figure 2)[7]. While inconspicuous, 'looked at more closely as the mediaeval sculptor looked at it, Mugwort does prove to have some attraction – especially in its leaves, deeply and delicately cut, dark green and glistening above, white below. In a vase it looks surprisingly agreeable'[8]. An accurate botanical description runs thus:

> An erect herb up to a metre in height with tough, grooved stems and many deeply pinnatifid leaves with five to seven lobes, dark-green above but silvery and hairy beneath; small, green-to-yellow, egg-shaped flowerheads crown the plant in long terminal spikes; the taste is bitter…Common in waysides and waste places throughout temperate regions of the world[9].

Folklore associates Mugwort with fair

journeying and inspired dreams: for the former, the traveller should carry Mugwort leaves, or perhaps eat one or two to relieve fatigue; for the latter, one might sleep with a small bundle of leaves under one's pillow to make a 'dream pillow' or drink an infusion of the leaves before retiring to bed. One of the earliest, most exuberant references, is from Pliny, who 'saith that the traveller or wayfaring man that hath the herbe tied about him feeleth no wearisomeness at all, and that he who hath it about him can be hurt by no poysonsome medicines nor by any wilde beast, neither yet by the sun itself'[10]. This import is recognised across these islands and further afield:

In the Isle of Man...it was gathered on Midsummer Eve 'as a preventative against the influence of witchcraft' and placed in chaplets and the heads of man and beast to ward off evil influences. In France...it is worn to prevent aches and pains. In Germany, the people had like customs and eventually threw the girdles and crowns of Mugwort into the Midsummer fire. In East Prussia it was used for divination. At Midsummer *Artemesia alba* is used as a fumigant in Morocco[11].

Strikingly, for such an easily overlooked plant, Mugwort is a significant feature in folklore and herblore as far away from my Hampshire home as North America and China[12]. Much of the folklore on Mugwort is compiled in Frazer's *The Golden Bough*, a work of armchair ethnography published in 1890

which remains a popular classic but has been summarily deconstructed by anthropologists. In addition to the lore cited above, Frazer notes the use of Mugwort in magic, to prevent sore eyes, to protect against witchcraft, thunder and ghosts, as well as its use in exorcism. The time of Midsummer is especially auspicious, not only for using Mugwort in magic but for gathering the plant

CORBEL A FROM THE LADY CHAPEL IN EXETER CATHEDRAL, ALMOST CERTAINLY DEPICTING MUGWORT (LATE THIRTEENTH CENTURY.

and for throwing it into the Midsummer fires[13]. Though fascinating, all of this must be viewed critically, as a matter of course, but it is clear from Frazer, Armstrong and other sources that Mugwort has been viewed as a special, magical plant, in a variety of folklore traditions, across cultures.

Mugwort and the Nine Herbs Charm

Perhaps the most intriguing citation of Mugwort in the lore, at least to a Heathen in England like myself, is in the Nine Herbs Charm. This charm originates in the 'MS London British Library Harley 585' manuscript, named *Lacnunga* ('Remedies', according to Cockayne[14]). 'Approximately the size of a modern paperback'[15], this 'book', was perhaps 'a general practitioner's travelling reference work'[16] – the term *læce* meaning healer. Roper addresses the status of this 'practitioner', noting that 'wise man' or 'wise woman' was an enduring term for a charmer; also 'cunning'. In Old English we also have the terms 'conjurer', 'wizard', and even 'doctor'[17].

While eighty of the ninety Anglo-Saxon charms are in Latin, the last third of *Lacnunga* is written predominantly in Old English and includes the charms entitled the *Nine Herbs Charm*, *Against A Dwarf*, and *Against A Sudden Pain* (or, misleadingly, a 'stitch')[18]. 'Charm' is a thirteenth century loan word from the Old French, a reflex of the Latin *carmen* ('song')[19]. In Anglo-Saxon, charms were terms the

charm is *galdor/gealdor* – 'an incantation, divination, enchantment, a charm, magic, sorcery', this term being connected to *galan* ('to sing, to enchant')[20], cognate in turn with the Old Icelandic *galdr*[21]. The power of speech, or words of power, is key to understanding Anglo-Saxon magic. Speech was, as Barley puts is, 'an incorporating act. It establishes contact'[22], enabling the charmer to make magical connections to 'things'. In this sense and in a wider Northern frame, charms might be seen as *varðlokk(k)ur*[23] – 'guardian spirit fastenings' or 'guardian spirit enticements'[24], meaning those words of power enabling the charmer to attract, entice and perhaps control, or at least, 'fasten', spirits. They might also be interpreted as *seiðrlæti*[25] – 'sorcery songs', or as *fræði* – 'a mumbled formula'[26]. All of this suggests these charms were much more than the superstitious 'charm' as this concept is understood today, and so is intriguing when it comes to understanding the context of Mugwort in the charm.

I took an interest in the Nine Herbs Charm as soon as I learned that the Anglo-Saxon god Woden is cited in it. After the nine herbs have been introduced, Woden intervenes by charming an adder and striking it with nine 'glory twigs'. Woden figures strongly in my Heathenry because the cognate lore about the Old Norse Oðinn tells us that he learned the wisdom of the runes,

knowledge which has been passed on to humankind, in an ecstatic ritual. Whether or not the runes were used in divination, in the casting of lots, in the ancient past cannot be proven, but as many Heathens will attest today, they 'work'. And whether or not scholars agree as to whether Oðinn was a shaman-like figure, the lore is striking in this regard and many Heathens today find resonances between what the mythology tells us about Oðinn, and their own neoshamanistic practices. As a committed runecaster for over fifteen years, Woden's appearance in the Nine Herbs Charm has always intrigued me, as has the meaning of the nine herbs in the charm, and particularly Mugwort. A quick Internet search or browse through a herbarium quickly points to Mugwort's 'active constituents'.

An empirical note:
Mugwort's 'active properties'

Mugwort contains 'ethereal' or 'volatile oils' such as cineole and thujone. Cineole or 'wormwood oil', related to eucalyptol, can reduce inflammation and pain, and clinical trials show effectiveness against the symptoms of sinusitis. Thujone has a reputation by virtue of its significantly active presence in absinthe, thought to give the drink its 'hallucinogenic' properties by affecting cannabinoid receptors in the brain in a similar way to Tetrahydrocannabinol (THC). While the molecular shapes are similar, thujone actually acts as a Gamma-aminobutyric acid (GABA)

receptor antagonist, so that neurons may fire more easily, resulting – in high doses – in muscle spasms and convulsions. Thujone may also help regulate menstruation, but caution is required: at said higher doses, it may act as an abortifacient (causing miscarriage)[27]. Other constituents of Mugwort include flavonoids (antioxidants), triterpenes (resins), and coumarin (an anticoagulant and derivative of the blood-thinning drug warfarin which is used for certain heart conditions) derivatives. According to herbal medicine, chewing some leaves reduces fatigue and stimulates the nervous system, it has been used as an anthelminthic (a vermifuge, expelling worms from the body), has stimulant and slightly tonic properties, and works as a nervine, emmenagogue, diuretic and diaphoretic.[28] Mugwort is also used in traditional Chinese medicine in the form 'moxa' for moxibustion (an external heat and smoke treatment)[29].

Mugwort's special status in the lore, then, is vindicated by empirical data. But for me this is not the end of the story; indeed, to approach and understand Mugwort based only on chemical composition and empirical effects, is problematic. In not considering Mugwort as a whole, as more than its constituent parts, is to be disrespectful. I have come to regard Mugwort as an ally (I prefer not to use exaggeratedly beneficent term 'helper' or rather irrelevant 'spirit'), have come to know her, and as a result I'm wary of

'scientific' investigations and explanations for their own sake, without looking further. No doubt, certain 'active properties' are evidenced and relevant; yet as such Mugwort becomes objectified, the plant – her person – less relevant than the effect(s). Any sense of relationship between 'agent' and 'recipient' – indeed who is agentive in this dynamic – is lost. And as the Nine Herbs Charm sets out, Mugwort is a significant agent.

A revelation: Mugwort's personhood

The Old English greeting to Mugwort offered in my introduction, which opens the Nine Herbs Charm, can be translated as follows:

> Remember Mugwort what you made known,
> what you set out in mighty revelation ,
> 'the first' you are called, oldest of herbs[30]

Mugwort (and other plants in the charm) is addressed directly and consistently, with a personal pronoun, the second-person 'you', and the intention of the poetic phrasing is clearly honorific. More than 'a plant', as biological classification delimits epistemology, Mugwort is approached respectfully in the second person singular, indicating a 'person'. This seems to me much like meeting a human friend whom one respects, but more than this it is clear from the charm that Mugwort holds important wisdom; indeed, she is recognised as the first and oldest of herbs. One of

MUGWORT HERBARUM

Mugwort's achievements is marked out as 'what you set out in mighty revelation': the Old English *regenmælde*, which I translate as 'mighty revelation' is cognate with the Old Icelandic *regin*, 'rulers' or perhaps 'gods' or 'councils'. North thus suggests an intriguing translation of *regenmælde* as 'a council of natural powers'[31], or what I'd put more accurately as 'a council of nonhuman agencies'. Clearly, then, Mugwort is presented as an important agent in the Nine Herbs Charm.

Approaching the Nine Herbs Charm as a store of useful Heathen lore which is closely connected to the land in which I dwell, I have in recent years been exploring the deeper meanings of the charm and of Mugwort, and built a relationship with her. The cycle of the relationship begins in late July and early August when I harvest parts of her. Being Heathen, any 'ritual' element to this is pragmatic and direct rather than sonorous and protracted. Ideally I might harvest Mugwort precisely at dawn, at Lammas (31st July), which may in both respects be auspicious, but equally practical: the best time for harvesting is around the time that she flowers, and earlier in the day the plant has not been warmed up by the sun, so that her 'active constituents' are at their best. Approaching the plant, I kneel, make a salute and recite the opening of the Nine Herbs Charm, as a sign of my respect. Since I am taking parts of her living body, so it is important that I make a sacrifice too, so I

proceed to make a libation of cider, mead or beer, much as I do with the offering stone at home. Chanting softly I then cut nine stems from a number of plants, never taking so much from one that it cannot remain healthy and strong. These I bind with string, and hang from my belt. Before leaving, I sign Thunor's hammer with my blade as a gesture of good will, touch my hand to my heart and give a nod. Back at home, I dry the herb by my shrine and within a few weeks the leaves are dry enough to be used.

Mugwort makes a soporific tea and a pleasant incense, and the lore indicates that Mugwort was used in these ways in ancient times: 'taken in a drink, mixed in a salve, or smoked'[32]. The find of a 'doctor', perhaps a 'druid', from a mid-first century CE grave in Colchester, near Essex, with a locally-made copper-alloy strainer bowl last used to brew a herbal tea containing Artemisia[33], is strongly suggestive of the sustained use of Mugwort over the *longue duree* of the late Iron Age to early Medieval periods in England. In each case of preparation, the effects are noteworthy.

One user comments:

[For incense I use] dried leaves and find that inhaling just a sniff or two puts me in a very noticeably altered state. It's not dramatic...but there is a definite and pokey alteration of consciousness in which, yes, things are 'revealed' (for example, meanings of runes).

And the more I do it, the odder the experience becomes, as if intensified by repetition. Very odd…very pokey (Letcher pers.com, 31 July 2010).

Yet when examining the use of a variety of 'narcotics and intoxicants', in his excellent, dense study of *The Viking Way,* Price makes no mention of Mugwort, and in her study on Northern shamanism focussing on *seidr* (sorcery/magic/shamanism) practices (past and present), *Nine Worlds of Seidr Magic,* Blain mentions a number of indigenous entheogens which may have been recognized as such in the Old North, such as Henbane and Fly Agaric mushrooms, but she addresses Mugwort's effects as 'mild if there at all'. There are many more powerful entheogens but while Mugwort is subtle, she is special. I tend to prefer incense and smoke over an infusion, although Mugwort-leaf tea (I have found the flowers less strong) is surprisingly refreshing and 'pokey', to use Letcher's term. In any case, the right set and setting are important.

Negotiating Mugwort: a Heathen en-placed

The place of ritual, the place in which my Heathenry is set, is crucial to the practice – my Heathenry, to reiterate, is embedded in and I think inseparable from place. This speaks to the practice termed in Old Norse *utiseta,* 'sitting-out'; that is, sitting in a wild place or on the heath (as a 'heathen') and engaging with the wights there, in order to perform one's magic or spiritual work. In a typical ritual I will go to a local sacred site, such as the Yew grove I visit with my companions every Monday evening for our runecraft. Approaching the grove, I stop, raise my staff, touch my fist to my heart, and offer a respectful nod. I then touch the trunk of the closest tree, making a physical connection, and recite the stanza of the Anglo-Saxon rune poem devoted to the Yew tree:

> Yew is outwardly an unsmooth tree
> Hard, fast in the earth
> A keeper of fires
> Roots writhing beneath

Advancing to the centre of the grove, to the oldest of the trees, I settle myself next to it and make an offering of cider (much as I do to Mugwort and other plant-people). The ritual usually begins (although of course it had already begun when I started walking, with intent, up to the grove) with a mark of respect to the wights of the place, which I do by shaking a shrill-sounding rattle hung with bells and charms. A further mark of respect (I hesitate to use 'invocation') is then made to Woden, by chanting poetry and galdr in associated with his name. Finally, I speak the opening of the Nine Herbs Charm for Mugwort, light the incense and inhale the smoke:

I take my dark, rutilated quartz sphere from its pouch and let Mugwort carry my scrying. Consistently, the experience is ecstatic.

Under the spell of Mugwort, an otherworldy glow, hue or fuzziness comes to vision; as such, Mugwort offers a certain experience of otherworldliness, of being in an altered place/space. Mugwort intensifies my experience visually, focusing vision in certain ways. Interestingly, there are numerous finds of quartz crystal spheres in pagan Anglo-Saxon cemeteries, particularly in the south and southeast of England. These amulets or talismans (perhaps dipped into water to empower it for healing purposes), often found in leather pouches worn at the waist known as 'elf-bags', along with keys and other signatures of women of some status, were arguably associated most strongly with the graves of 'cunning women'[34]. We do not know they were used for scrying, but as Heathens today we inevitably need to be creative in our reconstructions of the past. This is not to say that any interpretation fits, however, because the evidence is not that flexible, but we do have precedents for the use of quartz crystal spheres among our heathen ancestors. Mugwort adds another dimension of significance to this: not only is it well-known as a magical plant in the lore, but also it is an effective aid to scrying.

Mugwort's presence is gentle, yet pokey, subtle, but profound. I am reminded of the term 'giddy' which derives from the Old English *gydig*, 'engaged with a god'. My awareness widens, my senses are heightened, taking in all my surroundings. There is a great sense of vitality and life, of connection to all of the living things surrounding me. I recognise that I am inseparable from this place and 'nature' more broadly, nor from the Earth – *Erce, Erce, Erce, eorþan modor*[35] – herself. Everything is, to use a now-prevalent phrase, connected. My sense is that Mugwort assists in attuning to other plants and in communicating with these other plant-people. I have wondered if Mugwort might be a conduit to enable human-people to communicate with the spirits of place and plant-people in particular. Or perhaps Mugwort is speaking through me: my experiences strongly suggests that human-people act as vessels for the plant to communicate, in a sort of 'possession'. Mugwort has taught me how to attune to places in deeply profound ways, and to other plant-people in particular. While some Pagans might want to 'awaken' or 'invoke' the 'spirit' of a place – a misguided and disrespectful endeavour, if ever there was one – I am interested in approaching respectfully the persons living there; in this case yew and ash-persons, a mouse-person, bumble-bee people and on occasion, fox-, buzzard-, badger- and lizard-persons. And I use this terminology, cumbersome though it may be, quite deliberately.

Animist Heathenry:
a landscape filled with 'persons':

Recent scholarly thinking on animism – I would self-ascribe as a Heathen animist – is less concerned with how 'primitives' attribute spirit to matter (an outmoded Victorian misconception of animism) than with how indigenous ways of being and knowing disrupt such orthodox Western dichotomies as 'spirit' and 'matter' and instead look to a world which is filled with 'persons', only some of whom are human, and whose own ways of seeing are respected as equivalent to one's own. In addition to the lore set out in the Nine Herbs Charm, there is substantial evidence for animism in the Migration Age. The belief that plants had their own wights, or were wights themselves, is indeed evidenced in German, English and Norwegian folklore[36]. The tone in the charm is, as I have noted, 'reminiscent of animistic or polytheistic belief in the way the lay personifies the herbs'[37]. While these sorts of 'beliefs' are often viewed negatively[38], as projections, as anthropomorphism, it is more appropriate to think of animism as respect for other-than-humans and negotiating relationships with these agencies as equal 'persons' in a shared world. On a day-to-day basis, our Northern ancestors related to elves, among other wights: 'fellowship with such beings and small offerings made to them on a daily or near-daily basis was likely the most common aspect of Germanic religion'[39].

In the daily lives of our ancestors, then, we may find respectful, relational engagements with the other-than-human world which resonate with animist ontologies elsewhere.

'Repay gifts with gifts': negotiating a relationship with Mugwort

The address to Mugwort as a 'person' in the *Nine Herbs Charm* is indicative not only of personhood, but of a respect afforded the plant by the reciter of the charm, as well as a relationship between charmer and plant-person, with the singing of the charm working as a mechanism or medium to establish contact with Mugwort. In an ontological system in which gifting, reciprocity and obligation are key, it seems logical to infer such relations at work between Mugwort and the charm-user in the *Nine Herbs Charm*. A gift offering from one human-person to another requires a gift of return (at some point); the gift of Mugwort-perception (for want of a better term) afforded by Mugwort as a helping plant-person (again, begging a finer term) betokens a gift or offering in return – and so a relationship, or perhaps more accurately a negotiation, is instigated. Whosoever chooses to engage with Mugwort – to collect it, to dry and prepare it, to use it as incense, drink it or use it in a salve – must, I think, consider the associated lore laid down by our ancestors. In short, respect, courtesy and appropriate etiquette are key to negotiating an active relationship with this extraordinary plant-

person. Nine (that magic number of the Old North!) basic rules for dealing with wights, drawn from the ancient sources, might look like this:

1) be courteous and respectful;

2) do not 'refuse food or favours in general. Even a gift that seems worthless may prove to be of great value';

3) but be careful about accepting drink, which is often too intoxicating for humans, and joining in dancing;

4) if asked to do favours, do them, however inconvenient;

5) give warning when, outdoors, lighting fires, tossing boiling water or relieving yourself;

6) never lie;

7) do not use steel;

8) do not be the first to speak; do not boast about favours received from them or ask for gifts;

9) never disturb stones, mounds or other dwellings associated with them without permission[40].

Working animically with Mugwort has occasioned experiences of otherworldliness, of encounters with other-than-human beings (by which I mean 'people'), which are outside what tends to be called 'rational thought'. Indigenous animistic ontologies, I think, offer a corrective, readjusting a human-ist perspective which is skewed towards human ways of knowing, to recognise the variety of persons with whom we share this world and to whom respect is due. Mugwort, as an ally, has greatly assisted me in this process, working as a leveller.

Conclusion:

And perhaps this is really the point. I do not seek 'spirits' which are situated in a 'spirit world' distinct from the 'real world', because all of these concepts are largely dualistic and tend to divorce 'people' (all persons) from places. I approach a world which is filled with persons and I seek to come to know those persons, as closely as possible, on their own terms, and this quest requires negotiation, respect and due etiquette. This approach could usefully be framed, I think, to use Viveiro de Castro's terms, as a multinatural and unicultural ontology, not a multicultural and uninatural one as rational materialism holds. I understand this to mean that to recognise a world filled with diverse persons is to appreciate that all persons, as equals, know in the same way, or have a related 'culture' (unicultural), but that our natures, our ways of seeing the world and one another in it, are different (multinatural). There is, then, not one nature 'out there' (separate from humans) with culture imposed on top of it, but uniculture with a multinatured variety of ways of seeing one another. Crucially, in this approach humans are not superior because all persons

are of one culture, but their ways of seeing are equal and as such multinatured. 'Seeing' with the assistance of Mugwort enables me to adjust myself to meet the communicative level of other-than-human-persons, something I cannot do in an 'ordinary' state. The long and the short of this, is that my experiences with Mugwort, in tandem with the directive of new animism, have profoundly changed the way that I view the world, with implications not only for how I operate as a Heathen but, perhaps to state the obvious, in all aspects of my life. In my scholarly work, for instance, an animic approach has led to useful insights into the production and consumption of prehistoric rock art and other visual/material culture, and I have also been exploring the way in which today's pagans are looking to animism as an ontological and epistemological resource, in part influenced by the dissemination of academic thinking on animism in pagan discourse (see especially Graham Harvey's work). My engagements with Mugwort have re-ordered for me my place in the world, the places in which I am en-placed, and contributed to an ongoing process of re-enchantment, a creative and magical act which resists[41] the conventional 'worldview', even if I cannot fully escape it.

References and Further Reading:

Dubois, T. 1999. *Nordic Religions in the Viking Age*. Philadelphia: University of Pennsylvania Press.

Fries, J. 2002. *Helrunar: A Manual of Rune Magick*. Oxford: Mandrake.

Griffiths, B. 1996. *Aspects of Anglo-Saxon Magic*. Frithgarth, Norfolk: Anglo-Saxon Books.

Gundarsson, Kveldulfr. 2007. *Elves, Wights, and Trolls: Studies Towards the Practice of Germanic Heathenry, Volume I*. New York: iUniverse.

Hall, A. 2007. *Elves in Anglo-Saxon England: Matters of Belief, Health, Gender and Identity*. Woodbridge, Suffolk: Boydell & Brewer.

Harvey, G. 2005. *Animism: Respecting the Living World*. London: Hurst.

Harvey, G. and R.J. Wallis. 2007. *Historical Dictionary of Shamanism*. Lanham, Maryland: ScarecrowPress.

Johnson, N. and R.J. Wallis 2005. *Galdrbok: Practical Heathen Runecraft, Shamanism and Magic*. London: The Wykeham Press.

Pollington, S. 2000. *Leechcraft: Early English Charms, Plantlore and Healing*. Hockwold-cum-Wilton, Norfolk: Anglo-Saxon Books.

Price, N. 2002. *The Viking Way: Religion and War in late Iron Age Scandinavia*. Uppsala: Department of Archaeology and Ancient History.

Rodrigues, L.J. 1993. *Anglo-Saxon Verse Charms, Maxims & Heroic Legends*. Middlesex, Pinner: Anglo-Saxon Books.

Wallis, R. J. 2003. *Shamans / neo-Shamans: Ecstasy, Alternative Archaeologies and Contemporary Pagans*. London: Routledge.

Wallis, R. J. 2010. 'In mighty revelation': The Nine Herbs Charm, Mugwort Lore and Elf-persons – An Animic Approach to Anglo-Saxon Magic. *Strange Attractor Journal*, volume 4: in press.

Notes

1 A complex term, here used to mean something like a 'non-human agent'.

2 See Johson & Wallis 2005.

3 Armstrong 1944: 22.

4 Grigson 1987[1955]: 384.

5 Grigson 1987[1955]: 382.

6 Cameron 1993: 177.

7 Certain carvings have been identified as Mugwort (see Hope 1971; also Walker 1979; Grigson 1987[1955]: 384).

8 Grigson 1987[1955] 384.

9 Mills 1989[1985]: 154.

10 See Hope 1971: 18.

11 Armstrong 1944: 22. See also Grigson 1987[1955]: 382-384.

12 Armstrong 1944.

13 Frazer 1890.

14 Cockayne 1864-1866.

15 Roper 2005: 24.

16 Page 1998: 162.

17 Roper 2005: 24. Davies 2007[2003] discusses the variety of charming and cunning folk in historical context.

18 Roper 2005: 30; see also Wallis 2005.

19 Roper 2005: 14.

20 Thus, the nightingale is the 'night singer' or 'night charmer'.

21 Roper 2005: 14.

22 Barley 1972: 71.

23 As found in the saga of Erik the Red (*Eiríks saga rauða*), for instance.

24 Price 2002: 207.

25 This term is used in *Landnámabók* and *Laxdæla saga* 37.

26 Price 2002: 208.

27 Mills 1989[1985]: 154; see also Lust 1993[1974]: 284.

28 Grieve 1992[1931]: 557

29 Grieve 1992[1931]: 557.

30 A note of caution: 'Because of the corrupt condition of the charm in the manuscript, any translation must be tentative' (Cameron 1993: 144).

31 North 1997: 210-211.

32 Jolly 1996: 136.

33 Benfield et al, 2008.

34 See, for example, Meaney 1981, 1989; Welch 1992; Wilson 1992: 96, 113, 138; Stoodley 1999; Pollington 2000: 48.

35 'Erce, Erce, Erce, earth mother', from the Æcerbot (charm for 'unfruitful land') recorded in the early eleventh century (metrical charm 1, BL Cotton MS. Caligula A.vii).

36 Gundarsson 2007: 28

37 Jolly 1996: 127. See also Storms 1948; Griffiths 1996: 47; Roper 2005: 32.

38 See Archbishop Wulfstan's presentation of *deofolgyld* ('idolotry') in the law written during Cnut's reign (1016-1035), translated in North 1997: 207; also, Halitgar's *Penitential* II: 22 (eleventh century), also translated in North 1997: 276.

39 Gundarsson 2007: xi.

40 Here, I am drawing on Gundarsson 2007: 3.

41 Letcher's (2007) notion of 'resistive discourse' resonates for me here.

Wild, wild, enchanted water …

Lou Hart

They come here for healing, from all of their ills
A draught of well water is better than pills.
We help with both childbirth, and eye complaints
With seizures, convulsions and all sorts of faints.

(Song of the Water)

Have you ever heard singing in a waterfall or in a stream or the sea? Who are the singers? Ancestors? Spirits? Forgotten gods? In streams, rivers and waterfalls if you listen (absently rather than closely) you can sometimes hear music; calling and singing, sometimes the same three notes over and over. And you will not be the only one. The singers are quite often referenced in local myths and stories and are known in many places including Rostherne Mere in Cheshire, on the Mermaid's Rock in Lamorna at the far end of Cornwall, and at Llanllwchaiarn in Ceredigion, West Wales. Are the voices related to some mythical, legendary, historical event or people, or to something more natively intrinsic, to water itself?

Have you ever washed your hands of something you no longer wanted to be involved with? Have you ever put coins in a fountain and made a wish or thrown them into a well or river? Have you ever purified yourself with water?

If so you are part of a long tradition of sacred interaction with water. Whether standing in the spray of a waterfall in full spate, sitting beside a stream gurgling over rocks or walking on the beach in a storm when crashing waves are high and the air is charged with salt and foam, I have often felt exhilaration and sheer joy whilst in the presence of wild water. Add the voices and the singing, which are heard in some places and the water becomes the carrier of legend with its still, timeless energy. Sometimes I feel connected to the ancestors of days both quite recent and long past:

charcoal burners in the green woods by a stream, walkers by the worn path of a riverbank, dreamers by a waterfall, are all suddenly within reach, their presence seemingly amplified and absorbed by the water. The area reverberates with a charged magic, and I know that the things that I choose to do here and now by waterfalls and streams will carry something of myself to recreate further magic.

In this writing, I will explore some of the properties of wild water (for it is wild water that has been venerated by peoples around the earth since time immemorial) and describe some of my visits to places where wild water is known for its healing, singing or mystical properties.

What is it about water that is so special?

Healing

Wild water runs its own course; wild water left alone is the source of life for many aquatic species; the salmon and herring, the click beetles and otters; sea weeds and shrimp; coral reefs and algae; plankton and whales. It is also

the source of life for all other creatures and inhabitants of this planet including us. Wild water has a spiritual and vibrant quality that is lacking after it has been processed and chemically altered. A member of one of the old Derbyshire witch families once said that *water is the spirit of the earth.*

There is also the physical fact of us as watery beings: water flows in our inner ears and blood vessels, surrounds our brains and seeps from our pores and membranes. The adult human body comprises approximately 60 percent water, the brain over 70 percent, blood 82 percent and lungs are nearly nine-tenths water. And water is also a great energy conductor whether that be kinetic or electrical or thermal (water absorbs heat from a warm body 27 times faster than air!) The slightest movement in water becomes a ripple that spreads and spreads. If the pattern of this ripple is frozen and broken up, each tiny piece contains a hologram of the entire ripple.

Water is unique in that it is the only natural substance that is found in all three states – liquid, solid (ice) and gas (steam) – at normal Earth temperatures. More substances will dissolve in water than any other medium. Additionally, there have been studies suggesting that clean water in itself has healing properties; water carries memory; and may be affected by emotion.

Is it any wonder then that peoples from around the world know that wild water has properties of healing? In Britain and Ireland, during Celtic and Romano-Celtic times, wild water appears to have been regarded as sacred, whether manifested as sea, well, spring, waterfall, lake, stream, pond, bog or river. Watery places were often associated with or inhabited by a local deity or spirit that represented the power and movement of the water, and who often conferred gifts of healing or divination on the visitor. At Coventina's Well (Carrowbaugh, Northumberland) c14,000 coins, figurines of bronze, beads, glass and ceramic items were discovered in the well shaft. In Anglo-Saxon and Viking times the continuing belief in spirits of water is well attested by the continuing enormous number of votive offerings found in rivers. It was (and still is!) believed that water had the power to cleanse objects and take away ill luck. The interaction with water spirits was so popular that representatives of the early Christian Church, eager to distance themselves from a Pagan past, denounced nature worship included water customs:

> "Some men are so blinded that they bring their offerings to an earth-fast stone, and eke to trees and to well springs, even as witches teach, and will not understand how foolishly they act…" Aelfric in his "Lives of Saints"[1]

Today large numbers of natural springs, many subsequently repackaged as holy wells,

can still be located. There are about 3,500 holy wells in England, Scotland and Wales, some 3,000 in Ireland alone, and interest in them has revived. Some of them in Ireland are connected with the great Irish tutelary goddesses such as Brigid, or throughout Britain, with greater or lesser-known saints, who may well have been local spirits or even deities before their absorption into the Church and their ascendancy to sainthood. These wells are often associated with miraculous cures for anything from leprosy to infertility.

Wild Healing Water: Holy Well Bay, Cornwall

This is probably why I find myself trudging up a long beach at Holy Well Bay in Cornwall at low tide. I am scanning the cliffs for a fissure that would recognisably lead me into somewhere very special. On my right hand side is towering grey rock with many openings that turned out to be dead ends. I am looking for a sea cave and am also very nervous knowing that when the tide is in (and it come in quickly) I can be stranded. Eventually I find an opening that looked promising. It has a long, slanted pillar of rock leant over on the side of a sort of oval/triangular entrance. I walk over shiny, multi-coloured pebbles and strands of entangled slippery seaweed lying on the cold sand and enter the shadow of a large cavern. Going in deeper, I stand entranced. Even knowing about this cave did not prepare me for its beauty. Ahead of me

and to my left is a long bank of ferrous red calcite and above it terraces of blue, cream, pink and mint green like steps made from melted tutti frutti ice cream rising into the roof. I clamber onto the lowest one and scramble up. At the top is a chamber where a spring trickles in – making this a numinous place – one where fresh water meets seawater at high tide. In medieval times this cave was a place of pilgrimage for people who were desperate for healing. There are stories that crutches were placed in the upper chamber and people left offerings there. The chamber is big enough to crouch in and there is a stillness in the cave, that contrasts strongly with the deep voiced singing of the sea outside. Although access is limited by the tide, it is that very tide that washes through the cavern every day, purifying it anew and removing all trace of humanity – restoring it to its pristine self. I make a prayer for healing and gave thanks to the spirits of the place and of the watery healers.

This is not the only cave of this type along this stretch of cliff so why did it become the one where pilgrims were wont to go? I think it is because of the spring coming through the roof of the chamber. It is the wild spring meeting the wild sea that makes it so special.

Singing

In magical practice, I have often utilised wild water as an amplifier – for trance states (try

sitting by a stream tumbling over stones) or for divination or scrying (done with a bowl of water or a bowl of water blackened with ink) or for calling the spirits. I have also experienced the loss of boundaries when immersed in water, leaving me feeling part of it! My memories of ritual are full of watery images: for example, in a Radical Faerie sanctuary in Tenessee one night, after a Beltaine ritual, I danced outside the bandstand whilst the rain that sheeted off the forested mountain drove horizontally across the land whipping into me in the darkness and driving through my hat and jacket, drenching me. I will never forget the ritual or the sense of exuberance that arose from this experience. Water here, has acted like a mnemonic.

There are numerous legends of lost towns and cities where the bells of churches or the voices of the drowned can still be heard and there are towns and villages lost by the processes of sea erosion or by the construction of dams or reservoirs. I have visited many of them - like the coast where the village of Sea Palling in Norfolk once was. (The main street used to lead off the beach and into the sea but now all is gone). The watery voices are extremely powerful in these places. But they are also heard in wild, non-human inhabited stretches of water. I have heard them in the laughing waterfall at St Nectan's Glen in Cornwall, at La Pouldu in Brittany, as the setting sun was reflected in the evening tidal swell, and in Lough Arrow in Sligo, sparkling under a hot summer sun (when I visited the dramatic and awe inspiring cairns that make up Carrowkeel in Ireland). I find myself humming the songs heard in waterfalls or in showers of rain and, indeed, the *Song of the Water* (at the beginning of this chapter) has 12 stanzas that I woke up singing, after I dreamed of flowing as a river.

Wild Singing Water; St Nectan's Glen Cornwall

Rocky Valley is also in Cornwall. After walking across the turf overlooking the sea that is the cliff path from Boscastle harbour, I walk down a steep descent into the Trevillett river valley. The wild water runs down to the sea on my right, and upstream and inland is to my left. The grass that the path wanders through on the other side of the valley is short as if cropped by sheep and there is a bridge over the stream at the bottom of the incline. Crossing over, I turn inland; the bank of the wooded stream clearing after comfrey, brambles and fern and the ruin of a water mill becoming visible on the opposite bank. It is easy to cross back over at this point – the water is shallow here. In the ruined shell of the mill building backing onto the slate ravine walls and surrounded by trees, I see two carved mazes or seven spiralled labyrinths approximately 16 inches across. When I first started coming here it was thought that they were thousands of years old and I hardly ever

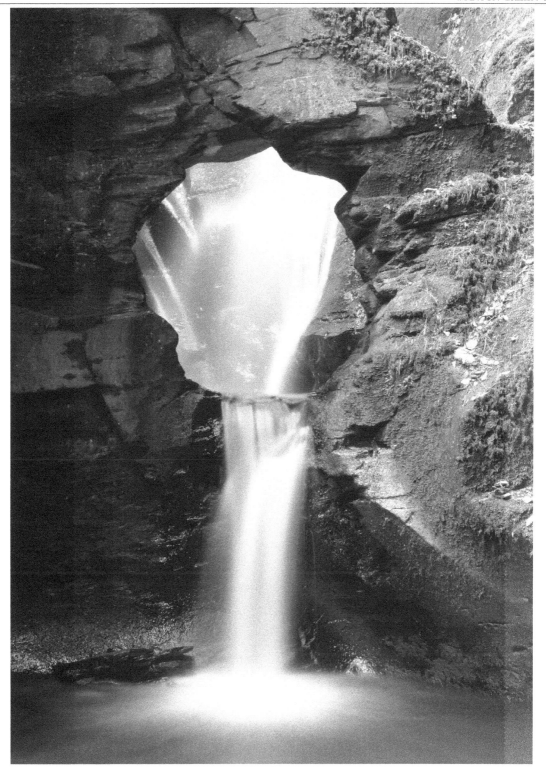

ST NECTAN

saw anyone here but it now seems as if the labyrinths may be much more recent. Now, many, many offerings have been made here – with flowers, nightlights and more damagingly, coins pushed into the fissures in the slate.

Going upstream I walk along the woodland path; surrounded by the dappled hazel and globed leaves of oak and bladed ash; on, past mossy banks and ferns; on, past herb robert, campion, cocks-foot and bramble; on through the woods until the path begins to rise and there are signs of fencing. Staying on the path but walking uphill, leads to the St Nectan's Glen Hermitage building. (Some say that St Nectan is actually a Christianised form of a Cornish water god – Nechtan). Entered via the woodland path, there used to be rather quaint tea rooms here next to a wooden gate at the top of the cliff (but the place is being sold and there is a campaign on to save it from being privatised.) The entrance to the glen is via this gate and there is a leaf encrusted muddy path descending down to the bottom of the bluff where the water falls.

I descend and, turning back on the path, suddenly arrive at the bottom of the waterfall. I am astounded, as ever, by the sheer spectacle and beauty of it. Water pours from the top, 40 feet above, and down into the kieve through a giant ring of rock into a shallow bowl. The air is full of cold spray. The water in the basin is so clear, all the pebbles are translucent and shiny. Looking up to the top the cliff, I feel joy as the water throws itself over with complete abandon. At this point I am mesmerised by the fine mist and sound and suddenly I can hear the high pitched singing sound. It is like three notes and I find myself humming the tune of it.

Meeting the dead

Wash our hands of it, wash away sin, cleanse ourselves, feel it in our waters, thirst for knowledge, the source, waves of emotion, full of juice; our language is full of references to water and its powers. It is no coincidence that ceremonies of spiritual and physical purification have often involved immersion, drinking, washing or sprinkling with water. Throughout the world, lakes, river and water features are still held sacred, from the Ganges in India to Lake Baikal in Russia and many involve ceremonies for the dead.

Water is also the barrier, in many mythologies and cultures, between the world of the living and of the dead. In Dionysian religions, initiates were often buried with gold tablets that gave detailed instructions including crossing a river before entering the land of the dead where they would meet up with other initiates. I was interested to find, on being contacted by a woman who worked within Macumba tradition (albeit her priest was Cuban), that water was also seen as a boundary around the land of the dead and in order to call her ancestors we had to bring them, through water.

Water as the barrier that separates the world of the living from that of the dead is one of the important features found everywhere. I have followed the spirit paths for the dead in Cap Reanga (Te Reanga or Te Rerenga Wairua in Maori) that lead along Ninety Mile beach and down via the Pohutakawa tree into the place where two oceans meet; one brilliant green and the other dark blue. I have travelled the spirit path of the dead across the sea to Bardsey island off the coast of Wales on a sea that was (for once) tranquil and then walked the corpse way past masses of pink thrift down to the rocks at the end of the island. Both these places to me, resound with the voices of ancestors and the sheer joy of the sea.

Wild Ancestral Water; Janitzio. Mexico

I reach the island by travelling over a dark inland lake as big as a sea; the water occasionally lit by bowls of fire atop pilings driven into the lake bottom, that loom out of the darkness and then are lost behind us as we move on. In Patzcuaro I had been told that it would be cold on the island and that I should wear warm clothing but the night is warm; the lake still and so tranquil that not a breath of wind stirs the surface of it.

The island is conical and sits in the lake with lights shining through the darkness as we approach. On disembarking I walk up the narrow streets. No cars are allowed (or would

be possible) on this island. Outside their houses, people have set up tables selling some form of pulque (a sort of alcoholic punch) I am invited into one of the houses where they had altars set up to their dead, replete with photographs and offerings. Near the top of the hilly winding streets I emerge into a square with tiered seats around it. I sit near the top and watch as men wearing costumes with the blue-black sheen of beetle wings weave an elaborate and complex dance around each other.

JANITZIO, AND/OR 3.1IV IMG 125

Later we all go to the cemetery; a large flat shelf-like area below the summit of the island. Women start to arrive, I only see one man – his white hat glowing in the dark.

Many candles light the darkness. The women set out baskets of food covered in cloths, more candles and copal incense in black ceramic holders. They lay out elaborate floral constructions and trails of flower petals; orange, white and blood red. Apart from the odd marble slab, the graves are hard to distinguish. Many are just slight mounds in the bare earth. The women in their black shawls kneel and chant softly. A priest arrives and leads a prayer through a microphone. All in the cemetery join in and they call the dead along the pathways that have been made for them.

After a while I feel a sense of presence and simultaneously realise that I am freezing. Looking out over the lake I see the once clear vista has vanished and we are surrounded by thick white mist. The dead are here. I know the women feel it too. Everyone has fallen silent as pungent copal smoke rises before the gateways and arches of flowers built on each flat earth surface. I breathe a prayer for my dead and am now reminded of lines of Kipling:

Take of English Earth as much
As either hand may rightly clutch
In the Taking of it breathe
Prayer for all who lie beneath

Not the great nor well bespoke
But the mere uncounted folk
Of whose life and death is none
Report or Lamentation
Lay that earth upon thy heart
And thy sickness shall depart.[2]

Unusually (for Kipling) it is both prayer and spell.

Mystery

As a species we need mystery. But, according to Charlene Spretnak in her classic analysis of the relevance of wisdom traditions to the modern age[3], the validity of mystical experience, the state of 'grace', is often devalued in favour of technological advances and pragmatism. We are supposed to ignore the light touch of spirit, to rely on logic and technology. But more and more people are validating their spiritual experiences as something outside of the technology and rationale. Mystery brings us a sense of wonder and makes us think about our relationship to the universe and the (largely) unseen. Wild water is an ideal place to seek those experiences.

There are magical, haunted lakes that I have visited such as Silent Pool, near Guildford in Surrey, or dwellings of the legendary Lady of the Lake in places such as Dozmary Pool on Bodmin Moor. The mystery of water is rich in these places or in places that have disappeared like Sea Henge. (This was an ancient circle of standing posts that contained

an inverted oak tree in the middle. It used to be uncovered by particular tidal formations and was remembered by generations of Norfolk villagers until English Heritage removed it and put it in saltwater storage – now it is just a collection of timbers standing in a glass case in the Lynn Museum.

Many sacred places that I have been to are found or built next to or upon water. I used to have a habit of sleeping out in the landscape that I was drawn to: I slept atop Glastonbury Tor during (I confess it) Harmonic Convergence. The night before the dawn of, yet another, new era the Tor was surrounded by thick mist, white in the darkness, which resembled nothing so much as an inland sea with the tree bespattered tops of hills poking up like an archipelago. I also once slept atop Silbury Hill and, in the morning, thick, wet mist had arisen and left me and my companions and the entire top of the mound surrounded by a white circular wall that was so timeless that I expected the ancient ancestral people of Britain to appear on small garrons charging across the hill!

Most of the sacred places I have visited have water as a nearby component of a mystery. At Palenque, I bathed in the warm water tumbling from a cliff behind the temple complex – a turquoise waterfall set in the jungle like a jewel. Next to it were yet more remains of buildings that the trees and saplings had grown through. I felt a deep connection with the peoples who built the temple and probably bathed there themselves. In Rotorua I met an English woman with a broken leg who had been kicked by a cow. She was convinced that it had happened after swimming in the tapu Green Lake –a Maori sacred place – forbidden to tourists. I believed her. Wandering across Dartmoor with Starhawk and others – singing what she told us was a rain chant. Four hours later I was pouring water out of my walking boots

Wild Mysterious Water: Star Well, Wiltshire

I walk through a muddy field full of thistles and cows on a cold day in September looking for a natural spring that throws up perfect star shaped stones. The well was described by the antiquarian John Stukely in the 17th century; *"East of Bitteston...is a spring - they call it a holy well, - where five-pointed stones doe bubble up (Astreites) which doe move in vinegar."* and was originally also called Holy Well. It has taken me a long time to find this place, once surrounded by a stone wall, the blocks of which are still visible. I brave thistles and cows to approach the natural spring that lies in the field but there are no stars to be seen on the day that I am there. The cattle have come down through the elder trees and muddied the spring so much that there is no clear water but a terracotta sludge in which nothing can be seen except mud. However, the sheer excitement of finding the place is worth it.

The well has been known to local and travelling people for a long time and has a second name of 'Star well' due to the 'stars' that have appeared in the water. Apparently, later studies showed that the 'stars' are in fact small fossilised sea lilies which resemble starfish. They are composed of calcite and are released from their tomb of earth by the action of the spring. I give thanks that such a place still exists.

There is a suggestion that the 'stars' were dissolved in vinegar and drunk for their healing properties but more than anything they were and remain a mystery – something that would bring wonder and was unexplainable for a long time.

Taking the waters is still seen as a cure for many ailments, but now many of us have had waters taken from us! In Britain, many of us buy our drinking water from privatised water companies, via the tap or bottled and filtered, without having to go to the wellhead. We miss that interaction with living water and it becomes easier for water to become a commodity rather than a living presence.

Worryingly, we now face a scenario where something that is so sacred and so necessary for life and is, in itself, so vital, is the basis for war and exploitation. Water has become the new target for privatisation with the erosion of 'commons' water rights in many countries and it is increasingly utilised in the pursuit of corporate greed[for example in the production of luxury food items that provide profits for companies at the expense of local communities' water needs. The effect of treating water as a commodity that can turn a profit was illustrated by Ismail Serageldin, vice president of the World Bank who, talking about global water requirements, said in 2009; "People… therefore, are out on the knife edge of starvation, and we are increasingly seeing environmental refugees on a large scale. At the same time, you have growing global population and rising incomes, which mean changing diets… animal proteins are increasingly part of the global diet—and it requires much more grain and hence much more water to provide meat. So there's a great impact on water as we strive to provide the diets that people want."[4]

At a time when the earth is drying (due to deforestation, urbanisation and industrial scale farming) and available fresh water constitutes less than one percent of all global water, the new water managers (backed by the World Bank which may stipulate water deregulation as a condition of investment) are trans-national corporations who profit by raising prices. In some areas, they stop the water supply. Some water companies have refused to extend water services to poor neighbourhoods and cut off water services where people are too poor to pay. The companies save money by non compliance with maintenance schedules, by cutting workforces (whilst raising prices), by

increasing rates to hugely high levels and then threatening legal action against people who wish to change their supplier; and by treating water (as they have already done with the land and all its diverse inhabitants) as just another commodity – just another saleable item.

Add to this, new dam construction, the greedy over-extraction of water, consequent lowered water tables and damaged rivers and wetlands, industrial contamination , and the destruction of coral reefs, together with the demise of aquatic species through pollution, fishing and hunting and we cannot fail to see that greed and the 'commodification' of water and its inhabitants has led to an urgent imbalance in the oceans, rivers and lakes of the world.[5]

Wate is in severe danger. In Ecuador, an American oil company apparently spilled 17 million gallons of oil into the rivers in 1992 and has also (apparently) dumped millions of gallons of crude oil in the western Amazon over the past 25 years. During the course of a massive lawsuit the company tried to pursuade the US government to cut off trade with Ecuador . More recently there have been oil spillages with devastating effects on the sea and the creatures that depend upon it.

In this light, I am heartened by Ecuador's declaration of the constitutional rights of Pachamama or Nature herself (and the fact that Nepal and, hopefully, other countries are considering similar legislation). As the first article says:

Nature or Pachamama, where life is reproduced and exists, has the right to exist, persist, maintain and regenerate its vital cycles, structure, functions and its processes in evolution.

Dolores La Chapelle in an article published in 1984[6] wrote about ritual as a necessary guardian for the environment. It is people's rituals involving rivers and streams - the making of offerings, the seeing of them as enspirited and sacred which protects and guards them. Examples she gave were of some of the oldest societies on earth that survive because their rituals prevent over-hunting or over-fishing or destruction of the forest. The reverence that sees the rivers, forest or the animals that inhabit them as sacred, and performs rituals as relationship to them, maintains and protects them.

I have no hesitation in saying that Water is enspirited. In many traditions this 'enspirited nature' has taken the form of a deity – Manannan, Tethys, Grannus, Sulis, Board, Jenny Greenteeth or other river gods or goddesses, Lords or Ladies of the Well or Fountain or the Sea, or it has taken the form of a loa or orisha or devi. Water is sacred and, in my experience, is a collective presence which may manifest ancestral voices or events and replay them to those who are listening but

equally water is a mystery with its own inherent value.

As a queer activist and Pagan I try to live my life with the acceptance and celebration of difference. This involves letting each of us define our selves not in the mirror of what society would have us be but what *we* know we are. Most *Queer* people have a history of being outsiders – often being thought strange or mad because their reality is often different from the macro-culture. For me, it is intrinsic to identifying as *Queer* that we honour difference and remember our radical selves and that we have an analysis of the way in which the notion of 'normal' is used to control people and resources,[7] including water.

I reject the notion of private companies having 'control' over something as fundamental and sacred as water. My spirituality derives from direct relationship with the forms of Nature rather than any institutionalised or doctrinal religion and It also applies, of course, to the way in which I regard Air, Fire, Water and Earth. Aelfric and I would not see eye to eye!

As Vandana Shiva writes: " Water cannot be substituted. Water is intrinsically different from other resources and products. it cannot be treated as a commodity"[8] .Wild water must be freely available to all creatures on the earth. And, as humans, I believe we must relearn our respect for wild water. We must revere it for its powers of healing, of cleansing and of mystery and of sustaining life. It requires our rituals and our protection and it requires us to be vigilant against those who would exploit it, pollute it or drive its creatures to extinction.

Notes

1 'Aelfric's Lives of Saints' ed. W W Skeats ; pub for Early English Text Society by N. Trübner 1881

2 Lines 1 – 10 of 'A Charm' by Rudyard Kipling

3 States of Grace; Charlene Spretnak Harper Collins 1991

4 28 World Policy Journal Winter 2009/10

5 'Blue Gold:The global water crisis and the commodification of the world's water supply': A Special Report issued by the International Forum on Globalisation (IFG) by Maude Barlow National Chairperson, Council of Canadians Chair, International Forum on Globalisation (IFG) Committee on the Globalisation of Water

6 Ritual is Essential; seeing ritual and ceremony as sophisticated and spiritual technology' (Art & Ceremony in Sustainable Cultures (IC *5) Spring 1984

7 For this reason we will often find queer identified people in the thick of resistance to exploitation; for example at Camp Bling or as Queer Urban Farmers resisting the giant agri-businesses' strangle hold on food and bio-fuel production or in resistance to genetically modified organisms (some of which are developed by companies that were previously involved in manufacturing weapons!!)

8 Water Wars by Vandana Shiva

Facing the waves: an animist view of the sea

Gordon MacLellan

It is the smell that hits first; the pungent salt-rot of seaweed, lifted and lightened by the breeze. Or perhaps "arriving" begins earlier than that with the change in the sky before ever I see the waves: a lightness, a sense of space, a buoyancy reflected on clouds or hidden but present in the drifting curtains of rain. Or earlier still, facing the waves begins in the anticipation. A dry whisper of excitement like the rasp of the seaweed hanging weather-wise on the wall. A childhood shiver of growing excitement, of sandy toes, buckets and spades. An excitement that decades have not dimmed. An excitement that wakes a stillness that swells with the waves, rising as steadily, remorselessly, as the tide.

"Going to the seaside", an adventure full of childhood memories and excitements. A starting point. For me, the sea has never lost that wonder and I recognise in that lifelong relationship some of my earliest spiritual experiences and explorations that set me on a career as ecologist, artist and storyteller.

Now I am here. Standing on the sand, watching waves, watching rocks, watching gulls wheel, slicing the air above me. Terns floating, white leaves, flakes, feathers, lilting. Now I am here, trying to let go of agendas. To be here is not to come with a ceremony in a carrier bag to enact on the seafront. To be here is not to have rehearsed the words, the prayers that should be said, the responses that should be expected. To be here, to really be here, I need to give myself to this moment, to the movement of water on shingle, to the sigh as the wave breaks on the sand

In modern western animism and some other forms of paganism, we have no key texts or received teachings to guide us. Our practice, the expression of our way of being, grows out of our experience of the world we live in. That world is a living world, unfolding, evolving, within its own consciousness, full of spirit, full of connections, a flowing pattern of woven strands that draws me, draws us, into the growth, the change, the richness of it all. So I stand by the sea: not to be taught and instructed or to expect profound revelations, but simply to be. The challenge is to learn to relax. To be still within a place, to open myself to it, to the presence of it, and let it fill me, move me. Swallow me.

Barefoot. The feel of sand sifting between toes. The way it compacts under my feet. Following the wavering driftline, sea-sanded wood, feathers, shells, cuttlefish bone. Seaweed dries. Sandhoppers explode. The plastic debris of human disrespect. Barefoot. Cool water. Sunlight slides on the ripples. A movement. They themselves are too fine, too much of the sun-flicker on the wave, too shimmering, to be easily seen. Only their shadows on the sand as they pass through the shallows gives the juvenile sand-eels away. The sound. The repeating murmur of wave upon sand, wave upon stone. The smell of the seaweed drying.

To sit on stone as the tide runs out. To breathe. Breathe in the fullness. Breathe in the pulse of the waves. Wait in stillness. Wait in silence and a holding-breath, contained delight until the shy fish under the stone slips out into the sunshine. Wait. Until the ghost-shape of a shrimp settles on stone. Wait for the small crabs to sidle out and pick their way along the edge of the shadows. Watch. The slow sway of seaweed in a pool.

The cry of a gull lifts me up, to look out. To see the sea. Beyond everything, Immensity waits.

Leather-bladed kelp, tree-tall and towering, encrusted as whaleskin with life, crawling, vertical pastures. Seaweed forests, dancing with slow submarine grace. Surge and sway, turn with the pull of the waves. Undulate. The kelp moves me out, beyond the edge of the known, beyond the ninth wave of our stories and out into the open ocean.

We may not have set teachings to guide us but we do have stories: legends shared with other people, other lands. Tales from other, older, cultures speak to us, not to give moral certitude or to define responses but to take us into a moment, a passion, feelings to explore.

Facing the waves, the breathing sea, I slide into the wildness of Manannan, his chariot wheels drawing the lines of foam across the waves; his horses tossing white manes in the breaking waves, hair flying, spit blowing along the wind. The waves pull. The stillness here lies within, a stillness contained in the endless

movement of fast-breaking wave, of tidal flow, of currents running deep and deeper, slow as blood running through the veins of the Earth. The pull of the waves speak of old Aegir and Ran, netting the northern seas in a wooden boat hung with skulls and wings and the smell of snow. Icicles knife the rigging. The decks are rimed with frost. A gull steals a morsel that falls from a curved knife, catching it before it hits the freezing wood and sliding into the air like laughter.

Even the breadth of the sky speaks of sea. Winds that play with the wave-crests, winds that have come running down from the freezing north and up from a balmy south. Clouds hang like the beaches and reefs and seaweed forests of another sea. Memories of the crystal ships that sailed through the air and the high air over the wide seas, the wild seas to old Ireland

And the seagull drops me to plunge as a gannet into the waves and sink, floating freefall, in the shallow seas. Manannan again, his palace a seamount of cold water coral and drifting schools. Blue-barred mackerel swarm within a sense of emptiness. Wreckfish hang brooding in the shadows of the mountainside, wide mouths and gunmetal flanks, rolling careful eyes, watching, waiting, breathing as slow as me. Open floors and clustered rocks. A dream of mermaids, of classical tritons, of Hebridean Shony with his scaled skin and sea-wracked hair. Their strangeness enfolds me,

welcomes me into a warmth and the wonder of difference. And still the seaweed sways, small and gentle in my rockpool and kelp-hugely here.

Out. Out. Over the edge. To fly here is to fall, floating slowly downwards, drifting in the rain of debris to the floor. Echoes of ancient processes in the slow snowfall of plankton to the seafloor, breeding chalk, breeding the limestone of the hills of my home. Feel the endlessness. For tens of millions of years the plankton have swarmed in the warm surface waters, glowed phosphorescent, died and drifted down, engulfing ancient scorpions, engulfing ammonites and ichthyosaurs and fish, gently sealing everything in slow-growing stone.

Out. Beyond is the Deep, the Darkness. A rolling formless immensity: not named god or goddess, a primal consciousness. The Deep is an awareness without names, without voices, without malice, without mercy. A beginning, heavy with the passion of all life that ever crawled from the sea. And quietly, I hear myself whispering names, a litany of deities, their names soft and gentle as the waves on the sand. The people of the sea, the ones who stand closer to the immensity of it all than I......Dylan eil Ton, Oceanus, Amphitrite, Poseidon. Tethys. Thetis. Manannan. O Manannan mac Llyr! Fand, Penardan, Iweridd, old Llyr himself, and the names that run the deepest. The whisper of life in the coldest

trench: Qailertetang and Sedna: Arnaknagsak: She Who Waits.

A wave breaks on sand, over the stone where the seals bask and a seagull scream swings me back into all the poignancy of the selkie, of love doomed between seal maid and fisherman, between land and sea, between graceful dancer and heavy-footed, heavy-handed sea-lover, seal-lover. Tragic tales full of grief and pain and with them we can hear the souls of the drowned that come back in the cry of the gull fading away on the breeze.

I am left sitting on a stone as the tide turns, watching the seaweed with a head full of stories and a heart full of sighs and a deep tidal stillness. The prayer that lifts me then is not of submission before any thing, any god, any goddess, but an offering born out of wonder and delight that moves first a finger, a hand, my whole body in a dance of the small stand of seaweed with its holdfast on the rock at my feet but with the swaying swirl of its movement rooted in my heart

I am an animist, a pagan. I sit by the sea to remind myself of hugeness, of stillness, of the deep patterns of tide and flow. I sit by the sea to be swallowed by the tiny things, the cousins that live under rocks and watch for the shadows of the gulls.

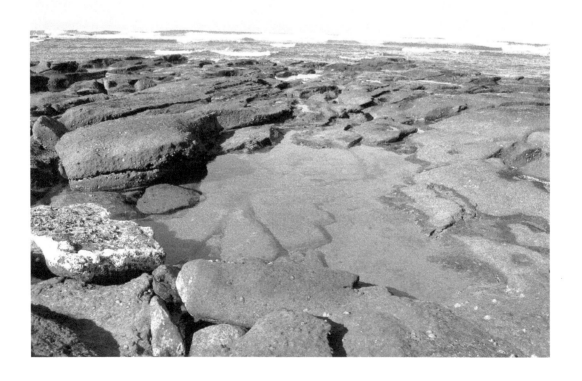

The Dragon Waters of Place: A Journey to the Source

Susan Greenwood

Walking home from school between the ponds at Carshalton each day my friend and I, aged thirteen, would point to some enormous old dragon-like ivy that was twisting itself around the massive boughs of a pine tree and say in unison 'That's ivy, you know', bursting into giggles at our own silly joke. Every day we would say the same thing, and every day we would share that moment in a peal of laughter. The ivy, serpentine in its embrace of the tree, guarded the ponds at Carshalton, one of the sources of the River Wandle, a tributary that flows into London's River Thames.

The seemingly insignificant schoolgirl joke about the dragon-ivy connects me in my memory to the waters at Carshalton. I was born close by and I grew up and lived for the first part of my life in the surrounding areas. I have fleeting reminiscences of school days where the rector of All Saints, the church opposite the ponds, fought to teach us irreverent girls religious knowledge while we made fun of him, and later, when I was eighteen, of dancing, draped in gold and silver tinsel, on the tables in the large backroom of The Greyhound, an old public house adjacent to and overlooking the water.

Now, many years later as I reflect on Carshalton, the place where I was born, knowings whisper from where all waters meet. The old dragon-ivy is now gone, but young ivy tendrils entwine themselves anew around the trees by the ponds. I want to know more about the old feelings of the place.

The spirits of the waters at Carshalton

Ivy is tenacious; it clings on regardless, gradually growing and spreading its coils; it is a dragon sentinel for the waters here. People come and people

go, and the ivy has seen them all in streams of movements. Intersected by a road bridge and bounded by a park, the church and The Greyhound, the waters reflect the images of the ivy as well as all the life that has moved in and around the place. The waters hold the mystery of the dragon.

In the seventeenth-century, racehorses were led past the waters of the ponds on their way to the stables at The Greyhound to be prepared, inspected and paraded before being taken to race on the nearby Banstead Downs. Streams of people would go to the races, while others would be occupied with everyday village life by the water – people going about their work, visiting the local shops and talking to neighbours. The ivy marked the passage of all.

The ivy and the dragon connect in my memory. I had a snake dream that I know now was the beginning of the dragon emerging in my consciousness. Dragons combine the qualities of many creatures and they also move through air, fire, earth and water. Sometimes described as winged serpents, worms, or wyrms, dragons combine all the characteristics. Dragons are symbolic of creative and destructive elemental energy across eons of time.

THE DRAGON

In the dream a friend handed me a basket that another friend had given her. I took the basket and removed the embroidered flowery lid; a white snake rapidly unwound itself from inside the basket and sprang out upon me. It fastened its fangs into my arm... I awoke feeling that it was a very profound experience. Being bitten by a white snake in the dream seemed like a form of initiation to me. I did not know what the experience meant then, but more recently I came to realize that it was a stirring of the dragon as a sort of elemental awakening.

The dream took me back to memories of my childhood. I had kept grass snakes as pets and was captivated by their beautiful smooth zig-zagged patterned bodies, and their abilities to glide across the ground and swim through water. I loved letting them slide over my arms and legs as I watched their black forked tongues flicking neatly in and out as they smelt the air. I was also fascinated by earthworms and spent time playing in the wild and overgrown end of the garden. Uncovered all year, the sand pit became the home of all sorts of wildlife: from millipedes and woodlice to wriggly ginger wireworms, but most especially for earthworms. I watched how they changed shape by contracting and then extending their bodies, and how they gradually brought the sand and the earth in the sand pit together.

Snakes and worms share some of the dragon's qualities of transformation: snakes shed their skins representing cosmic renewal and rebirth following death; worms transform the earth. I later came to learn that it was the naturalist Charles Darwin (1809-1882) who had written that the differences in mind between humans and higher animals was one of degree not of kind. Darwin changed many people's perceptions of these seemingly lowly creatures noting how worms are better at tilling the soil than us; they swallow the earth ejecting what they do not need for nutriment in a fine tilth that cannot be matched by human ploughing.

Reconnecting me to my childhood experiences with snakes and worms, the dream combined with my memories of walking home from school beneath the dragon-ivy. In time I would come to realise that this would connect me with the spirits of the waters of the place where I was born.

Carshalton has always been known for its spring waters and it is popularly said that these may have given the place its name Cars-Aul–ton, 'Aul' meaning well or spring, and 'alton' coming from the Anglo-Saxon 'Aewelton', the 'settlement by well or spring'. The Domesday Book of 1086 records 'aultone' as a 'farmstead at the source of a river', and a church is also listed. In Anglo-Saxon times it would have originally been made of wood and turned into a stone

structure during the eleventh-century. Today the church of All Saints stands facing the ponds.

Just outside the churchyard wall and also adjacent to the ponds is Anne Boleyn's well. Surrounded by railings and overgrown with lavender, it is now neglected. Buses and other traffic thunders past and probably not many people know that the well is there, quite a contrast to earlier times when a bowl was kept chained to the railings to slake travellers' thirst.

Queen Anne Boleyn was the second wife of King Henry VIII and mother of Queen Elizabeth I, and according to local legend the well was so named when her horse kicked a stone and a spring of water appeared. It is also said that the name of the well is a corruption of Notre Dame de Boulogne, after a chapel dedicated to Our Lady of Boulogne built near the well, the Count of Boulogne being Lord of the Manor of Carshalton in the 12th Century and ancestor of Anne Boleyn. Boleyn, or Bullen, is a corruption of Boulogne, and the Count of Boulogne acquired the manor of Carshalton not long after the Norman Conquest.

It is an informed guess that earlier the well in Carshalton was named after St Anne, the cult of St Anne being popular in England in the 14th Century. However, during the 16th Century Reformation such Catholic holy places were secularised, and this is probably when the legend of Anne Boleyn was

established. This was a time of political upheaval when Henry VIII broke from the Catholic Church in Rome; Henry's wish to annul his marriage to Catherine of Aragon and marry Anne was the primary reason that sparked the formation of the Church of England. With the Dissolution of the Monasteries in 1536 all religious houses, monasteries and priories were closed, the monks and nuns dispersed and the buildings, their possessions and lands, were seized for the benefit of the throne. It is likely that the well was named after St Anne, but that the name was changed to that of Anne Boleyn at this time. I think that well had older associations as a Pagan spring dedicated to a female deity.

In ancient times, springs and wells - where life-giving water trickled from a hillside or welled up from the earth - were regarded as sacred places between the everyday and spirit world. We can find material artifacts for archaeological analysis, but they do not tell us much of the spirit beliefs held by the ancient peoples who probably venerated the waters of what is now Carshalton. The prehistoric cultures were oral cultures - knowledge was passed on from mouth to mouth. Most clues that we can gather about what people believed come from myths, legends and place names.

Norse mythology reflects this regard for the creative power of water. The Élivágar are eleven rivers that exist in Ginnungagap, the

primeval void that arises from Hvergelmir a bubbling boiling spring in the cold realm of Niflheim. From the meeting of the ice from these frozen rivers and fire from Muspellheim, the fiery realm, water is created. From water the cosmos is formed. Such is the importance of water in this creation story. However, with the advent of Christianity, the church tried to eradicate or take over Pagan beliefs about sacredness of places where waters emerged from the earth. Bede, an eighth-century scholar monk, notes how the Pope Gregory I gave instruction to Augustine in 602 to encouraged the christianisation of the Pagan practice of decorating sacred places, and so springs and wells gradually became holy wells.

The history of the well at Carshalton, and the name of Carshalton itself meaning well or spring, gives some indication of the sacred connection of the waters. It is possible to find a pattern of associations through the name 'Anne' as deriving from Ana, a prior Celtic goddess of fertility, said to be ancestress

ANNE BOLEYN'S WELL

of all gods. The Anglo-Saxon Angurboda, a nature spirit with primal connections, might also derive her name from Ana.

I want to connect with the spirits of the waters at what feels like my primal place. I need to know more about the ancient sacred relationships with water. It is Angurboda, the nature spirit, who speaks to me as I meditate on the waters at Carshalton. Angurboda is the mother of the serpent Jörmungandr, fathered by the trickster god Loki, who encircles middle earth. Angurboda is a primal energy manifesting as a creative female force; she is a terrifying mother, a nurturer and healer of sorrows. She brings me home to myself:

> *The waters hold me in their embrace;*
> *give birth to me*
> *as I am. Now.*
> *My skin sheds, layer*
> *after layer,*
> *Until I come home.*
> *Dark is its hold*
> *in the cradle of life*
> *And death*
> *until I return*
> *once more.*
> *The spirits of the waters at Carshalton bring*
> *me home to myself.*

The spirit of the red dragon

The waters of Carshalton have brought me home, but there is a paradox: the more I feel

connected to the place of my birth, the more I am able to relate to other places. Meaning a broad sense of material space, a dimension of defined or indefinite extent, the word 'place' dates from around 1250 and it relates to a sense of self, community, locality, environment, and landscape, as well as spirit; it forms a connection extending into all relationships.

My feeling of place is both internal and external and my research has led me to the study of place. The word *topology* originated in the late nineteenth-century and comes from the Greek *topos* meaning 'place', the study of place. Topology is the study of the way in which rivers, mountains and other natural features of the land are interrelated or arranged. There are different ways of knowing about place – from the geological study of rock formations, to the manner in which we humans have lived in our environments, to the ways in which we tell stories and myths, and our internalized feelings of relationships about the land with which we are connected.

In a sense, we connect with topographical formations of the land within our own bodies. Individual life experience makes a pattern through which we come to understand our own topology of place. I found that I could relate easily to Carshalton, the place where I was born and grew up, but how is it possible to relate to other places, ones with which we are not so obviously

connected, or perhaps that have a difficult history?

One such place for me was the industrial landscape of mid and south Wales. I was invited by a friend and colleague to participate in a research project to create a 'dreaming' of the River Taff – to build up feelings and experiences as part of an on-going mythological and historical story of the environment.[1]

South Wales was once a land of coalmines and the Taff was so polluted that it was said to run black with coal dust: at one point it took 100,000 tonnes of colliery waste each year. Pitheads and slag heaps once dominated the landscape, but the coal industry declined from its heyday of 620 mines in working operation to none, the last mine closed in 1994, but the remains of its industrial past can still be seen surrounding the river.

I had already spent time in Brecon Beacons, the source of the Taff, and I wanted to connect with this river more. It is easier to feel a direct connection with the familiar, but it is possible get to know any place. It will speak, if we will listen.

The name Taff may have the same origin as the Thames being derived from the Celtic *Tam*, with a root meaning dark, smooth or wide-spreading. Rivers are symbolic of life and death, time and destiny; they spread the waters of life. We are all connected to water – in our bodies and our minds – and I wanted to

connect with the Taff to find out more about the land, its history and its magic. This felt like a journey into the unknown.

It was a freezing cold day in February and the British Army was on manoeuvres when we arrived at Taf Fawr, the 'Big Taff', one of the two sources of the Taff in the Brecon Beacons. Soldiers were running over the mountain in camouflage gear carrying rifles; there was an air of activity blowing across the snow-covered terrain, and this was echoed in the river which was rushing down from the mountainside, cold clear and bubbling. I stood beside the river and tried to

let go of all my thoughts to let the place speak to me.

Rivers have hidden depths, and labyrinthine, subterranean elements; they also link people and places as they flow. It is necessary to have just enough information from maps, history, folklore etc. to set the scene, but not too much because it can cloud direct experience. I started to feel the whole course of the river, shifting my perspective so that I could approach it from the point of view of water as it coursed downwards into Cardiff Bay. A different pattern emerged resulting from its complex history from early prehistoric settlements to the intense industrialisation of the coal mining and iron

working around Merthyr Tydfil. As I let the clear, cold waters wash through my awareness, my internal thought processes start to flow away and I can start to feel the raw pulse of life through the water.

The rapid movement of Taf Fawr was in stark contrast to the second source of the Taff, Taf Fechan or 'Little Taff', a few miles away. All is silent and still at Taf Fechan. Here the second source of the Taff is tamed into the Talybont Reservoir. Weirs are managed by the Wales Water Company and the river is frozen and looks like a scene from the Artic, so different to the activity at Taf Fawr. The dark gothic architecture of the Victorian waterworks adds to the eerie atmosphere of the place, it could almost be the surface of the moon. Everything feels held in abeyance; there is a peace and quietness here, a time for reflection, such a contrast to the rapid movement of Taf Fawr.

The Taff, like all rivers, has accumulated its own memories but this river has a special history because of its industrial past. The Welsh valleys were rich in coal and collieries were opened to meet the demands of the iron trade and coal and iron were carried by canal barge down to ports at Cardiff and Newport. Working conditions were tough for the miners, who included women and small children as young as six years old. The younger children controlled ventilation systems, while older children and women hauled coal from the face

to the bottom of the mineshaft. Thousands of miners were killed in roof falls and explosions. The situation of the miners was made worse by housing overcrowding and unsanitary conditions, both of which led to outbreaks of cholera. There is pain and deprivation; it is said by some that the souls of the dead linger here.

Moving on downstream, we come to the confluence, sometimes called 'the dark pool', the swirling part of the river where the Taf Fawr and the Taf Fechan meet at Cefn Coed-y-Cymmer, just below Merthyr Tydfil, home of the 18th and 19th Century Industrial Revolution. The first train to run on rails ran here, and it was the place that gave birth to the Labour movement - the Merthyr Rising of 1831 saw between 7,000 -10,000 workers march under the red flag as a protest at their working conditions.

The confluence feels like a very powerful area due to this history, and also the different aspects of the Taf Fawr and the Taf Fechan meeting. It is almost like the coming together of fire and ice in Norse mythology where two opposing forces combine. The place has a power, but now it has been neglected - there are lots of slag extraction piles, rubbish, and a feeling of an abandoned river. The industrialisation process has taken its toll on both human beings and the land.

The Pontycafnau bridge over the Taff is the first iron railway bridge ever built in 1793, it also served as an aqueduct. Today the shadow of the bridge transmutes the natural habitat of the river as a reminder of the dragon in the swirling waters – I look into the depths and feel the memories of the past.

Rivers have different currents, eddies, and depths and all are part of the general stream; they form their own ecological habitats, as well as tell many stories and hold feelings, memories, and emotions. We can look to the past to learn for the present and the future; this can bring healing for human beings and earth. Shifting patterns, shifting awareness, looking deeper into the water can help us reconnect with the natural world and our own nature. The river holds many different ripple patterns. What images, feelings, sounds and memories come from the water?

Feel another knowing of the body, through breath and the pulse of blood through the earth.

Water in pre-historic times was seen to be the source of all life, but culturally we have lost this sacred connection. Water is the matrix, a deep and ancient force, and we are all born of the primordial waters. We grow within a maternal embryonic sac, and water makes up most of our bodily composition so we are physically linked. The mind of the river holds my reflections, like the waters of Carshalton, the waters of the Taff hold me:

The water holds the place
of my deep knowing
of the past;
it takes me
darkly
through time.
And lingers
in my being
to connect with ripples
Brightly.
A perspective from the other side: what would
the river see?
Something trying to communicate
through frosted ice.
Spirit to spirit.
The land and the spirit are one.
I cannot speak for the river;
maybe I am a vague flash in its memory.
Through aeons, what do I matter?
Small, insignificant, a whisper then gone.
But then again,
perhaps the river does ken with a kenning within
its unfathomable depths.
A sense of yearning to hold space;
to share the second of eternity in the moment.
In the moment we both flow as one.
And that is all that matters.

The flow is a reminder not to get stuck in the past – to go into the depths but not to stay there; to keep things moving, ever flowing. Everything changes; move onwards. The river tells me to look into my own reflection, but not to become fascinated or mesmerized by

it. Look deeper. The river can help bring memories into the present where they can be healed.

Seeing life mirrored in the waters of a river is a reminder that we can create change. Rivers, like dragons, can transform one thing into another. At that moment we both flow together. Reading about the Taff, I felt I had accumulated some of the history and the pollution of the industrialization process of the Welsh valleys. It felt that it was important to clear up the rubbish and litter along the riverbanks, but there was also a corresponding process within me.

During a shamanic drumming journey – an active meditation guided by the rhythm of a drumbeat - the dragon came as a purifying force; it appeared as the rivers of the land and took me deep down into the underground waterways. These needed spirit purging of human exploitative activity. I was taken into a white spiral and a red dragon emerged strongly, fiery and angry at not being recognized, it told me that the Taff is part of a whole process of extraction that has drained its life-blood without acknowledgement.

The dragon took me down blue smoke tendrils deep into the mineshafts and caverns of the Earth. It felt like the red dragon, the symbol of Wales, was the angry emotion of the Earth that had been plundered

PONTYCAFNAU BRIDGE

thoughtlessly. The dragon's smoke tendrils were messages from the Earth and I could follow them down into the source of the pain. To feel the anger and to feel the pain was to experience the roar of the dragon; going snake-like into the mineshafts and dark caverns was to acknowledge the Earth's hurt:

> *Fire of red dragon,*
> *burning bright volcanoes,*
> *sending smoke spirals upwards.*
> *To follow them curling downwards snake-like,*
> *is to see and to heal the hurt that is done.*
> *The ivy tendrils grow once more.*
> *Now salmon swim, gone is black coal dust.*

Now there is purification of the waters of the Taff: fish swim where there was once coal dust pollution. Things are changing, renewal and healing is happening.

The red Welsh dragon connects with the ivy dragon sentinel at Carshalton that had been cut down years ago, but not destroyed. Today small ivy tendrils are growing around the base of the big trees by the ponds. The ivy indicates resilience and tenacity, as the dragon symbolizes renewal.

I have learnt that communicating with the spirits of the waters at Carshalton, and their guardian ivy-dragon sentinel, has opened up a process that has helped me relate to other places in the knowing that all are connected through weaving patterns of relatedness. The spirits of the waters give life and flow through all beings before returning once more to their source, there to be reborn and renewed.

Notes

1 This *Walking through the Sacred Landscape: the Aboriginal Dreaming as Generative Model* project was run by Professor Geoffrey Samuel of the School of History, Archaeology and Religion, Cardiff University, Cardiff CF10 3BG.

Catching the Rainbow Lizard

Maria van Daalen

from the collection "Ask the River"

1

Even if love didn't exist

the lizard would have found it,

the little rainbow lizard that hides in its velocity.

Whiptail, you bruise my skin

until blood seems to burst from underneath

a layer of throbbing colors. Piercing

my deepest thoughts, the newly found,

from which the senses branch out in every direction,

it awakens a trail of struggle; pain

ends up in a fan of spraying sands,

spraying layers of particles and hitting ochre

fill my nostrils, my ears, my mouth, my eyes.

2

So much has been said for velocity

that I will not speed up his mind; he

has done that to me already, turning

me on the banks of whirling Cedar River,

while overhanging branches make a deep, bending

room with shifting sides that quiver

in every direction of this poem. Green words

bud from his lips and make me leaf

through his fingers, twirl and weave the agile

letters of his name into lines that festen

me, keep me bending over and inward

fasten the recurrently unbranching touches.

3

But unbranching: for nothing faster

than the green gold looks of his eyes

touch reality. Loosen my limbs,

weaver of death's textile, the skin

softens and melts with my bones, white

earth becomes earth upon your voice

and uncovers the form that I am

when you call me, out from the depths

of past time make me step forward;

because oblivion, that benign

caretaker of pain, has to be

acted upon and hit, hit very hard to make my body appear.

4

Caressing with sandpaper:

I took this layer of immense colors

to be a trail of infinity,

but the little lizard ran all the way

and adjusted my lines with sweetness, sourness

biting through pain like a poem.

I invited you to be with me,

but I didn't realize that capturing

might make you loose your colors

and so I loosened even the thought of you

running along an unseen desert trail

and I remember how the sand smelled, and streamed.

The Rite to Roam

Julian Vayne

All over this wasteland

In the bushes. Nothing special, just the kind of municipal planting one finds in new towns and suburban developments. A rectangular area thick with one type of deciduous shrub (I have no ideas of the species). The space would later be colonised by garages, mostly built by my father. The leaves of those bushes were vivid green in spring, later turning an almost bluish tone and lastly fading into curled crisps of russet.

It was here that I built my first temple.

Adults sometimes assume that what we might call religious or spiritual concerns are of no interest to children. For me at least this wasn't the case. I was perhaps seven, maybe younger, when I discovered 'the Orb'. The Orb was an emerald-green-faceted bead of glass, no larger than a pea. I decided that it was special, very special, in fact that it was a God. I scrambled my way into the heart of the bushes, the darkness of this miniature forest. There, among the scraps of litter and cracked clay, I created a pyramid. This stepped ziggurat was the podium upon which my small God would sit. The Orb was installed and I began a daily ritual of worship. Picking my way through the low canopy of leaves, my nose close to the dusty earth, to the shrine I had made. Here I would make offerings of perfume (Swizzels Parma Violets), flowers and my own hair. Sometimes sorcery comes quite naturally to the young.

I never forgot The Orb (though its whereabouts now I can hardly guess). But what stayed with me was that secret sense that comes from being in the woods, especially in the woods doing magick.

Being outside, surrounded by natural forms (whether it be trees in a plantation or ancient wildwood) can induce in me a rapture of delight. Sometimes this comes from a small space. Like the bushes by my family home, the fairy hollow in a tree, the tiny crook of a stream, these can invoke this most powerful of feelings. I am at once me and more than me. I am a creature moving across the land. I am connected by my sight, my breath, my motion to this much larger cosmos. Tiny spaces can do this as easily as the awesome void of the desert or the looming forms of great mountains.

I was captivated as a child by all those diminutive worlds that one encounters. Rock pools, tiny cone shaped fungus, the cracks in pavements from which emerged robotic ants. Growing up where I did there was always plenty of wasteland. Places that had been, and would again be, filled with concrete and brick and human structures. Always in an indeterminate state between having been built on and awaiting new developments. Like an uneasy cat in Schrödinger's box, wasteland hovers between the worlds. Here punks and naughty boys gather to drink, sniff glue and undertake essential experimental work (for

example, what happens when you chuck an aerosol can on a fire?). Here was broken glass and wood and all kinds of half-remembered detritus. So far from the sea as I was, this was the place I could plunder for urban flotsam and jetsam. A crooked metal rod would be my Martian wand. Foundation slabs of concrete would be the stage upon which I conducted my childish rituals, drawing sigils, circles and mystical signs.

The most impressive thing about the wasteland, as those of us who love it will know, is that it is far from desolate. Bindweed drowns the hulks of burnt out cars, teasels strike up between rubble hillocks. Brambles finger their way across the splitting tarmac. Birds and scurrying animals abound. These are the pioneer species, so full of thrusting, lusting life. In the brief gap we humans leave, wild nature comes rushing in and inundates our works. But we are not easily forgotten. Digging in the rich dark soil there are the folded fans of plastic wrappers, hard glass, oddments of vulcanised rubber. In parkland humans allow nature to flourish in a strictly controlled way. Here humanity, by clearing the land, has allowed nature to flourish ungoverned by our desires.

Standing in those wild, waste spaces I could feel the multiple layers. Like the soil, shot through by shredded bin liners. We are part of and yet so different from the rest of nature. We come and make our spaces,

destroying to carve out our domains. But no sooner do we turn our back and all the little things; the creeping things, the crawling things, the tendril wavers and gossamer weavers, move back in. This was the transient chaos of these spaces. Beautiful, ghastly, temporary autonomous zones. For me they simply stank, not only of dog piss and cow parsley, but of magick.

Green is the colour

Blaise Castle was perhaps the first adult sized landscape that I developed a deep relationship with. Described, tongue in gothic cheek, by Jane Austen as 'the finest place in England' in her novel *Northanger Abbey*, Blaise sits on the northern edge of Bristol. Hundreds of acres of former mansion house estate are open to the public and it was here, during my late twenties, that I first really met the genius loci.

There are several gates. From my flat I could walk down the humdrum streets of the parish of Henbury, the bungalows peopled by an aged and delightfully quiet population. From here, cross the road and into the park. Through one gate, a sward of lush grasses, fringed at the far end by dense trees. Here, small human tracks criss-crossed the space. People meandering while their dogs skittered from fascinating scent to scent. A few impressive oaks, one lightning struck, a carbonised great god. Antlers spreading out in layers like coral shelves into the sky. Walk a little further, down to where the path begins.

Again, there are choices. We can descend into the gorge which forms the heart of the estate or else skirt the houses that lie between the road and the grassland, and snake back toward the Church of St Mary's.

Another route into this sacred space is to walk through the churchyard. Crossing a stream by a narrow footway, we emerge into the cemetery. The church is an ancient low slung building. Interred within its curtilage are the bones of black men and of wise women.

One grave stone, is dedicated to the memory of 'Scipio Africanus' who was servant to Charles William, Earl of Suffolk and Bindon, who married one of the Astry family of Henbury House. The black servant was named after an ancient Roman general of African origin, Scipio Africanus. Scipio died in December 1720 at the age of 18. His is one of the most ornate graves in the churchyard. The inscription of the memorial reads:

> I who was Born a PAGAN
> and a SLAVE
> Now Sweetly Sleep a CHRISTIAN
> in my Grave
> What tho my hue was dark
> my SAVIORS sight
> Shall Change this darkness
> into radiant light
> Such grace to me my Lord
> on earth has given
> To recommend me to
> my Lord in heaven

Whose glorious second coming

here I wait

With saints and Angels

Him to celebrate

Another liminal figure in this bone yard is that of Amelia Ann Blandford Edwards. This lady was an explorer, writer and Egyptologist. She founded the Chair of Egyptian Archaeology and Philology at University College London. She was also a determined campaigner against the looting of Ancient Egyptian antiquities. Upon her grave, close by the wall of the church, is a beautiful obelisk and a large stone ankh resting on the earth. Symbols of eternal life and resurrection from that more ancient religion rubbing shoulders with Christian angels and deaths heads.

Blaise is so rich! So many walks and ways to explore it! I'd often give visitors that I was guiding through the gorge two choices. 'Would you like water and earth or fire and air?' If they chose the first we would walk down the valley, following an easy path. The beech cathedral would be on our left. A stand of high trees on a steep but climbable slope. These tall queens of the forest sprang from knobbed and exposed roots, smoothed like beach pebbles by the run-off. Walking on downward, our next stop would be Goram's Chair. This vast double limestone outcrop (the arms of the seat) was the resting place of the giant Goram who made this gorge. He and the giant Vincent, who mined the Avon gorge, had a battle to see who was the stronger;

Legend has it that two local giants, Goram and Vincent - who, according to some versions were brothers - both had a bit of a thing for the same woman.

She was the lovely Avona, 'a Wiltshire-born merry belle' and promised to marry the first giant to drain the great lake that once stretched from Bradford-on-Avon to what is now Bristol.

Goram picked his route through Henbury Hills, while Vincent instead opted for Durdham Downs.

But the digging was thirsty work, and Goram soon succumbed to the heat, had a few pints and fell asleep in his favourite winged chair. Meanwhile the ever-industrious Vincent furiously kept digging, emerging at Sea Mills, and duly won Avona's hand.

Avona gave her name to Vincent's Avon Gorge while Goram, who was broken hearted, hurled himself into the River Severn and drowned himself.

His head and shoulders can still be seen poking out of the estuary mud as the rocks of Flat Holm and Steep Holm, and his channel became known as the Hazel Brook gorge.

St Vincent's Rocks, near the Clifton Suspension Bridge, bear the name of the victor in this contest, but Goram is arguably more famous.

Giants moving on the land, making the places we little folk inhabit.

A little further down and we'd arrive at the giant's soap dish, a series of pools and ponds fed by the bright spilling hazel brook. For those who know, there is an ancient oak hidden away in the forest at this spot. This great plant is hollow and one can stand inside, look up to the azure sky and hear the wind speaking doleful notes across the open tube of the trunk.

For a fire and air journey, we wind up the opposite side of the gorge. Here one encounters a low man-made cavern in the rock. Crouched inside this tiny space the ceiling is made from stones that point downwards, like the improbably numerous teeth of a shark. Up the hill, heaving in breath, getting closer and closer to the light. One might stop off and see Goram's footprint, an ancient depression in the rock (rather small given the prodigious size of his chair). Then darkness closes in as yew trees screen the gorge from view until one arrives, dizzy and gasping, to the look out. From this vantage place you can gaze out across the valley. Looking across the crowns of the trees and towards where the sun, in all her glory, is risen.

Turn the corner and you're at the famous folly celebrated by Austen. Folly is perhaps a misnomer since the structure was, until recently, inhabited and furnished in fabulous style (suits of armour, stags antlers on the walls, coasts of arms and rich floor rugs). The building is, as any five year old will tell you, a castle. Crenulated towers stand proud on a close-cropped lawn. We may go one way and down towards the giant sequoia, with its strange fibrous red bark, and back to the manor house. Alternatively we might turn and walk out past another stand of trees and along the ridge where the ancient Roman sun temple once stood. It was on a walk that took such a route that I met Pan.

Many of my walks on Blaise were in company, sometimes alone, many times with my allies. At that period of my life they were typically LSD and cannabis. A typical practice would include nothing more elaborate than making some simple prayers, taking the acid and meditating until I (or we) could feel it coming on. Then we'd go outside to trip, to make the psychedelic journey linked, enhanced by, the actual journey through a fairly safe certainly very beautiful landscape.

But the time I saw Pan I'd not taken acid, although it's probable I'd been smoking weed. This was relatively sober vision.

I'd gone for a walk, just because it was a gorgeous day. High summer with that full deep green, not yet tipping into the dusty gold of early autumn. I walked up the path of fire and air, paid my respects at the Castle and then set off to look for the Iron Age mound on the ridge. This structure can be seen, since the land is a dense field of grasses with only a

few hawthorns dotted here and there. The low mound overlooks Avonmouth and it was on this hill that the Romans placed their solar shrine. Standing in some oak woods looking across the grassland I exclaimed to myself, 'well, if there is a Lord of the Forest, this is where he'd be'. The god I imagined was the strong, vigorous deity of the sun, the oak king, the bright jocund Emperor of Summer.

As I turned around there, sitting on a fallen oak, was a man. He was dressed in a dishevelled suit which was of indeterminate age. He wore a bowler hat and had a purple necktie. What was odd, and I only had a few moments to notice it, was that his suit, indeed all of him, was green.

"It's a beautiful day'. He said with a slight Irish accent.

Stuck by his silent arrival I simply smiled and nodded.

"Ah well, you go your way and I'll go mine." He said, and winked.

I turned my attention for a moment back to the grasses swaying on the field. Of course when I turned back he had gone.

I looked round for him. There was only one easily accessible path

And he didn't look the athletic type, but he was nowhere to be seen.

Was this figure a spirit? Perhaps my Green Man of the Woods? Or was he nothing more than a Falstaffian tramp, a gentleman of the road who'd stopped to take a breather in the shade of the woods? Was he the jolly incarnation of Pan, more *Wind In The Willows* than the rampaging deity of Crowley's famous invocation? There was a gust of wind and a distinct sense of the sacred.

With the miracle medicine of LSD inside me, I'd seen many signs that pointed to the power in that landscape. The washing in and out of the trees, standing proud on the ridges of the limestone gorge. I'd watched the crows flying across the dawn chasing the pale departure of the full moon as the sun swept up into the sky. I'd watched as my friend Richard became a leaping lion in the moonlight, aboriginal markings on his face reminding me of the antipodean continent he was visiting me from. I'd felt my body electrified with energy, scrambling a scree slope of the valley, and seen the hair of a beautiful woman merge with the yew tree in which she sat. But never had I experienced such a commonplace, defiantly real and yet mysterious encounter as with that green man. That was a special blessing from that landscape that I'd fallen in love with.

Going West

Since moving to north Devon I've had many opportunities to get to know the countryside of the most south western part of Britain. Frequently these journeys have been in the company of Greg Humphries my dear friend, magical collaborator and sometime co-author. Together we've walked the landscape of

Cornwall, infested with Neolithic monuments and the echoes of tin mining. We've delved into combes, those special deep wooded valleys, of north Devon. Together we improvised and deployed a range of different techniques for engaging with the spirit of the land.

A few examples follow, suggestions to inspire your own roaming into the spirit of your land

Shrine Making

Found objects and those brought along expressly for the purpose can be used to honour the local spirits. Shrines are built, little altars dressed with flowers, coloured wool, trinkets, and offerings of money and joints. Such interventions serve to mark our sacred attention to the landscape and leave a trail of ritual that, I hope, enhances the journey of those who subsequently discover them. Tiny transient mementoes of meditations which punctuate the ritual walk.

On fences, ribbons may be tied, grasses woven with spells through the mesh, and feathers stuck in the gaps between brickwork. Our magick seeks out these crevices in the works of man, unstoppable and temporary as a mushroom that pushes out of the gap between paving slabs.

Offerings

A shrine is a species of offering. A marking not of territory but of sacredness. Offerings can also be made to gatekeepers and sacred spots. Candles are left at wells along with silver coins (and wishes). Blood may need to be spilt or tobaccos placed under the earth.

Artworks

Inspired by Andy Goldsworthy, leaves can be laid in a line. Graduations of colour, from green to autumn reds mark this out as the work of man. The large rounded grey pebbles of the north Devon coast can be arranged so that the veins of quartz crystals within them line up. These bright white lines snake across the beach, creating an order which is distinctly human. Or they may be piled up, balanced on top of each other (I once saw a beach on the isle of Agnes in the Sicily's that had hundreds of such piles, a sculptured landscape).

Drawing and painting on surfaces; abandoned signs, great rocks, can also be a way of honouring the spirit of place. I usually content myself with chalk rather than spray paint.

Right Way of Walking

The terrain offers many ways of locomotion. Walking up a hill, head down looking just a few feet ahead, against the solid wind. Then looking down from a high place once a vantage point is attained. In this way we go from the view of the mouse to that of the hawk. Once Greg and I climbed a slope covered in heathers and moss. Like pawing over the luxurious hair on the vaginal mound of a huge goddess.

Sniffing her, feeling her wiry fur. So absorbed were we in this erotic close contact that it was only when the ground ran out we realised we'd climbed a huge sea cliff. Over the sharp edge was the glittering ocean and air.

Then there is the part of the walk that is real Work. The interminable slog back to the car along the unrelenting metalled road. The final push to get to the peak before we can rest and take it all in. Walking can be a challenging business.

Entheogens

Taken inside entheogens tend towards introspection or group consciousness if used as part of a collective ceremony. Outside they allow us to see the fantastic beauty of nature through fresh eyes. We slow down; take everything in. Tufts of dune grass blowing in the sun become the tousled air of bleached blond surfers. Rivers are seen and known as the veins of the planet. Birds become messengers from other worlds. We see in a way that is both hyper-symbolised and yet somehow also shorn of preconceptions. We focus on those aspects of the land that have something to teach us. I spent one journey obsessed by 'the edge', the razor cut sheering away of cliffs. The point at which the sea and the land and sky all meet. Entheogens adjust our perception so that we are seeing the liminal, the within and the without as they meet.

Of course one must judge the dose well, especially if interaction with other people or negotiating dangerous landscapes is required. LSD, mushrooms and other typtamines are wonderful spirits to go walking with. As one commentator put it;

But they (drugs) all do sort of the same thing, and that is rearrange what you thought was real, and they remind you of the beauty of pretty simple things. You forget, because you're so busy going from A to Z, that there's 24 letters in between...

The term 'museum level' has been used to describe the dose of a psychoactive where one might be able to function in a social space (for example a visit to a gallery or cream-tea shop) and not be so wired that you get thrown out (or become reduced to a paranoid wreck). Such a level of intoxication is ideal for walking. One can also use the shorter acting substances (for example smoked DMTs) at the literal peak of a journey. Clearly one should find a safe environment within which to take these substances since they can be temporarily incapacitating. Proximity to cliffs and mine shafts is to be avoided!

Song and sound

Another archaic technique of ecstasy. Whether it be listening hard to the sound of your own feet on the earth, humming or singing as one walks, or perhaps using mantra and vibrated words of power at stops along the route, by making sounds we contribute to

the soundscape of a place. By inducing trance, rhythmic sound can help us to focus deeply on one aspect of a location (playing with echoes and percussive sounds is an excellent way to do this). As we become ecstatic, literally standing outside of ourselves, our perspective can shift. We are no longer beings walking on the land, instead we are in it and of it.

Prayer and words of power can be spoken at sacred locations; lone trees, crossroads, bridges. We can programme ourselves with spelling, sounding out our intentions as we send driftwood wands out to sea, or touch sacred objects; megaliths, doorways, windmills.

It's good to save words at some points in a magical walk. Make times when chit chat is minimised. Walk in silence and only say when you are moved to do so by deep unconscious forces. Make sounds in reply to the wind and talk to the animals and plants with respectful, measured dialogue. This way the act of speaking is potentiated. Listening is also enhanced this way. And if there is conversation it should be remembered that this is as special space and words should be chosen with flair and care.

Hiding Things

Talismans, witch bottles, runes and tokens can be buried and secreted along the journey. These act as Gnostic strange attractors, linking your power to the place you have visited.

Eating and Drinking

It's possible, even on an urban walk in all but the most densely populated areas, to find wild foods to eat. Seaweeds, blackberries, the cucumbery taste of fleshy navelwort, the coconut dryness of gorse flowers. Literally eating the landscape it becomes you. Drinking from a stream where the water is fresh, tasting the brine of the sea. Getting all gustatory with the planet is good for the mind, body and soul. It also leaves you with a nice feeling that if the total breakdown of civilisation happens anytime soon you'll be able to survive for a while at least.

Naturally this is an incomplete list. The key is to listen to the place, the space, and respond to it. If that means silent meditation, do it. If that means breath work or bathing in the sea, let it happen. Watch how water courses move, if they are flowing away from you ask them to help you banish restrictions. If towards you, ask them to bring you insights and divinations. Listen to the earth, press you ear down on the soil and really strain to listen. Is it speaking? What does it say?

Built environments of course present their own opportunities. Watch for omens in pub signs and random graffiti. Deploy your mobile phone and exchange pictures with confederates who are walking at the same time but in different locations. Mobile phones incidentally also provide a social cover for techniques such as glossolalia. One can burble

into a state of trance with a mobile held to the ear and thus appear to be speaking a curious language rather than being certifiably insane. In cities one can move through passageways that you've never investigated before, back alleys of the towns that are analogous to the half-hidden routes through your own unconscious mind.

Let us make these movements of our journey full of pleasure and freedom and power. Let us be inspired by the spirits of place, work with them, honour them and see ourselves in relationship with all those things that share our world. Let's explore this territory like astronauts on a new planet, or toddlers discovering for the first time how it feels to walk on warm sand. Let's disorientate ourselves with chanting and drifting, with drugs and art. And in this disorientation we pray for a new connection, a re-enchantment of the land and our place within it.

Pull back; see the setting sun not as the orb of light going down, but as the planet turning at hundreds of miles per hour in space. Glance down; and watch the tiny spider sucking the life out of her captives, these myriad transformations on every scale. By these acts, these shifts of perception, this relationship we make with the earth, we expose the magick in all manifest existence. So it goes.

Places of Power

© Jan Fries

First published in Rollright Times

"Could you write something on shamanism?" asked my editor, who is always a cheerful soul when it comes to inventing new projects, "it's for those pagans who have bought the Rollright Stones. They could do with a bit of support." This set me thinking. Recalling the Rollright Stones was easy, but I simply couldn't think of a way of fitting shamanism into the picture. I remembered our visit to the site, a few years ago, in the dusk of a long summer day. I had heard of the Rollright Stones, but what I had heard had not prepared me for the actual event. When you've seen places like Stonehenge, Avebury, or the stone avenues of Menec in Brittany you may develop the idea that people who build megalith sanctuaries like to do this in a large size. This is understandable, as most people represent important ideas in a big form, and to most people of the prehistoric days, religion seems to have been an important issue indeed. Rollright was a surprise. The stone-circle seemed so small that it felt comfortable. There was a friendly atmosphere to it, a sensation that reminded me less of a church or sanctuary but of a living room. Yes, there are megalith structures incorporating small megaliths! What the builders of Rollright had achieved was not just a miniature, however. The stones of the circle had that special appeal which you can sense in small but exquisite works of art. Each stone was very much alive-a good indication that plenty of people were coming there and keeping up the sentience, but also unique in a way that you may understand when you go there for a peaceful evening. We said hello to the place, explored the range of bizarre rocks, walked around the circle for a while and finally used the opportunity for a little seething, as you may have read in *Seidways*. During the trance, I was amazed how easily the place responded. The ground seemed to ripple and vibrate, waves seemed to run through the supposedly solid earth and out of the strangely shaped stones, faces and forms of animals appeared.

This was a highly subjective impression, of course. It does not matter much whether the stones actually house animal spirits, or whether the builders of Rollright had this effect in mind when they built the circle. They might just as well have thought of them as little people, as gnomes, dwarves, as place guardians or whatever. In another mood the stones might have given an entirely different impression, and indeed this is one of their best points. Looking at bizarre stones, such as the ones at Rollright, you can discover lots of hidden meanings, the stones being a Rorschach ink-blot mirror of yourself. Few arts are as subjective as the art of communication with places of power. If you like subjectivity, and want to treat your own subjectivity to some interesting experiences, here are some hints on how to get going, and what to do when you get there.

Ever since Castaneda's books became bestsellers, the idea of powerplaces has haunted the minds of New-Age mystics. Generally speaking, a place of power is one that has an influence on your mind. This may seem a little too general, as most people seem to think that the real places of power are somewhere else, preferably in the wilderness. Magick, however, is much easier to practise where you are than somewhere else, and your awareness responds to every environment, no matter whether it is new or old, natural or man-made. If it does not, consider whether you might be dead. One of the most important discoveries of Tim Leary was the insight that Set (your mind-state) and Setting (the world you perceive at any given time) influence each other. He learned this while experimenting with acid, but as it soon became obvious, the acid only makes the relationship easier to perceive. So, where do you find a place of power? Here we encounter the joys of subjectivity. Places of power need not be exotic, or special, or far-away. Any place that influences your state of mind is a place of power for you. To become aware of how many of them are around, you could do yourself a favour, get hold of paper and pen, and list as many as you can. The important issue is to keep the definition of power as loose as possible. When people-especially those who have had too much Castaneda and not enough to laugh-think of power they usually consider something dramatic, mysterious and dangerous. This isn't bad, but it leaves out hundreds of powerplaces that might be of use for magick if only they were remembered. If you ask "what power is it then?" you may get much further. There are plenty of different sorts of power. Which environments do you like? Which make you feel at home? Where do you like to go to relax, to find new strength, to discover new ideas? What powerplaces did you enjoy as a child? What sorts of memories come up when you go there today? Some of the places of power

store old memories, their magickal power, if you like to call it so, is the power to remember. Or think of the places you really don't like. Which places make you feel unhappy, or angry, or upset? How do you feel when you walk past a public rubbish dump, through a landscape poisoned by pollution or through the corridors of a welfare office? What about hospitals, military property, mega-size shops or the tiny bits of landscape hidden between monster motorways? True enough, such sites may not seem magickal to the romantically minded, but they do excert a certain spell on the mind, they influence your consciousness, and this makes them valid places of power. You might argue that you don't like them, but then, this only means that you haven't found a way of making use of them so far. Think of the Chödpas of Tibet. These ascetics developed a form of meditation that made use of frightening and terrible visualizations. To make the most of them, they sought ought the very sites where other people did not want to go, the places shunned and dreaded as they housed evil spirits, demons of disease or dangerous beasts. Such places may not be nice, but they can be of use to dissolve an overly rigid personality. Plenty of rituals make use of a bit of fear or exhaustion to get the ritualist out of the usual mind-scape and into a new consciousness. In Tibet, such places may be natural, but in Europe you also have the choice of making use of man-made sites of terror.

Many seem to think that meditation is something that ought to be practised in places of beauty and solitude. One expert delighted me by insisting that real meditation is only possible in the Sahara desert, as everywhere else it is just too loud. It can be an interesting experience to perform a calming and peaceful meditation in a railway station during the rush-hour. As I learned when practising, this is not exactly easy, but if you can do it under such crowded and hectic circumstances, you can do it anywhere. In this case the station becomes a place of power, that is, the power to ignore a lot of disturbing sensations while remaining aware enough not to be plundered by pickpockets. A place of power needs not be nice, if you are creative enough to find some good use for it. And how are you getting on with your list of power places? Did you remember to include places like soccer stadiums, concert halls, museums, libraries, airports and the like? Or consider the places that became powerful to you. Think of the street where you grew up, the school you went to, sites of childhood holidays, the places you visited with your first love, your first jobs-any location that connects with some important item in your personal history. These places may not be useful to other people, but they will hold a certain power for you. Which of them may be useful for your magick today? You could go there and remember something useful that you may have forgotten in the

meantime. Or you might find, as you explore them, that you have really changed a lot since then, and that the dreams, hopes and fears of then are no longer valid to you now. Both of these options-and can you think of others?- are useful rituals.

Then there are what I'd like to call simulacra of power places. Think of those places where you didn't really experience anything powerful, but where you are reminded of places that had powerful experiences. It may be a couple of trees, a few rocks, a certain form of landscape-you respond to them as if they were places that hold a lot of meaning to you. Especially the places of your childhood dreaming are interesting in this respect. As a child you associated certain experiences with certain landscapes, and when you encounter a similar landscape today, you may find yourself responding as if it were the one that influenced you so much in the past. The same goes for town-scapes and city-scapes. This effect is not limited to the natural world, as consciousness makes use of similar structures wherever you go.

Let us now turn to the sort of power places that most people seem to look for, that is, the ones in a semi-natural environment. People occasionally like to say that a place is magickal, but what they fail to define is "to whom and under what circumstances?" As you will know when you've spent some time at some sacred site or place of great natural beauty, there seem to be lots of people around who do not seem to notice any of this. Lots of folk go for walks in the forest without really noticing where they are, let alone responding to the charm of the natural world. You can observe them talking (loudly)about the most trivial everyday matters, behaving like insensitive brutes or littering the countryside without consideration. The sensations that the environment offers pass unnoticed, and the mind-set of everyday problems, troubles, quarrels, work and whatnot effectively prevents the experience of anything new. This all too usual effect shows that a place can be as powerful as you like, but unless you open your mind sufficiently to its influence, very little is going to happen. Or think of an occasion when you visited a place of great beauty but failed to make contact with it. The most magickal powerplace in the world is no guarantee for anything magickal when you happen to be caught up in some obsessive inner activity. Even simple tiredness or weak health can prevent contact, or take the joy out of the situation. This seems to show that a place of power only functions as such when it is encountered by a certain awareness. Basically, a place is just a place unless you make the power happen.

This raises the question how you can make it happen. Its probably not too popular a thought, but even dedicated pagans, tree-

huggers and nature-lovers occasionally find themselves out of touch with a place of power. Sometimes one is too intensely caught up with the experience of the inner world to become aware of the possibilities existing in the outer. There are days when one feels weary, tired, or is obsessed by other matters. Luckily, there are plenty of ways in which awareness can be switched to the outer universe. Some of them are detailed in *Visual Magick*, so I won't bother to list them here. But there are others that could do with a bit of creative experiment, and as I'm sure you are just the person for the job, here we go.

One of the important issues in relating with nature is the consciousness frame you are maintaining. Imagine you want to visit a place of special power. However, you happen

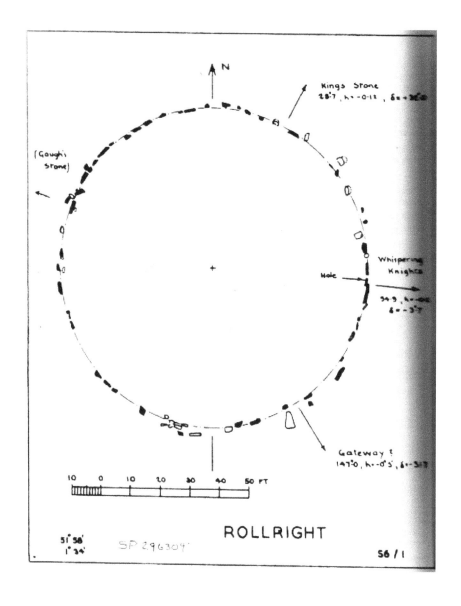

to come from work and have a head full of human trivia. These may be important enough for the reality-tunnel that humans get into (when they forget to laugh once in a while), but anyway they are there and what do you do to clear your mind for new experiences? The easiest approach is to have a break. Having a break means changing the pattern, i.e. the pattern of your thinking, motion, posture, behaviour etc. Every consciousness that you can produce is linked to certain forms of behaviour. It is, for example, an easy matter to produce a depressive mood when you accompany your thoughts by a stooping posture, flat breathing, eyes that are glued to the ground, infirm or fluttering motions, shaky steps, the occasional sigh and so on. These forms of behaviour come in one package with a depressive mood (just like certain forms of imagination-representation and a certain tonality of your inner voice) and indeed they are required to maintain the mood. Consciousness does not simply happen, it is made and it requires maintenance, otherwise it goes away. It can be rather hard to be depressive when you jump and bounce cross-country. Jumping and skipping produces a break from the behaviour required to keep depression going. Likewise, a mindset focused on adult human thinking requires specifically grown-up human behaviour. You can change this in several ways. One way is to change your walking pattern. Have you ever considered how adults like to go from A to B in a steady and continuous motion? This is a linear sequence. Children have a different mode of walking. They also manage to go from A to B, but they don't do this as directly as adults do. First they may go over here, then they discover this, watch that, drift over there, run a bit, stop and look at that, go somewhere over there, return, play around, remember what they had set out for, go ahead, are diverted by something really interesting, climb this thing there, jump over that, run a bit, change direction and eventually they may get to where they had intended to go in the first place. Can you remember what it was like when the world was simply too fascinating, and so full of interesting things, and you followed your impulse to explore them all? The same method can be used in approaching a place. You don't go there directly. You go anywhere else. You change the walking speed every few minutes, you stop and go as you like, you allow the world to fascinate you and explore everything, not just by looking at it but by going there, by touching it, by doing and playing and enjoying. And when you come to that place you don't proceed to do your ritual or meditation. Use the oblique approach and go sideways. Drift around, explore the place, find out what is new, build up a desire before you start. If you use such patterns you may find yourself experiencing the place in a new way.

Or imagine you are an animal. Change your posture, change the dynamic impulse of your motion. Allow the center of gravity to drop, take wider steps, open your eyes wide, become aware of the sense of smell, approach the place cautiously, walking as silently as you can. Most animals are a bit shy and cautious, they take in as much of their surroundings as they can.

Or use the good old fear routine. Imagine there are malevolent and dangerous beings around and that your survival depends on seeing them before they see you. Allow your eyes to dart around, see, hear, smell and feel everything as you cautiously approach your destination. Shifty eyes, by the way, are a useful technique to maintain a paranoid state. This may be a game, or a reality, but whatever it is, it will make you sense differently and get you out of your routine mind-set soon enough. You can observe similar forms of behaviour in many 'shamanic' systems. Plenty of novices are scared with spirits, are made to behave irrationally, or have to struggle and climb their way along dangerous pathways to come to a place of ritual or initiation. If the approach is too easy, the novice is in danger of not being wide-minded enough on arrival. If it is too hard, the strain may also interfere with mystical insight, and this leaves you with the obligation of finding out what you need at each given time. Don't make a routine out of it, as anything that becomes a routine will lead to habitual mind-frames.

The next question is how to interact with a place of power. As you will understand as you go along, there are plenty of different forms of power around. Some sites seem to have a strong energy field. As we are in the wide world of subjectivity, we could class (or invent) several sorts of energy. There may be earth energy, for instance, which is the sort of power that dowsers, ley hunters or feng shui experts get excited about. There may be some strong elemental power, as when you encounter a wind-swept hillside, a waterfall or a cluster of great rocks. Or maybe its a field of belief energy, the sort that gets built up when a place receives an imprint from strong human emotions-religion, war, tragedy, superstitious dread or whatever. All of these may be power of one sort or another, but what really matters is whether it suits you. Or consider the time. Some places respond differently in various seasons, at certain festival days, in certain weather or during full-or nu-moon. Then again, the quality and nature of power vary a lot. There are places that can charge you with energy if you stay there for a while, but which provide an overdose if your stay is extended. Typical symptoms for an energy overdose may be tension, edginess, cramp, fidgeting and nervosity. Other sites have a way of draining excess energy. They may be useful to relax someone who is too

powerful, mind-bound or hyperactive, but if you go there when you're feeling weak, the place might only make you weaker. Places can work like medicine, and you are wise if you make sure you get the right amount, no more and no less. Many New Agers take the easy approach and pretend that such differentiation's do not matter. They see each sacred site as a battery which is just waiting to be tapped. This sort of attitude is little better than parasitism. Before you decide to use whatever is there, you should find out just what it is, and consider if it suits you. In all honesty you could also consider if it suits the place. A place of power usually has a certain sentience. It also has a history, a personality of sorts, and certainly it is used to a specific scope of behaviour. This is not a question of using a thing but one of learning to communicate with an entity.

When you enter a church, you ought to behave in a suitable fashion. When you enter a mosque, another set of rules applies, and when you visit a Kali temple you'd better tolerate people who slaughter goats and grill them on the lawn outside. Most people try to accept this with regard to religions that exist today, but when it comes to prehistoric cult places, cautious conduct isn't fashionable any more. It might be worth considering that many of the old cult-places were created by religions that are not only hard to understand for modern minds but possibly even hostile to them. Just because something is old or pagan it doesn't have to be friendly with you. And it gets more complicated yet. What if a place has been used by several cultures? Maybe you are sympathetic with one of them, but what do you do with the memories and powers of the others? Some sacred sites have lain dormant for centuries. When such a place wakes, due to ritual, trance, meditation or plain synchronicity, it may well be confused, if not annoyed, and require an update to come to terms with the present. For the fun of it, imagine you would meet a priest of, say, the pre-Roman Celtic period. Explain to her/him how you live, what you do for a living, how society is organized, how religion functions in our age and just why so many people spend their lives staring into boxes full of moving pictures. Chances are that s/he would be totally confused. What has happened to tribal warfare, to the extended family, to clan-loyalty, to divine kingship, to fatalism and the will of the gods? Now go back to the cultures that preceded the Celts. Imagine a priestess, sorcerer or shamaness of the stone ages, and explain what it means to chose a religion, to have a holiday in a foreign country, to get an old age pension or to read a magazine. Most of the issues that make up our modern lifestyle would be next to incomprehensible to earlier cultures. And isn't it just as hard for us when we want to understand customs like human sacrifice, head-hunting, divine judgment or the

fact that diseases are caused by elf-shot? All of this raises the point that a place of power has a right to be approached with respect. Maybe you'll come to know and love it eventually and maybe you wont. You cant force it to be nice to you.

For the practising pagan or magician, the first question with regard to a new place of power is how it reacts to you. This is a matter of practise, not of theory. How can you determine the effect that a new place has on you? As we are dealing with a subjective experience, we can use totally subjective means to find an answer. One way is dowsing. All you need for dowsing is two L-shaped pieces of wire. Coat-hangers will do fine. Sure, there are merchants who make money by peddling ultra-sensitive dowsing rods to those who think that esoteric toys have to be expensive. Personally, I find it more useful to believe that the ultra-sensitive apparatus is the human being, specifically the deep mind, and that the rods are just the needle that indicates what the deep mind has divined. Consider them a signaling device. Dowsing itself is simple. You take one of those L-shaped rods in each hand so that the long end points forward. Then you walk slowly over the place you want to explore. Go gently and hold the rods so softly that the long ends can freely swing around (if they want to). For simplicity's sake, I'm not going to bother you with geomantic theology. For one thing, dowsers are far from agreeing

with each other, and for another, theory often gets in the way of experience. The science of geomancy postulates all sorts of theories in the vague hope of becoming objective eventually. It hypothesizes about the subtle effects of hidden waterways, magnetic fields, ley-lines, energy currents and adds complicated networks, such as the Curry- and the Hartmann-grid, all of which produce a highly complicated mess. Searching for such items will produce plenty of speculation but very little useful data.

More useful is a simple and careless approach suited to practical minded loonies like you and me. Instead of asking whether there are all sorts of obscure energies around (which may or may not agree with you at the time being) you can divine the effect a place has on you. This is a subjective question and you will get a subjective answer. Consider what sort of place you are seeking. Do you want a place for a short rest, for a longer stay, or one to spend a night at? Do you want a place for sleep, or one for meditation, or one that charges you up and produces excitement? A place for a wild trance or for a peaceful one? A place to get rid of tension and excessive energy or one that lifts you up and exhilarates? There are plenty of choices, and as you'll learn soon enough, you won't find everything in one location.

Let us imagine that you want a spot to relax for a few hours. You hold your rods and

as you walk over the place, ask yourself in a clear and steady inner voice "Is this a good place to relax for a few hours?" Keep repeating the question to yourself and observe the rods. Usually the deep mind signals that it has found such a place by allowing the long ends of the rods to swivel towards each other. When they cross, this is a signal that the place is as you ask. If they cross swiftly, the affirmation is more intense, and if they cross and swing towards you it may be that the place is more than you asked for. If they swivel outward, and point away, this may indicate that the place is definitely not suited for relaxation. I hope this suffices to get you going. The language of the rods, as detailed here, is basically a convention. It is not necessarily true, but it can be useful to communicate certain ideas. Your deep mind tells you what sort of effect you can expect at the time being in a given place. It does not signal why, or what reasons it has, nor do you need to worry about the complicated lines, grids and whatnots. Your answer is quite as subjective as your question. It is suited specifically for your awareness in this specific situation and better still, it happens to work.

Nor is this the only approach. You might as well ask your deep mind for an ideomotoric signal, such as a twitch, to tell you when it has found a suitable spot. It doesn't really matter what sort of signal you use as long as your deep mind can give it and you are sufficiently awake to notice. To understand a place more fully you might walk over it several times. Each time you do it, ask for another effect the place may have for you. Draw a map if you like. In some locations you can find a wide scope of effects in only a few yards, other places are of a more extended nature and are only suitable for specific experiences. The important thing is that you keep an open mind and do not take yourself, nor the results of your divination too seriously. It can happen that a place is good for meditation one day but not during another. Maybe this is due to the nature of the place and maybe it reflects the state of mind you are in. The reason why you get an answer is hardly relevant here. Isn't it more useful to ignore the "why" and better start looking for a place that provides what you need? In practise, you will notice that dowsing gets easier once you gain experience. You may also find yourself developing a useful dowsing-trance that shifts your awareness and makes you more sensitive to scenery, no matter whether this scenery is of a real nature or all in the mind.

In certain states of awareness, scenery becomes a reflection of consciousness and vice versa. As you go out to explore the sacred locations of your neighbourhood you are equally exploring the sacred landscape of your mind. This makes each encounter with nature a unique chance to learn of and communicate with yourself. I leave you here, a long way from

the power-place tourism that has become so fashionable in recent years, with the option to go beyond the limits of your conscious personality into a wide and rewarding world that offers a wealth of sensual experience and unexpected surprises. Will you surprise yourself when you realize the secret blessings of each sacred site? How deeply do you care for it?

Finally, I would like to propose two interesting rituals. One of them consists of spending a night at a place of power, alone, awake and in the dark. This sort of thing was a magickal practise in the North Germanic cultures which had the name *utiseta*, meaning "to sit outside". It was used to receive visions, to raise spirits, as a form of necromancy or as an oracular rite (if done during the night of new year). The important thing about *utiseta* is that you do it on your own, and that you refrain from lighting a fire. This may come as a surprise to all who work rituals around fires. A fire, after all, is something nice and cheerful. It keeps you warm and comfy, gives you something to do, and keeps out the darkness and the unknown. On the other hand, it effectively shuts out a lot of possible experiences. In many places, fire is a threat to the environment. It can damage trees, branches and roots, which is not a good method of producing a friendly atmosphere. Even when a fire is carefully managed, its tell-tale signs will tempt all sorts of fools to build

another one. Perhaps you are the careful sort of person who only builds a small fire. However, next week some idiots may come along who feel invited to have a great big roaring pyre, who damage trees and leave garbage and broken bottles behind. Also, a fire has a tendency to keep you in a human mind frame. To maintain a fire is a strictly human activity. It produces a bright space, a room of sorts, and shuts out the night, the rest of the environment and most of the animal life as well. This may be my own personal crazyness, but I learn much more by blending with the night and the scenery. A fire may be good fun for festivity and dancing, but it seems to reduce sensitivity to the place you are visiting. If you really wish to learn about a sacred site, do it in silence, darkness and solitude.

The other ritual worth recommending is the magickal rite of cleaning a place. No, I'm not thinking of esoteric exorcisms and the like. Its simply the fact that the more rubbish you have in a given place, the more will be thrown away. This says something about human nature. Think of garbage collecting as a form of offering, or perhaps as sigil-magick in reverse. Instead of adding things to a given site, you help it rid itself of undesirable material. Again, this sort of thing has only become popular among the more dedicated pagans, among those who really care for the places that they visit. There is a cult cave in

Northern Hessen which may have once been associated with the goddess Helja of the underworld. For centuries, the locals used to go there to offer flowers on Easter Sunday and to collect the water from its source, as it was certain to heal all sorts of diseases and to give overwhelmingly good looks to the ladies. Nowadays the government has closed the cave, but it is still possible to slip past the gate if you are agile and slim. Cave-ecology is a delicate affair. Its a rather nasty surprise when you turn on a torchlight and find out what people can do for the sake of their religion. I found heaps of flowers, not only on the rocks but also rotting in the water. Candles, cigarette ends, rusting cans, pieces of newspaper, empty lighters, foodstuff, bottles, plastic bags, tobacco offerings and plenty of occult graffiti. Apparently the place has been visited by pagans, wiccans, would-be shamans, heavy metal Satanists and other folk who thought it necessary to leave their friendly little offerings behind. This goes a bit beyond offerings, in fact it reminded me of the ancient mammal-custom of marking territory with excrement. Humans are territorial animals. Now I'm certain that some of those visitors only left small or 'harmless' offerings behind. However, if one group of primates marks territory with gifts of flowers, others are bound to leave different markers. And strangely enough, nobody felt responsible for the garbage left by other folk. Thus, instead of meditating, I found myself cleaning the place. When I visited the megaliths of Brittany, I was amazed how many of them were damaged with graffiti. Plenty of dolmen were in regular use as public toilets, and numerous stones lacked pieces that had been taken by souvenir hunters. As a result, the French government has closed many megalith sites to the public. You find guards at the dolmen, fences, barbed wire, and some places, like Menec, can only be viewed from a safe distance. While this is deplorable for those of us who love and care for megaliths, it seems to be the only way to preserve the stones for the next generations. In Britain, the megalith sites I saw were usually better cared for, but on the whole each offering, no matter how small or spiritual, tempts some idiots to leave their own litter behind. You can become friendly with a place by helping it to return to its natural state. You can also make the clean-up operation a ritual that changes your mind. Simply suggest to yourself that with each bit of garbage you collect, you are equally getting rid of waste existing in your own mind. If you suggest this with proper intensity and congruence, you may find yourself doing something for your own health. This may not sound like a dramatic or mysterious ritual, but it does happen to work. Its a splendid opportunity to do something useful for a change.

Natural
Magic
is
art

Greg Humphries.

There's No Place Like Home

How do you get to know a place and how does it get to know you? Time is a factor certainly, a sense of belonging built up from accumulated memories and feelings. You need to sit and listen. Hear its breathing hear its voice. Listen to its rhythm and pace. "Why are you here?" it says and I have no answer. Yet.

There seems to be a yearning in the soul of the Western individual to re-connect with Nature. The devices we create continue to dissociate us from our surroundings. Just turn on your iPod or computer and tell me you are connected to the wind in the grass outside your window or the pigeons on the roof across the street. The more devices we create to fill the gap, the further we move away from a sense of belonging in this world, the greater and stronger walls we build against the natural world we rely on for our survival. A dangerous route to follow, as the further we retreat from it the less we understand it. The less we understand it, the more we see it as something useless and redundant, or even threatening.

How do we reverse this trend towards isolation? There needs to be an acknowledgement that we depend on this place for our survival. Without clean water and food we would be reminded of this very quickly, but we are insulated by the systems and devices we have created through the use of fossil fuels. Our food is flown in from all over the world, our water comes from electrically powered, chemical based treatment works. Without cheap and available fossil fuels, these things would very quickly become

expensive beyond the means of most people. And the fossil fuels are running out fast.

Don't despair! Get to know your local area, look at maps, find out where the local wells, rivers and springs are. Have a look around for potential food resources, both wild and farmed. Join a local Transition Group (www.transition.org.uk). We can do all these things and more to become independent of those systems that we have relied on for so long. I am not advocating some Luddite, anti-technological future society where we return to some pre-industrial Golden Age (which

never really existed in the first place!) but that we all have the ability to provide the basics of survival for ourselves (food, water, shelter, fire) should we need to.

This practical action is one way to re-connect with the place in which we find ourselves, but there needs to be something more. There needs to be a willingness to let the place into your soul, a poetic invocation which allows it to enter and affect you, its spirit merging with your own to bring about awareness of both your Self and It, to bring about change within.

LAMB'S NEST

This change is obviously emotional, intellectual and profoundly spiritual; yet it is also physical. Many indigenous farming communities around the world believe that toxins leave the body through the feet, and so they wash their feet everyday and place the water on the crops they will harvest. The crops that survive then have developed immunity to the toxins present and, once consumed, provide the medicine for the people to cleanse them of the toxins. Therefore over time both the people and the plants grow stronger; they are intimately and physically linked over time. The roots have grown deep.

How long have you lived in the place that you currently call home? One agricultural cycle? More maybe? Do you grow food in this place? Do you know the plants that grow wild? The plant realm is a gateway through which you can step into a place. Through the cycle of planting, growing, tending and harvesting you get to know the soil, the air, the weather, and the animals that feed on and surround these green friends. The feeling that you are connected to something greater, something Other. In this sense a Place acts as a doorway to the divine. To forces greater than yourself, and in this sense the connection with Nature is a journey of the Spirit.

Physical Exercise Is Good For Your Art.

I have a confession to make. I am an artist, and art has tried to connect people to Nature for a couple of hundred years. William Blake and the Ancients (e.g. Turner, Gainsborough, Constable, and Friedrich), the forerunners of the Romantic Movement tried to capture the essence of beauty and the sublime in Nature, to paint it in a picture, or write its essence into a poem. To communicate this sense of nature in words and pictures is a magical quest, attempting to strengthen the connections between the individual and Nature through the medium of the visual image. These artists saw the "dark satanic mills" of the industrial revolution as the first indication of the distancing and isolation of the human soul.

Landscape painters continue to attempt this today through varying degrees of abstraction. The abstract attempts to convey emotional meaning rather than relying on a literal description. Abstract landscape art is simply an extension of the Romantic idea. It is still trying to connect us to Nature through the art object, even if it is directly evoking emotion and feeling. After all, abstract art is not meant to look like anything in the visual realm; it is meant to bring forth feelings or sensation. The 20th Century is littered with examples in both painting and sculpture. The St Ives school, Hepworth, Heron, Matisse, Picasso, Van Gogh, etc. But does it really work? Does the art object really connect us to Nature? We may recognise the place, appreciate the craft and skill of the artist to manipulate paint on canvas, or work marble

with mallet and chisel; but does it bring us closer to Nature, to a particular place or landscape?

The problem for me with all this object-based art is that the object itself acts as a barrier to the connection. Take a painting, for example. Its frame defines a window through which you can view another world (In a figurative painting this world in a physical reality through which you are invited to step, and in an abstract landscape it is an emotional inner landscape). But looking at a landscape through a window is not to enter that landscape, it is not to become part of it, but merely to observe it; distanced from it by the window/art itself. The art object acts as both mediator and barrier to this communion, and the medium becomes the obstacle to achieving the aims of the idea.

The late 1960s and early 1970s brought new artists wanting to connect people with Nature, or with a certain place. These artists saw the landscape itself as the artistic medium for their ideas. Land Art was born, forming and transforming soil and plant in their own image. The classic example is Robert Smithson's "Spiral Jetty" where Smithson used tonnes of gravel to create a spiral jetty at Rozel Point, Utah in 1970. Terraforming. The artist as God. In contrast to the egocentric Smithson, David Nash lives in Wales, and has done so for most of his life. Nash has been growing an ash grove on some land

bequeathed him by his father since 1983. Each year he returns to the grove to tie, prune, splice and graft the limbs of the trees into a perfect dome. Hearing Nash talk about this project is eye-opening, because he regrets starting it, claiming that each time he returns it feels like he is torturing the trees. The question for me is this: if Nash just planted the trees and let them alone to grow naturally, would that still be art. Could he simply create a beautiful ash grove to be enjoyed by him, his family and local community and it still be an artistic expression connecting people with Nature?

Natural Magic is Art

Some of these artists turned to reclaiming wasteland and transforming it into beauty. To do this successfully needs tender care over time, either through the artist themselves or through the community that live near to the site. Through this tending a growing connection with the place occurs. A healing is manifested both for the Place and the artist/community who live with it. A spiral of regeneration and health. Art as Natural Magic.

Art and magic are both a part of the same shamanic journey. To go into another realm to retrieve knowledge or information which may be useful to the wider community. Magic is the map by which we can navigate this space, or embark on this journey. Altering consciousness, or Gnosis, is the means to travel "there" and art is the means of bringing that information back to this world, to

communicate the knowledge found to beings in this realm. To be a landscape artist is to be a shaman. To work magic through the realm of landscape. To gather knowledge from that realm and bring it back to this world; thus forming a link with that which lies beyond. The Artist as Magic Man.

The act of communion with a place is an ecological and truly shamanic journey. If you start you will be undertaking one of the most important and noble journeys, perhaps the most important journey a human can undertake at this time in our history. It is no wishy-washy New Age undertaking and you must realise what this communion with Nature brings. The Shaman knows her place. She willingly joins her spirit to that of a place. Taking on its pain and sickness, then with the help of her spiritual guides and helpers, healing that sickness and transforming it. This is no Western concept of New Age shamanism,

watered down to a few workshops or "by mail" courses of study. This is hands-on knowledge, in at the deep end. Just think on this for a moment. To be a shaman in a place is to explore all its pain and to physically take this into your own body. Your body and that of the land are one. The superstore that squats on the bypass is your appendix, swollen and bloated. The sewage polluted river is your urinary tract, infected and stinging. The chemical plant in the industrial estate your prostate tumour. And you still want to become a shaman?

Enter the landscape itself. Go out of the gallery and enter the picture itself. Work and create your art with the materials of the place that you wish to gather a sense of. Collect soil and sand, leaves and twigs. Treasures for your palette. Get your hands dirty, communing with spirits of the Earth, whilst your hair is blown by the spirits of the Wind. And you still want to become a shaman? I salute you!

Pagan Ecology: on our perception of nature, ancestry and home

Emma Restall Orr

When asked for a concise definition, the majority of British Pagans would probably describe their religion as a nature-based spirituality. It's a simple phrase. Yet as three words, a catch-all, a sound-bite, it is one of those wonderful phrases that may actually be saying nothing at all.

After all, what on earth is meant by nature? The notion is vigorously and often emotively debated, and rightly so, for it has been used as a political tool in countless ways by governments, corporations, protest groups and religions. How broadly one might extend it, and what might be included within its embrace, has changed over the centuries, as cultures have considered the natural and unnatural, seeking to describe the ungodly, the uncivilized and dangerous, or that which should be prioritized, protected and treasured: nature has been defined equally as the acceptable and the unacceptable.

Perhaps because the breadth of possible definition is so broad, even where other brief descriptives are used to sum up Paganism, the essential focus on nature is often still there. Expressed in countless ways, a gentle process of distillation brings us back to those three words. Pagans might, and freely do, wrangle over the precise meaning of key associated terms, such as spirituality, deity and sanctity, and the implications for each definition with regard to religious practice, but these too boil down to the basic question of how our understanding of nature is foundational to our ethics and daily behaviour.

Indeed, in many ways, it is this individual fervour of self expression, often so protective of the validity of personal experience, with its inherently rich diversity and dismissal of any universal truth or certainty, that so often expresses – or even defines – modern Western Paganism, as much as its focus or basis on nature.

Yet being so simple, the phrase can easily be used in ways that can make Paganism sound sentimental, intellectually slack, even superficial or frivolous. Emphasizing the importance of the individual's engagement with and experience of nature, interwoven as that is with their developing and very personal understanding of it, Paganism is definitely subjective. Having no scripture, liturgy or singular deity, if one's habit or desire is to find universal truth it is easy to perceive the Pagan outlook as too diverse and individualistic to have any weight or worth.

In order to grasp anything tangibly, as more than mere abstraction, however, it is important to have a sense of its history, and a significant root of the modern Pagan movement can be traced back to the Romanticism of the eighteenth and nineteenth centuries, when great poets, artists and thinkers were responding to the extraordinary changes of their era. The dual forces of industrialization and the enclosures swept like a polluted flood through the landscapes of Britain, every crisis dismissed and every change justified by the increasingly vocal authorities of imperialism, enterprise and science. Railing against these voices of evangelizing reason, the Romantics cried out for the beauty of untouched wilderness, the importance of cherishing nature, the wisdom of accepting its inherent purity and value. Nature, they sang, should be our most respected teacher, for what was being taught by mankind was fast turning sour.

Many, not only in Britain but across Europe and the United States – Byron, Blake, Wordsworth, Turner, Gude, Goethe, Schelling, Thoreau, among what are a considerable number – have been fully acknowledged as extraordinary craftsmen in their own media, but for a culture that asserts a monist belief of salvation, whether that be through God or science, the subjective perspective of the Romantics was, and continues to be, decisively put to one side. Inspirational but not Truthful, such artistic expression is assessed as of value only if it is not allowed to influence the ongoing flow of human *progress*.

It may be easier for some to recognize the view of the Romantics if we remember the context of their concern and despair. Amidst the rapidly expanding cities, the resources of which were wholly incapable of maintaining the growing population, with little understanding of pollution and no restrictions upon it, the air and water thick with the stench

of sewerage and smoke, migration to areas of developing industry could seem to be no less than a descent into hell, particularly in comparison with the verdant beauty of the countryside and the ancient simplicity of rural living. Even where more work was available, more food and perhaps shelter, albeit in severely crowded slums, to the aesthetic sensitivities of the Romantic artist the exchange did not feel worthwhile. With a small number accruing significant wealth on the suffering of this new urban working class, the inequity was harrowing. It was hard to imagine what could possibly be gained from such a shift in society.

Furthermore, although the new science was firmly finding its feet, extraordinary new discoveries being revealed, radical new ideas emerging in pamphlets, journals, books and lectures, it was still hard to find what value it may have brought to humanity. A few may have survived accident or illness where previously they would not have done so, but the majority still died in pain for reasons that remained a mystery. The simplicity of nature was being all too quickly lost to the indignity of the dissecting scalpel and the peering lens.

With the first decade of the twenty first century behind us, it can still be perceived as irrational or unpatriotic to express doubt in the value of science, or even to question whether our dependence on science is wise or justified. Equally, we are given leave to say we may not much like the clamour and crowd of the city, but to be anti-urban is interpreted as a rejection of the value of human culture in its concentrated form, from the arts to the vibrancy of social interaction. It is perceived as dismissive of the value of human achievement, the humming creativity of the city, supporting as it does so many thousands or millions of souls. It is to turn one's back on progress.

Paganism is not, on the whole, dismissive of science. Very few Pagans call for a 'return to nature' that would require the abandonment of all our modern technologies and medicine. As a nature-based spirituality, Paganism asks that we learn about the world around us. We may language this more alchemically as the exploration of the forces and patterns of nature, or more animistically as meditation upon the gods and spirits of place, or in some other way, but what we are saying is generally the same: nature has inherent value, and as such we perceive it as sacred, and our task is to learn how best to express respect or devotion for that which we consider sacred.

The purpose of learning about nature is not then to ascertain some objective truth about its dissected constituents or their coherence as separate forms, but about exploring what is necessary to create sustainable relationships within nature. Every individual entity is part of a larger being, and is made up of smaller beings – the tree, part

of the woodland and its wider landscape, influences and is affected by the larger ecosystem, out to the planet's atmosphere and beyond, just as it influences and is affected by its wood and leaves, cells and bacteria, right down to levels beneath our ability to perceive. Entities, identities, wholes, exist on every level, and our task is to learn to engage effectively on the levels that make *sense* to us as human beings; in other words, acknowledging the limitations of what we can perceive, and extending those limits where possible, we work on those relationships that can be experienced - and honed.

This is our home. The Greek *oikos*, a house, is not just a building but a place that is lived in. It is the root of all those words that include 'eco', from ecosystem to economy. To my mind as a Pagan, seeking to understand sustainability and the sacred, it is always useful to remember that those three letters are a reference to 'home'. Our attitude towards the place we live is, after all, wholly formative of our state of being, our health and ease, and that of those around us. To name a place as home is to express an acceptance of that place, and a commitment to it in order that we may remain in a mutually beneficial relationship with it: we protect it, nurture it, care for it. Home is sacred.

Ecology, in this sense, cannot then be a process of dissection, observation and experimentation in order to find repeatably influencable patterns. It is not an objective exploration. If the place where we live is to be one where we can feel secure that we will be able to continue living there, if it is to be home, then we must acknowledge the innate subjectivity of it. Home is an ongoing and personal experience, as must be each of the many relationships that make up the weave of the fabric that is home.

Whether separated into the defined blocks of biology, chemistry or physics, as engineering, medicine or psychology, to the Pagan all scientific study must essentially be ecology. It is, after all, simply the exploration into how we perceive and engage with the patterns and currents, the gods and spirits, of this time and space where we live, of home.

Science is given authority under the conviction that objective truths can be found. Yet all that can ever really be discovered is the nature of a relationship, and to the Pagan the only valid place to lay any notion of authority is on the relationships that create the context that is the moment, the here and now, held as it is within its perceived context of time and space. Removing something from its context, breaking the relationships that inform and sustain something is sabotaging to any process of understanding, yet it is still an endemic mistake made and fundamental to so many scientific processes.

It is worth noting that where a scientific quest *is* focused upon relationships, where the

patterns and habits of nature are contextually observed and related, there can be nothing found through scientific research that would negatively affect Pagan religious or spiritual beliefs. For nature is not seen as dependent upon miracles provided by a transcendent or supernatural deity, whose existence may be thrown into doubt if nature itself were found to have all the necessary capabilities to create and sustain itself; there is nothing beyond nature, all that is creative and sacred being inherent to nature. It is only the 'knowledge' presented by science as a result of dissection and separation that tends to contradict the Pagan perspective, for its paradigms differ so utterly from those of Paganism. Where such science declares objective truths, the Pagan sees the scientist asserting mere beliefs based upon assumption and observation. If the purpose of studying nature is to seek sustainability through good relationship, the scientist's dissecting approach is clearly immediately flawed.

The Romantics expressed this in countless ways, through words, music and colour: beseeching their society to cast off the cold grip of science, not to return to an age dominated by monotheistic religious power but to open themselves to the natural world, surrendering to its authority, its passion and beauty, in awe.

Of course, if one accepts the power of nature to be as brutal as it is beautiful, such surrender is dangerous. To the reckless artist, poet or painter, to the philosopher for whom the finding of words to describe the experience of being is more important than life, such risks are worth pausing for if only briefly to consider and pass by, for they too are fascinating moments on the journey of experience. The Pagan seeking balance in his life, seeking peace and functionality, must walk the road with far more care, learning how to engage with the powers of nature without allowing them to overwhelm.

For the thinking Pagan is far from sentimental. He is passionate about nature, but his aim is to craft an effective and sustainable way of living. The gods are forces immediately around and within us that are beyond our control. A Pagan honours his gods because if he grows complacent those gods can create havoc in his life. If we don't keep on top of the weeds in the kitchen garden, our onions and lettuces will be smothered by dandelion, cranesbill and cleavers, all of which are expressions of the surging creativity of the green gods; we have made prayers to those same gods through the winter's digging and spring sowing, and now we must face them and negotiate, head on. Of course, unless one is dependent on the vegetable plot for food, it may not be serious to lose the ground. However, if we are talking about the gods of a river that at times gloriously fills its flood plain, of the sun on a

searingly hot summer's day, of the frost that comes killing on a winter's night, or - for the true polytheist - the gods who protect the home, such neglect may be devastating, not because the gods demand attention, but because a lack of wakefulness to such powerful currents within nature can lead us to make fatal mistakes.

It is not difficult to see how we might honour nonhuman nature. Green and environmental ethics, with their roots stretching back to Virgil's *Eclogues* and before, so passionate and tender with the Romantics' sensitivity in the surge of nineteenth century urbanization, instruct us as to how we might be less destructive of the planet in order that our species have a chance of surviving into the next century. The steps needed are not easy, even if all we are contributing as individuals are the adjustment of little habits in our lifestyle. Deep ecology takes the ethics significantly further, talking of nonhuman nature's inherent value, encouraging us to compromise a good deal more extensively, adjusting our behaviour to levels of care beyond that which is at base motivated by our desire for human survival.

In practice, Pagan ethics come in both light and deep greens, the increasing number of animists tending towards the darker hues. And no one denies that deep green ecology is a radical stance. To prioritise the needs of nonhumans over human needs, or even

human greed (often termed as growth and progress), is seen as *un*natural. If deep ecological values are to be enacted, massive change is required, and quickly, and while there is still complacency, old habits and lack of immediate crisis allowing the status quo, such changes won't happen. Deep ecologists are dismissed as idealistic: human populations cannot be ignored, particularly where democratic governments are in place, and powerfully wealthy corporations will do as they wish. Being passionate about nonhuman nature to the point of idealism is seen as fundamentalist, and so beyond practical application it is effectively no more than irrationally-fueled sentimentalism. The Romantic, the Pagan, the deep ecologist, is seen to have lost his ability to reason, overwhelmed by his own personal experience of being within the natural world. His subjectivity is broadly unhelpful; he should limit his expression of these experiences to artistic endeavours that can be admired yet have no long term influence on human thought. He is mistaking the idea of an ecosystem with one that must be shared, and generally (and increasingly) human beings do not want to share their home.

As the environmental crisis grows, a tiny proportion of our vast human population does strive to live within a better ethical framework. They make conscious decisions to consume less, coming to understand which

industries are the most brutal in terms of social ethics and most detrimental to the environment – products from oil, chemicals, nonhuman animals, cotton, palm and so on. However, their attempts are perpetually sabotaged. Governments encourage unlimited consumerism in order to keep market confidence buoyant regardless of sustainability, their focus and priorities making it clear that they believe the economic downturn to be more critical a crisis than our influence on global warming, the problems of pollution, overpopulation, deforestation and desertification of land and seas. The most powerful authorities in the world are multi-national corporations, run by massively wealthy individuals, utterly dependent on human greed; in order to sustain their level of power, their entire focus is to provoke and support desire for unnecessary consumption. Furthermore, there are countless millions scrabbling to survive on the barest living, unable to think beyond the satisfaction of very immediate needs, regardless of the impact they are having on the environment around them.

It can be hard to accept just how selfish human beings naturally are. The instinct to help, to co-operate, to share, often based upon empathies even where there are no obvious immediate mutual benefits, is within us and is evolutionarily important to us, there is no doubt. But we are also intensely selfish.

Human nature is as brutal and beautiful as nonhuman nature: we are, after all, no less made by nature and of the same basic stuff.

Understood *ecologically*, as the wholeness of home, nature then is not only that which exists beyond humanity. The Romantics were seldom dismissive of all that was human in favour of a nature untouched; many of them also called for a recognition of nature within us. Talking of our natural passion and purity, they urged their society to recognize how nature breathes within us, delivering us into the world with an untarnished receptivity that must be acknowledged and nurtured. Nature *includes* human nature. The Pagan's gods shriek with rage as much as with thunder, with stubbornness as much as through the mountain or ocean. The creative forces of fertility are within as well as around us; there is death and decay in every atom and cell; there is justice, and the very fine line upon which life finds its path of viability.

How then can we honour *human* nature? As said above, for the Pagan nature is sacred, and our task is to learn how to live sustainably within the fabric of relationships that make up our home. Just as it can be self-negating, even suicidal, to submit to a force of nonhuman nature, such as thunder or ocean, it can be equally stupid to submit to the forces of anger, fear or lust within us. If we don't understand the ecology of where we are hoping to grow our food, unless we are blessed

with pure luck when it comes to soil, weather, seed and predation (among other factors), we are doomed to fail; if we don't understand our own floods and tides of emotion, our motivations and moods, our drives and desires, our strengths and skills, our hungers and evasions, we are similarly more than likely to fail. We honour our nature by learning its nature.

As animists, pantheists or polytheists, Pagans will use differing words to describe these forces of human nature. To some they are natural gods, no less than thunder, with local or personal names, or they are aspects of the wholeness of nature as god; to others they are forces under the control of a god known from ancient times, from mythology or inscriptions, through folklore or family tales. Alternatively, gods amongst those whom they revere may hold specific wisdom and skills in dealing with such currents as they pour through the human soul, pushing and pulling our drives and emotions. Either way, it is a part of the learning journey of the Pagan, as he develops a growing depth of understanding within his religious tradition, to spend time with these gods and spirits, listening, meditating, pushing the bounds of his comprehension.

This practice includes a good deal of self reflection, and guides us to improve how we engage with others in our families and communities. However, it is not only those living with and around us now that influence us, but also those who have lived before. Time is not linear to the Pagan, it is circular. Just as we cannot declare knowledge of any objective truth about the world, for all we know is through the filters of our perception, so is time a part of that subjective perception. The past and future are part of the living, breathing, changing landscape, the timescape, within which we stand.

Having lived, our ancestors are part of nature's soul or consciousness. They remain within and around us, fuelling our drives and desires, providing strength and instinctive wit, tripping us up with patterns where nature is prone to habit and repetition, waking us that we might recognize new constellations and choose new paths to stride, new currents to ride. Consequently, naturally, a significant part of many Pagans' daily religious practice is the honouring of ancestors: meditating, listening, exploring the stories within our shared consciousness, it is another way in which we learn about *human* nature. Ecologically, our ancestors are integral to what makes home.

Again, there is no sentimentality here. Amongst our blood kin, amongst the kin of our people, amongst those who have lived upon the landscapes of home before us, there were thugs and abusers, as many as there were victims and those abused, there were heroes and those whose lives were insignificant. As the anarchist philosopher of science, Paul

Feyerabend, wrote: 'The most stupid student and the most cunning peasant; the much honoured public servant and his long-suffering wife; academics and dog catchers, murderers and saints - they all have a right to say: look here, I, too, am human …' By accepting the presence of all them, listening to the stories of each and every ancestors that flow in our blood and whisper in the wind, we are better able to hear the wealth of wisdom and creativity that allows *Homo sapiens* to be so adaptive, and survive.

Within any ecosystem, we have a *sense* of that place. In other words, we allow the sensations - the blending of countless immediate experiences of relationship - to move through us. The majority touch us in the darkness of our subconscious, a small proportion being felt and considered within our conscious awareness. All those sensations affect us, influencing how we perceive the world, and what we believe our choices to be. Our ancestors, as part of a place, are a enormous part of what we sense.

It is not then just his own nature that the Pagan explores, but that of his ancestry, the history of his people, his community, his nation, and that of the places which are important to his life and work.

Walking through a cemetery, an old cathedral with its many tombs, through the meadows of a Civil War battleground, we may feel the hush of the dead; we may offer prayers, as countless have done before us, that their souls be at rest. In such places we may expect to feel their presence, their stories filling us, thickening our breath, teaching us if we are willing to listen. Yet in a pub, a hospital, in a playground, in the places that we feel intimately as home, the ancestors are no less present.

In Pagan ceremonies, as in those of other traditions, the expression 'May they be remembered!' is often declared. It isn't warning us that the dead require our attention. Like the gods, however, they must be respected. For in forgetting what we are doing is failing to be wakeful to our nature, to nature, and as such we are likely to stumble into error. The Christian term, 'sin', literally means to miss the mark: if we forget to honour the dead, we lose our aim.

Although needless to say there is a wealth of inspiration and information in books, photographs, old documents, this is not what we mean by remembering the dead. Nor is it about laying a wreath at a war memorial once a year, or visiting a grave on a Sunday. The ancestors are with us. As nature, human nature, they have been integral to the creative process that has formed, shaped and honed, damaged and improved, clarified and muddied, the world within which we live. The act of remembering then, honouring their memory, is more poignantly the willingness to experience their ongoing presence.

In doing so, we are able to sense a deeper, visceral and timeless connection to a place, sharing it as we do with those who have lived before. We breathe the breath our ancestors have breathed. We find what makes us who we are, guiding us in our ongoing self-creation and self-identity, so that with confidence we can begin to let go that individuated 'self', releasing our being to merge with broader beings with whom we share home. We can become a part of the meadow, our soul dancing with the butterflies and bees amidst the oxeye daisies and buttercups, the knapweed and scabious, the foxtails, fescues and wild oat moving like waves in the breeze: such exquisite freedom, and not just for a few delicious moments as a meditation or daydream, but as an ongoing experience that remains with us, lifting us and reminding us of our connectedness within that shared *oikos* of an ecosystem, with all those who now breathe and those who have breathed before.

You will note that my image is of beautiful rural England. I have made choices and compromises through my adult life to ensure that I am able to live in a quiet part of the country. My childhood, however, was one of extremes, spent in various places around the world, with periods when the week was lived in the polluted chaos of the big city, breathing its squalor, noise and poverty, the weekends finding us in the mountains, desert or forest, at times in genuine untouched wilderness.

My first religious experiences came to me both in wild places and in very human places, but perhaps the most poignant were where the two were intimately blended, at least in my perception. An example that I would share here is that of lying on a warm stone in rural Spanish sunshine, alone, my eyes closed, my soul infused with the scents of cistus and thyme, listening to the sound of the goat bells above the tumbling rush of the river beside me, and I *knew* – with that subjective certainty which so thoroughly imbues such moments – that time did not exist: everything around me was the wholeness of all that had ever happened in that ancient valley. It was not crowded with humanity, but human culture was fully involved, scratching its living in the dusty hills, quietly but so very deeply rooted, and perpetually narrated by the stories and songs of those people, generation after generation. Eight years old, for me it was an experience of feeling completely held, in peace and security – home – to the extent that I recognize my spiritual journey to have been in some measure a seeking to recreate that exceptional feeling.

When first I started training seriously in Druidry, I sought out places of human solitude, deep in the woods or on the moors, lost in fields of growing wheat and barley, exploring the life of the meadow in rain and

sunshine, immersed in the music of a brook hidden away. I needed human silence in order to hear the songs of my own soul, particularly having spent my adolescent years saturated by the noise of city life. I had crafted an identity of myself as an urban creature, yet not only was it blurred with familiarity, it was hard to find my edges so thoroughly was I enmeshed in that thickly populated world. Away from everyone, I learned who I was, alone - and that is so crucial a part of the spiritual adventure.

For many years I found it hard to go back to the city. Yet, an important tenet of the Pagan teachings I was given was the obligation we had to live life to the full, breaking through obstacles to choice and freedom – albeit acknowledging how our actions affect others. I knew I had to find a way of being in the noise of the city without my sensitivity overwhelming me.

By blood, I am a Londoner. Every member of my family for four generations has been a Londoner, and the majority before that going back to the turn of the nineteenth century. My great great great grandparents were living in the slums of London's East End at the same time as William Blake, and as I read *Songs of Experience* I can smell the streets they all breathed, I can hear the clamour of narrow lanes, frustrated lives, and I can feel their determination. Blake's Romanticism seethes in the words of his poetry, his rage

and sensitivity shimmering through his vision, and yet no less evident is his absolute devotion to that place which was his home.

Walking the London streets now, I listen for my great great great grandparents, and all those of my blood who knew nothing but the increasing noise as the city grew, burgeoning, thriving year after year. I feel their footsteps beneath my own, guiding me to find their old worn paths, to find special places by the river, special places now so changed yet still somehow serene. I feel their voices in the air, amidst the cacophony of humanity, their chatter and calls like silken threads of sound casting webs of connection, strengthening the bonds of community, of home. And I feel the warm ease of certainty that comes with complete belonging, when we are rooted so deeply in the earth that any difference in the surface layers appears as no more than seasonal change. Through my ancestors, their presence within and around me, I have learned to recognize the flows of its ecology again, and it is home.

I no longer seek out every green space, reaching out to touch the trees as I pass, scanning the old walls for wild buddleia and ivy creeping through, as if desperate for a precious reminder that humanity is not all-powerful, always in need of that gift of green breath. Instead I watch the traffic as if moves through the old streets like autumn leaves upon a lazy river, flowing briefly along, then

caught in eddies, twisting and turning on the currents as they hurry slowly by. I feel myself in the hum of busyness, of lives lived at a pace so different from my own, then recall the sedate pace of my great (plus) grandfathers and grandmothers, standing their ground amidst the crowd, laughing as if they had all the time in the world, beautiful with the dignity that is born of confidence, of knowing home. I hear the noise all about me as a symphony of human songs, accumulated over generations, filled with tragedy and joy, and let my ancestors teach me how to dance its rhythms with ease.

I would not now choose to live in a city. But I miss the immediacy of my ancestors' presence when I am not there in the heart of London. Of course, many of my kin had migrated to London in the previous century, giving up hope of earning a living in the changing shape of rural Georgian England, coming from counties on every side of the great city. Now and then I find myself in a village where those of my blood once lived, and possibly other direct descendants of that line still do, and I feel the threads of connection pulled within me. I meander through the churchyards, looking at the names, gazing at the pubs and other buildings old enough to have been standing more than two hundred years ago, and I breathe deeply the breath that my ancestors breathed. There is often a gentle tug of recognition, of

acceptance, and the web of my family is given a little more substance. Yet it takes no hard work, no challenge, to be comfortable in yet another gentle rural setting. I have sat and wept with John Clare enough to know well the despair that sent that Romantic poet to Northampton County General lunatic asylum - and my great great great great grandfathers to London in search of work.

So is Paganism anti-urban? There is despair at the rapaciousness of human capitalism and consumerism. Yet, while it is easier to identify the destructive effects of human life in the concentration of a city, we should not confuse that with a hatred of urbanism per se. The Romantics too found horror in the changing face of the countryside, as land was taken into private ownership, the people's relationship with it torn apart, as mines, quarries and mills turned the green to grey.

There is certainly an identifiable divide between rural and urban Paganism in many ways: ritual and devotional groups from the city and the countryside tend not to mix, the practices being quite distinct. Some urban Pagans will do all they can to get out of the city for ritual, retreat and teaching, while others stay within it, feeling more at home within its environment. Urban Paganism tends to be more human-centred; human nature, after all, is the loudest perceptible song in the city, and to focus upon it can make more sense than

always looking for ways of shutting it out or evading it.

For myself, as well as ritual in the calm of my rural home, I need rites at times in the chaos and beauty of thickly human environments, to remind and challenge myself about the gods whose presence is so powerful and influential within our species, but whose song can be so quiet here in sparsely populated landscapes. I howl on the motorway bridge watching the cars shrieking by below, red running away and white speeding towards me; I meditate at the war memorial in a city centre, feeling the tides of emotion as they surge and recede in the humming of a midday crowd; I sit on the kerb at the petrol station and listen to the songs of the oil-fed economy, softly singing to the father gods of our people beneath my breath, wondering at the shape of our lives to come.

Romanticism is still intensely strong within Paganism, and like myself many are profoundly proud of that root. It is, after all, a celebration of the strength of individual experience, and a recognition that subjectivity is not only valid but that it is irrational to declare that any perception could be otherwise. Indeed, to dismiss a view because it is subjective is to reveal one's criteria as flawed: to use the scientific assumption of separation, which perceives each individual as distinct, separable, isolatable. To the Romantic, with his colours wildly blending, his notes exploding with passion, his poetic images shattering the mind's thinking comprehension into the *experience* of imagination, there is and can be no separation. To the Pagan, perceiving the world as an intricately woven fabric of relationships, every creature held within its community of being, its natural ecosystem, its context of *home*, there is and can be no separation.

To judge such subjectivity as sentimental is to misconstrue the fundamentals of ecology, misunderstanding the importance within nature of connection, and to dismiss what it is to feel nature as home. Many are drawn to Paganism specifically because they feel isolated, unable to relate to the consumer culture or religious conventions that surround them and, adrift, they feel alone. What they discover is a spiritual tradition which teaches that we are never alone: life is not possible in isolation. As we learn about ourselves and our nature, and the filters through which we perceive the world become clearer, we learn too a little more of what it is that we do perceive. So do we find how to interact, honourably, ensuring that our relationships within this place we live are sustainable. We come to know home.

Because we have no imagination…

Susan Cross

The archaeologist is talking, pointing at the four panels that interrupt my view of Knowth and this landscape of 'passageway tombs'. "Passageway tombs," he says, "were created by 'passageway tomb-builders' – we call them that because we have no imagination". We laugh, hollow and echoing.

I look beyond the introductory speech, behind the barricade of panels. An Irish hare leaps onto one of the cairns. No one else sees. It is easy to be invisible, it only requires people's attention to be directed elsewhere. My attention, however, rests with the sitting hare. At this moment, misled by the shorter ears, I am thinking 'rabbit'. I watch, wondering how many generations of rabbits have grazed this turf and whether, when they burrow, they kick aside human bones and molars. Then it unlooses long limbs, and lopes easily down the cairn slope, becomes a hare. It gains speed, runs over another cairn and threads a line away through the field towards the River Boyne. I watch the hare run, follow the thread in land and time, until it is out of sight. I sense other long ago watchers, seeing the hunt and the magic of the animal and am nearer to a deep that may be past.

He is still talking. He is trying to connect us, to tie us in to this ancestral place. Sand martins sweep around the curved mound, their tunnels surround the western entrance and small faces look out. They are more comfortable than we with their ancestors in this mound. They have a continuing blood-line to the ones who first built into the hill, who created this place of pilgrimage, of rebirth. They return year and year, on small graceful wings and know just what they are doing here. Their rhythms of flight and return are unbroken in time and in space, like an easy heartbeat.

We have moved on, to look more closely at the rock art, and are now too close to their nests. They are anxious. Don't fret, I tell them, we'll be gone soon. Yes, they say, we know, you have rhythms; smaller, weaker and tenser than ours. You'll be gone soon.

We are so near to gone already. I reach for the people we are here for. Not, in my case, the earnest young archaeologist, his clear passion masked by everything he has to tell us of excavations and reconstructions. I reach behind him to the people who left these markers on the land. Is there anyone here? Can I hear you? Or has the connection gone?

I remember back ten years to the Cheviot Hills, another landscape and other archaeologist. The fierce wind cutting in bright from North Sea where, he said the invaders came. Where the ancestors came. We talked of the Iron Age hillforts, and a people who may have practised transhumance, bringing their flocks and herds into the high hills for summer pasture. He was so clear about how little we know. As we left the crest of the ridge we came to that cist, like a small stone chest and he told us, slowly and graphically, about the skull they had excavated and examined. She was about six years old and had died of cerebral meningitis. As we walked away the wind grew fingers, slip-twisting into mine. I heard her words as clearly as I have ever heard any. Will you be my mummy? I would like a mummy. She held my hand all the way down the hillside. I knew she could go no further, when her fingers slipped out of mine and she sighed. Maybe I am not lacking in imagination.

There is no one like that here. We are not unquiet, they say, this is a place of balance.

We have little in common, then.

He is still talking, of chronology and stratigraphy. Our group of visitors has gone underground. We walk into a chamber that has been created 'to give us a sense of being underground'. I touch a rock for reassurance. It is plastic. There is no revelation here. We are all too quick, too timetabled, too noisy, too talkative, too much of everything. Suddenly, I have had enough, and, not being in the business of shouting at guides who are doing their job well enough, slide away. I leave the chamber and its backlit panels with diagrams of cross sections and his detailed explanations. Back at the entrance I stare through a heavy grill, down the long stone corridor to the heart of the cairn. The past is caged, I say. We are here, they reply, and always have been/will be. I put my hand through the bars to touch the floor. I smack my knuckle on real rock drawing real blood.

"Two artefacts" he is saying, and suddenly he is telling a tale from the heart of the dark, the deep of the earth. Now listen, they say. He is showing photographs and panels but behind it all, the story beats. I loiter outside. I begin to hear; the words in the air, in the rock, and in me, blend. At last, I relax into them.

The beginning

was a great granite bowl

stonewomb

for ancestors' ashes

A treasure

in the/ from the /of the

landheart

pulse of our being

 Around we built

a chamber, a swelling

earthbelly

to grow our tribe

We cannot say

who entered these narrow

rockveins

or what they did

This is our core

Where our life falls free

soilblood

holds us here still

At the point of connection, where understanding comes, words and thought seems to fail; as if they were always, ultimately, in opposition. But for an instant or maybe 5,000 years, I caught it.

The archaeologist is still talking. Now, I can hear him. He is showing us carved flint and I, because I know flint well, am amazed. I tune into him for a while and gather the information he can give.

We go back, too soon, too fast to the bus. I thank our guide. The visit is over. The next bus is unloading and we have to get on board. I long to walk, lie, dream, dance, chant around the rounded mounds; to see sunset, mist rise, rain fall. To feel the grass grow between my fingers, watch flowers seed and drop, hear wind, gulls, eagles, the return of the hare, the departure of the martins, the advent of winter geese. I want to see all seasons of this place, but my allotted time is over and we obediently process to our seats.

My lasting memories will be of the hare behind the panels, the echoes behind the grill and the beat behind the words. Maybe the value of any legacy is what lies behind it. In truth, I do not know whether anyone else in my busload of visitors sensed any or all of them. Certainly none of us said anything, and we walked this ancient site without overt reverence, because we are who we are and we have our conventions that tie us tight as ritual. So we walk quietly and obediently behind our leader keeping any spiritual experience small and private lest it cause offence or embarrassment. Maybe it is not that different from formal religion.

I look around the bus at the people who had chosen to spend time at this ancient place. I wonder what they had come here for; I presume to gain some insight into the past, what this landscape meant to the people who lived here way back, and what meaning this landscape and the lives lived here has now. Maybe they found what they were looking for. I hoped so.

We can only pass on what we have. In an age preoccupied with information and the material, we have investigated, interrogated, reconstructed, preserved and displayed these sites. We are not so strong or clear, these days, on spiritual meaning - and that shows. We find what we look for, we cast out what we do not understand. It was ever thus. When the past speaks to the present, or spirit speaks to flesh, the message received often reveals more about the receiver than the sender. I see us all on the bus travelling the green narrow lanes of the Boyne Valley, poised between past and future, our minds fired with words and pictures from the far past. I wonder what we will pass on.

KNOWTH ROCK ART, PHOTO PETER PHILLIPSON

The crossroads of perception

Shani Oates

> "Every Microcosm, every inhabited region, has a Centre; that is to say, a place that is sacred above all."

Mircea Eliade

If we were to speak of the centre of the world in metaphysical terms, this may be expressed as 'everywhere and nowhere.' Though often couched enigmatically, the greatest mysteries are nonetheless almost always 'hidden in plain sight' indicating the essential and requisite shift in our general perspective; that is to say from the profane to the sacred. To further demonstrate this vital and frequently overlooked key to our engagement with the quality we deem 'sacred,' we must examine what usage we articulate by intent.

While many of us may consider how our prehistoric ancestors viewed the numinous realms, beyond conjecture, we remain uncertain. In contra-distinction to this, the later classical world has gifted us a rich legacy of philosophy and experience in that regard. To them it seems, the word 'sacred,' rooted in the Latin *'sacrum'* referred to the gods and all things associated with them, be they animal, mineral or vegetable. Architecture in particular, if dedicated to the gods was described as a *'sanctum'* – meaning that which is not profane, set apart,' including a personage of 'awesome' (in the correct sense of the word) distinction, in whom the *numina* of deity resonates.

All derivatives of *'sacer'* imply a designated space denoted by a boundary surrounding a holy core, foci/altar. The priest in attendance here becomes the one imbued with that essence - *'sacer,'* enabled to fulfill his sacerdotal duties (hence sanctity and sanctuary).[1] As a heightened *meta* state it finds

variant expression within other mystical traditions and praxes ranging from *mana* to *haminja*. Of course the generality here may be explained by cynics as the wish-fulfillment induced under impressionable circumstances. Implying that wherever we might sense something other, even if entirely subjective, we will attempt to clothe it with the 'supraenatural.'

The outcome of this occulturization is either fear through discomfort or elation through the sense of transport and acceptance. We therefore invest our experiences with the expectations of our cultural and spiritual desires. Numerous attempts have been made by theologists and anthropologists to validate this genre of experience in terms of a *'hierophany,'* the transpersonal *epiphany*. This involution of spirit manifests itself within whatever is required of it, be that animal, vegetable or mineral, translating the metaphysical self or 'other.'[2]

It is noteworthy that several now common words (such as health and whole) derive from the 11th Century Old English word *'halig'* a derivative of *'hal'* describing the finest of conditions or states, as in health, joy and thought. Holiness simply extends this to infer a state of perfection[3]. The Greek cognate term *'Hieros,'* indicates all things 'of' the logos in terms of its virtue as emanations from it, or imbuement through it[4]

In ancient Greece, a sense of 'place' was expressed as either: a *topos*, meaning objective topography as in a physical or mundane location; or a *chora*, meaning a metaphysical, mnemonic, holistic dimension of mythopoetic sacred symbolism. Yet neither term should be understood as inferring a distinct polarization, as each effectively partakes of the other. Furthermore, the 'Power of Place' is not passive and is certainly instrumental in generating the somnambulistic waking dream where we may fuse our focus to cross the threshold in a lucid state of 'gloaming.'[5]

Memories are stored as latent images within landscape features awaiting the 'song' that will animate their collective treasuries into being. Singing, unlike speech, is a right-brain activity, vitalizing cognitive anamnesis and creative inspiration that allows the chorister to weave both realities into an organic flow that becomes always relevant to the moment. Sustained as a living myth, such an accessible 'Dreamtime' preserves a cosmological landscape peopled by ancestral spirits, a consciousness outside linear time and space, maintained from one generation to the next. Topographical features fuse with song and dance in celebration of their perennial at-one-ness with the Earth - the Great Mother as the absolute and inseparable Creatrix.

Using similar sentiments, tribal boundary features imbue landscapes with a sense of the 'sacred.' Secured and hallowed, they offer

security and continuity for those peoples, wherein they and the landscape synthesise as one sentience. Rupture from such a connection may even induce severe psychological trauma. Historical Celtic language peoples or tribal confederates invested their mythical worldview with such tribal boundaries, generated by sung or chanted narratives that bound the land and the people as one. Again, it is the right-hand brain mnemonics that infuse the landscape with trace patterns not discernable with the rationalist left-brain, trained instead to read, analyse and judge.

Our Earth exudes endless streams of data that bypass our conscious mono-phasic state: the 'reservoir' of Jung's collective unconscious (modern critics of Jung's term consider his archetypes not to be truly 'universal' but typically ethno-centrist). Sensitive or empathic people may retrieve this information, recognising projected symbols, but they will be unavoidably interpreted through their respective cultural filters, according to their learned perceptions.

Many ancient long barrows and mounds erected over blind springs are easily detected by man and beast alike. Temples, edifices, monoliths and phallic pillars mark these and other points of contact between earth and the heavens pertinent not only to the intrinsic power of place but also to some now forgotten astronomical wisdom. So in its

narrowest and most literal definition, geomancy translates as 'divination of the Earth.' In practise, this meaning is expanded to represent the perception of either the subtle or spiritual nature native to the physical environment, or the science of placing man in harmony with the character of his environment, both visible and invisible.

Temples and groves were and are chosen for their suggestibility within natural landscape features. Studies have revealed three recurrent elements of natural design that suggest sacred locations are far from random. These are: the enclosed valley (cleft), the mound (belly) and the twin mountains (breasts/paps). Seen from the correct perspective, in many examples, these features imply the prostate body of 'Mother' Earth. It must be noted that some 4,000 years later, the sense of sacredness at these locations has determined a certain continuity of the spiritual psyche such that modern Pagans, Druids, Wiccan, and some Traditional Craft groups may choose to use any one or more of the three sites, singularly or collectively for their reconstructed rites and celebrations.

Geomancy dictates that elements within the construction and design of buildings, including gardens, are in accord with the harmonious flow of 'chi,' often reflecting the natural topography that surrounds them. This aspect is crucial to understanding the mechanism for access to that perfect place,

the intersection and conjunction where our awareness of matter and spirit fuse as one. Go against that flow, create friction or simply fail to sense the 'nux' of it and the moment passes in a meta-second. Grasping it cocoons us in the arms of eternity. Sensitive or empathic people will readily tune in to the *genii loci* that will work with or against them dependent upon approach and intent. Though it now refers to a location's distinctive atmosphere, to our ancestors this spirit of place was deeded a sacred guardian spirit and in some cases even a tutelary deity.

A multi-verse of diverse energies or potentialities, not all of which are perceived by our material senses are currently under exploration by scientists and mystics, pushing the boundaries of our understanding regarding the enormity of an 'ensouled' Earth. Gaia is now widely accepted as a sentient, self-regulating organism that responds to electro-magnetic radiation received from the sun and other cosmic rays; from beyond these, the ionosphere acts as an electro-dynamic generator, dominating all above ground frequencies. Human beings will invariably choose to align themselves in accord with the north/south axis of natural magnetic force circumnavigating the Earth. Brain cells also produce a similar electromagnetic field around the brain due to the microscopic amounts of magnetite within them. More interesting still, is the brain's own natural magnet - the ethymoid bone, close to the pineal and pituitary glands that are commonly associated with transcendental experiences and psychic activity.

Investigations have revealed that electro-magnetic fields overtly affect the temporal lobe and pineal gland, generating a sense of 'elation' often resulting in spiritual 'experiences.' Responsible for dreaming and memory, the temporal lobe is acutely sensitive to electro-magnetic stimuli. Research has confirmed how our perceptions of time and space are altered when this lobe is artificially stimulated to resonate around 8-10 Hz. This generates heightened visionary states in which people have expressed a sense of the presence of 'god'. Yet the brain does not distinguish nor discriminate between natural and artificial stimuli; it simply reacts, believing it is in the presence of its creator, its consciousness merged with ultimate sentience.

Folklore supports many eerie, otherworld experiences where geophysical phenomena typically generate flux as the body resonates with its environs. It is known that meditation, chanting and other repetitive or relaxing practices can also reduce the mono-phasic 'beta' state (left-hand brain) to the 'alpha' state (right-hand brain), aligning our own vibratory brain patterning to match that of the Earth - 7-10 Hz, inducing a feeling of transcendence or at-one-ness.

Of course our brains have evolved as mutual symbionts of the Earth, pulsing unconsciously, resonating sympathetically with the flux forces of the Earth adjunct to spiritual emissions known by all its variants as mentioned previously, all of which embody a sense of 'being', a consciousness superseding the rather vague translation of them as 'energy.' Such elementals may be observed only by their effects: wind bending trees, or cresting waves; others such as radiation or microwaves require specialist equipment to detect them.

Sometimes the only proof we have of certain phenomena is our direct experience of them, leading to a belief in a thing's existence, which we then perceive to be true. In order to convince others of that truth we describe it in terms of metaphors, allowing them to share in our perceptions, though not the experience itself. The difference between our inner and outer realities is the difference between truth and belief.

This suggests that consciousness is a process rather than a product of mind, a state of being. More than an awareness, it is an understanding reached through experience, perceived wisdoms and subjective analysis. Subjectivity is crucial to our understanding of the complexity of consciousness, formulating the lens of perception that stands between us and what is objectively known to be. We create our own realities with every thought.

Consciousness merges illusion and reality, and for each of us this reality is very different. Perhaps then, our perceptions establish the reality of our inner and outer worlds, the power of place and the power of mind. Many suppose the inner realms may be explored to reveal the mysteries of existence and the origins of the universe itself. Certainly, freedom from the five operative senses of the outer world engenders an entirely contrary view to that of the subjective ego.

The body functions in time, but our consciousness may choose to leap through liminalities into eternity, from a reality to *the* Reality. Magic, religion, or science, it is all the same, ultimately. Nevertheless, as yet, no one has been able to satisfactorily define consciousness in absolute terms, nor prove its existence as separate. A fundamental premise of the Qabbalistic model of reality, for example, is that there is a pure, primal, and indefinable state of consciousness which manifests as an interaction between force and form.

Consciousness exudes the potentialities of force (energy) and form (manifestation); it is the primary substance of the universe according to mystical traditions and quantum physics in which communication between variant stages of consciousness occurs instantaneously irrespective of distance in time and space. It has been said that the *"physical world evolves in time; the psychological world rests in*

eternity" . This is profoundly true, especially when we recognize that it is time that has separated science from spirituality.

Units of time and space are measured by chemical and electrical data organised by the brain into pre-conceived constructs pertinent to the external senses of the physical body. This means it is pre-conditioned to interpret automatically what it feels, into what it thinks it sees. What is particularly interesting about this is how it reveals the brain's capacity to be programmed, to be fooled and, better, to be overruled by right brain activity and its ability for relative assessment. This is why in dream and trance the laws of standard physics do not apply - here there are no absolutes.

We must remember that our minds store data separately according to linear values of time. Each passing moment is stored as a memory, effectively in the past; the present remains our singular point of focus, whilst our hopes and expectations project our consciousness into the future. In reality, therefore, consciousness exists in all three time frames simultaneously.

Moreover, when we achieve a trance or dream state via any method known to us, shifting from mono-phasic to universal consciousness, we acquire three distinct sensory transformations. In this state shaman are able to produce a *choro*graphic map, of mood, character and memory to supplement the actual topography and geography of any given location synthesizing relative time with place, cognisizing a highly subjective reality.

Contemporary research opines a theory that three millennia ago, our nature and its responses were controlled by a bicameral brain, split with neither part self-aware, nor yet controlled by ego. Comprised of two parts, an executive part in the right hand brain known as the intuitive self, often perceived as the 'god' part, and the left hand analogue self, the part that acted automatically upon directives from the other side without the intervention of introspective thought. The command and action were not separated.

Then, sometime during the second millennium before the common era (BCE), material and linguistic obsessions distracted mankind long enough to erode his ability to 'hear' directly the voice of the 'gods'. By the first millennium (BCE), this preserve had become the domain of prophets, poets and oracles. Time and civilisation marched on until only the poet's lament recorded our loss for posterity. Consciousness then, formerly described as a process, was acquired during the final stages of our evolution. In the drive to know the 'self,' we disassociated ourselves from the greater consciousness; the individual sacrificed his internal connection to a nebulous Source. Intuition, instinct and right-hand brain patterning had developed the false ego, the self, the power of the individual, now disconnected from that Source.

A Jesuit palaeontologist has described the thinking layer of our existence as the 'noosphere', placing it alongside the lithosphere, the atmosphere and biosphere in terms of existence. Within this 'noosphere' of the earth each one of us is as a sub-atomic cell within our own brain, contributing to the whole, whilst remaining oblivious of it, at least consciously.

Individual consciousness simply flows from the greater sea of consciousness of the source, each vibratory strand terminating in the 'self'. In this sense we believe ourselves to be individuals, yet in reality we collectively form the Multi-Verse of Gaia, linked in symbiosis with all other living, forms of sentient force. She is the 'Noosphere', the Logos, the Spirit of Creation, the Universal Spirit of Consciousness - Psyche. Acceptance brings individuation.

Sacred sites therefore are those that evoke memory and inner vision, being most vitally and singularly intrinsic to our ability to experience that interconnection. Ofte, though not always, they have at some stage been used extensively for acts of prayer, devotion and ritual. When we engage the energies found at these interstitial places via the spectrum of trance induction, the observer, made up of billions of sub-atomic particles affects reciprocally the metaphysical integrity structure of not only the site, but all other observers present there.

This interaction generates a mystical experience within the '*noosphere*'[7] realm of consciousness; this trickles down into the ego, shifting its identity into one from archetypal myth. In this way we intuit gnosis from this theatre of the Mind, crucial to our evolution and well-being. Celestial nodes intersect geo-centric and andro-centric consciousness inducing spontaneous anamnesis. Hindus refer to this fording or '*crossing*' as '*tirthas*,' specifically, the leaping from reality to the '*Inter-world*' of spirit[8].

At such times we may enter the landscape of pre-history, accessing directly the world of tribal myth in poetry, dance, drama and ritual where the dominant modern intellectual concepts of linear time and space have no power over our apprehension of their Truths. Myth celebrates cyclical time, against which annual celebrations of recurrence, suspended in the dreamtime of the eternal present, preserve indelibly the relationship between man, his environment, and the Universe.

Against this symbiosis, the unconscious mind utilises specific symbols that alert the conscious mind of its origins and purpose within this eternal cycle of life and death. However, modern psychology may yet redeem the myth of the ancients, the hoary wisdom of the earth. By traversing the inner landscapes of the mind, we may come to understand the outer landscapes once again.

The cycle of transformation and renewal affects all nature and is the context of myth; its universal story is mankind's story. The movement of the heavens reflect those upon the earth. In effect a macrocosm of the microcosm. Geomancy's purpose then is to seek and preserve these sacred places that generate access to other worlds. Correct placement of a shrine, temple or baptistery is essential to ensure a beneficent fate or fortune, reflecting a harmonic accord with nature.

Increased ionization after rainfall infuses and generates primary sites with superior sensitization; where placed on or near water sources, a similar effect may be obtained. Fire also amplifies ion activity. Ambient energies in the form of natural radiation (radon), magnetism and ionization cumulatively affect neural patterning of the body-brain complex.

Light trance states are further enhanced by serotonin released through mild euphoria or joy. The living landscape becomes transformed into a map of the Universe. These are the liminal places of psychic mass in which we can explore relationships with ourselves as living breathing entities and with the inner, psychic self, linking in turn to the greater consciousness of being. Our minds appear to possess an inherent organizing principle that constructs our perceptions of the world according to data received through the senses. Nonetheless, we are capable of so much more than this egocentric view.

It has been proposed how the sacred science of geometry may represent the sacred myth of geomancy in the punning of Ge (Gaia/Earth) - O (gateway/pineal gland) - metry (measure in rhythm and vibration). We are nourished in life by the soil to which we shall return in death. Contemplation of our Earth through the medium of dreams and visions allows us living access to myths that reveal the mysteries of life and death exemplified best via the eternal union of male and female forces as both spiritual and manifest forms.

Windows to alternative realities open into a seemingly parallel universes, a state of being and knowing long understood and accepted by students of Zen wherein the idea is expressed that 'outside' and 'inside' remain indistinct from each other. All is one, all is nothing: the greater the view inwards, the greater the revelation of the exterior fabric of the universe. Neither is the power of place passive; it interacts with our consciousness in a dynamic way. Memories, locked away within the *genius loci*, are experienced via the appropriate mentally receptive state.

A sense of the numinous alerts the conscious mind to subtle manifestations of the eeriness of primal space. So it is immediately clear how ritual and ceremony held at these foci of energy flux would secure them as sacred places. Sonics, radiation and electro-magnetism all combine to accelerate

and amplify the physical activities of all celebrants once they have 'tuned' in. Through the power of place, the human and heavenly interact, harmonising a micro-macrocosm.

High levels of attunement at sacred sites often accompany equal fatigue, irrespective of actual physical activity, no doubt induced by exposure to concentrated amounts of natural energy fields. This is particularly relevant when we remember the healing properties noted in folklore of certain megaliths to cure bone deficient diseases and of the historical use of healing cells within incubation temples at noted locations of phenomenal activity. Rivers, waterfalls, caves and mountains as natural places of great power became emulated as simulacra within temple constructions known as '*abatons*' or nemetons for the purpose of '*psychomanteia*' - sacred dream incubations. Here, vision questors sought solace, prophesy or divination.

Littered across the archaic world are gates, symbolic of the '*crossing point*' between one reality and another. Guardians at these points denoted the engagement of Fate as a meaningful enterprise of choice. Such nodal reference points engender expansion of consciousness into transcendental states where we may once again experience divinity as directly as our bicameral ancestors once did. Temples and sacred shrines following these inherent harmonics of geomancy, when placed carefully within the landscape, serve to accent the numinous power of place denoting the expression of true deity within the topography of time and space.

Statues and icons placed within them represent those anthropomorphic deities as imagined by man. Whence removed, these icons retain the power to evoke memory in a way quite distinct from the 'power of place' to invoke anamnesis. The icon reminds us of the Temple, its place of origin; but only in that place of origin can we experience the full quota of history, within the 'otherness' of the space time continuum. Many believe these secrets have been encoded throughout the landscape in the distant past by priesthoods dedicated to the relationships between mathethatics, myth and magic, utilising the natural sciences of geometry and geomancy. From Druid priests, to Chaldean priests, and from Persian Magi to Indian Gymnosophists the sacred and tacit harmony of the world and our place within it was embraced unconditionally.

The divine proportions of sacred geometry as the 'measure of the earth,' inculcate the principles of quaternary, of stability and balance. From mandalas to holy cities, the four directions embrace cosmological harmony as celestial events are marked against the shift of relative time and space. But how many of us are in accord with these shifts? We are so disconnected from the source we are in danger of losing forever the

neural points of ingress so automatic to our bicameral ancestors.

In the Sibylline Oracles, the name Adam is expressed as a notaricon composed of the initials of the four directions; anatole (east), dusis (west), arktos (north), and mesembria (south), linking again the principles of sacred geometry with anamnesis of ancestral origins and with the human body compass. Cathedrals too are laid out following a soma-centric cosmology reflected in cruciform designs where man is the microcosm of the celestial macrocosm – vitruvian or 'perfect man.'

In the archaic Greek world, 'nature' represented a numinous principle of existence and power beyond the state of mundane creation; it was a sentient consciousness beyond form, in which each individual soul was perceived as part of the World Soul, the *anima mundi*. Communion at sacred sites is best prompted during the liminal periods of dawn and dusk, when the natural levels of solar radiation are at their most ambient, settling around 8-10 Hz - equivalent to the light alpha trance state. It is no coincidence that for many aeons these are the favoured times for prayer and worship, or for engaging Deity. Three elements will ensure success: a favourable underground force focussed within a sacred place or location; a favourable cosmic or celestial influence and an 'open' mind, free of ego-centrism.

To engage in this sacred dialogue, we have to re-enter paradise, the neural centre of the brain through the dreaming eye. Hypnogogic realms guide us into lucid dream worlds that challenge the warp and weft of accepted realities; in this gloaming we may perceive ourselves through a mirror darkly. Our 'outer world' physical or spatial boundaries reflect those of the 'inner world,' of the ego, whose existence depends upon separation from the Source. Boundaries assert liminalities, thresholds - the point of transition. Boundaries delineate both sacred and profane time, space and reality. To achieve non-spatial awareness we first need to develop the ability to plot the intersection of time and place in order to make qualitative rather than quantitative space.[9]

"Where then is the true boundary? In the thought, the Mind, the expression, or the action of intent? And is it anchored to place or being?"

Aldous Huxley ardently promoted the concept of unity within consciousness. For him there were no boundaries other than the brain itself, which he believed reduced the Mind into manageable portions. We receive data in the form of signals which we then convert into mass and form; we (the ego) make the separation, we make the distinction. From this explanation, it becomes clear why so many diverse peoples have over time,

considered their most holy places as the sacred centre of their universe.

Some of these most hallowed sites around the world are undeniably some of the most aesthetically inspiring: Mount Kailash, the Ganges river; the Dome of the Rock, Stonehenge, Newgrange, Mecca, Delphi and St Peter's, not to mention generic springs, waterfalls, moorland, wells, caves and temple remains.

All share the mind state of universal centrality, the axis around which numerous cosmologies revolve. From these points, the prayers of many millions of people have been given life, purpose and meaning. Towers and steeples rise upwards, ascending focus and attention to the heavenly hereafter. In Asia, minarets and stupas pierce the heavens, creating a divine intersection. Even temporary structures such as totem and may-poles offer this connection, at the conjunction of heaven and earth, where all elements combine, and where the twin involutionary and evolutionary spirits rise and fall. Hearths, altars and shrines all symbolize a position within, upon or around which the divine numinosity inhabits, transports or imbues itself. This geometric and geomantic centre corresponds to the heart, the fire altar of devotion and sacrifice, where the liminal shift occurs[10]. In fact, it has been justifiably claimed that:

"...the only logical direction perpendicular to three dimensional space is within"[11]

This cosmic union of celestial and terrestrial forces fructify within the yab-yum conjunction as we become aware of ourselves as the qutub or nodal, the point betwixt the ever spinning nowl star above and the Earth's core beneath our feet. Composed of quadrennial directivity aligned to the cardinal winds, we may project ourselves into the orientation of choice, because as mobile bi-polar units of energy, we dissect the intersection of land, air or sea at any given vector of spatial radii. All celestial features are drawn to the horizon, effectively rooting myth to place and time. As the omphalos of our own universe, the dome of heaven arcs above, centering us within its distant rim. As we move, the focus of those events aligned to each strand of our geomantic compass move with us, animating the landscape around us.

Static markers inhibit ingress and are contra to this synergistic process. Even so, sacredness does not emanate from the landscape alone; en-souling is the process of synthesis.

Imbued with the soul of its people who over time have lived and died upon it, it sings its song to those with ears to hear it. Each generation engages this organic symbiosis reaching into the dreaming states of the 'inter-world' - oneiric access to a parallel universe.

It is this all enveloping fabric that activates the necessary shift for many, facilitating the 'crossing' from the mundane into the sacred in terms of both conditions of mind and of space.

Trance states allow us to forcibly eject the lurker on the threshold (of consciousness) that otherwise bars our way; this primal interloper is the seasoned ego who serves to anchor us within one reality only. The resultant reverie induced by any combination of the various aforementioned trance-induction techniques, determines our approach to a given landscape and thus our expectation and experience of it. Using the visual features of a landscape to trigger anamnesis, holy men and women access this dreaming state or transpersonal reality quite easily; the rest of us have to work a little harder.

Ultimately we all mediate between the physical and the metaphysical realms where as the zero point hub our bodily sheaths resonate in tune with the event horizon - the liminal point of *'crossing,'* from one reality to another. The landscape invites poetic dialogue and the sensitive mind reciprocates. Perception shifts us from the outer to the 'inter-world,' where we clothe our impressions with a paradisial state, recreating Eden. This 'Pure Land,' the state of mystical awareness describes the intersection between the group soul of all humanity and the divine World Soul in the four square garden of the four-fold body, in the Sophianic Mysteries.

The yearning soul is readily seduced, embracing passively the construction of the inner temple or mystic rose. Nourished by numinous myth, the rose - the *'Xvarenah'* and central locus, unfurls. Through the unveiling of *'Haq'* (Truth) we will understand where the soul realizes itself as a product of God. Only the inner dreaming eye is witness to this absorption of Geosophy (wisdom of the Earth) experienced in the sublime mysteries of Sophia. Effulgent visions of the symbolic inner earth, of *'barzakh'* or cosmic centre, where no shadow is cast, are transmuted and transfigured by an act of alchemical mediation into the manifest plane of sensible form as light[12] . Perhaps then, to reclaim paradise, all we need to do is learn again how to see.

1 http://en.wikipedia.org/wiki/Sacred

2 http://witcombe.sbc.edu/sacredplaces/sacredness.html

3 http://en.wikipedia.org/wiki/Sacred

4 Paul Devereux *'Re-visioning The Earth'* (Simon and Schuster: NY, 1996) 82-87

6 http://www.iep.utm.edu/time/ source for Swedenberg

7 *"From the human perspective, the noosphere represents the attainment of the super-mind, a singular state of mind and consciousness where the individual and the personal have been totally subsumed into the workings of a higher mind - a superhuman mind. This is a mind and consciousness beyond what can be conceived of if we limit ourselves to descriptions and conceptualizations of*

consciousness that remain centred on individual self-realization" [http://www.lawoftime.org/noosphere/nooarticles/sriaurobindo.html]

8 Paul Devereux *'Symbolic Landscapes'* (Gothic Image: UK, 1992) p105

9 Paul Devereux, 1996, p95

10 Paul Devereux, 1996, p66

11 Paul Devereux, 1996, p70

12 Paul Devereux, 1996, p244

MUNLOCHY

Where are the wild places?
Devon, Faeries and me

Woody Fox

My name is Woody Fox and I'm an initiated witch and seer. My childhood magical education came mostly from faeries and the occasional ghost. As time went on, more beings of the spirit world helped me including, in adulthood, many deities and eventually the god Cernunnos, to whom I have been a devotee for the last 13 years. I work in a very shamanic way and my totem is Fox

I have been able to see and communicate with the faerie races since I was a child and am one of the lucky ones who have never lost that gift, and it is a gift that enriches my life and educates me in the ways of the world. It also has influenced my way of looking at the world and all of her beauties and has taught me the sense of honoring the land and all its peoples.

When I was six, I did my first eco warrior action; I was woken up in the middle of the night by some faeries I knew and told that my father was planning to destroy their home the next day. Sure enough, the next morning my dad, with his chainsaw in hand, found me sitting as high as I could in the tree. I began to see the importance of looking after your friends. This concept spread out further and further to encompass caring for all other spirits and forms of life.

This ability to hear what beings need, want and desire from any given action of mine makes life both easier and trickier. Easier because there seems to be nothing that is scared of telling you what it thinks and so you know the facts in no uncertain terms. and tricky because you can't pretend you haven't heard them. There is a real challenge in getting what you desire alongside the need of the environmental beings - but this is the joy of being aware of a diversity of spirits.

My love of the land, whether I call it the great goddess Danu, planet Earth, or some other local name of deity, is based on the principles of a diverse ecosystem, with its deity form at the top of the chain. This deity is incredibly important but so too are all the other chains of biological and spiritual life that lie beneath it.

We often hear of the need for biodiversity but I feel it goes even further than that. Biodiversity explains the 'living' and physical beings that we are all aware of. But everything is also balanced in spiritual energy. In my experience, spirits live everywhere, some fixed in place in rivers, ponds, woods, certain trees etc. Some are less fixed but stay in the general area, such as on a moor or a mountain. Others travel around doing their own thing anywhere and some are just so vast that they seem to exist everywhere.

The way it was explained to me as a young person was this: in, say, a wood the mineral, plant and animal kingdoms provide the energy for fixed abode faeries to live there, who provide more collective energy for forest spirits. These then collectively energise land spirits .., and so it goes on. This interconnected energy grows until the planet itself is fed from these humble energetic beginnings. The joy of this is that beings (human or otherwise) who enter into that perfectly balanced wood connect with and be vitalized by the power of that place.

We all know the sense of wonder and uplifting energy when we walk in an ancient untouched forest. We call it a "magical place" and indeed it is. You often feel like you're being watched (as indeed you are!) and here is where I think most people have their best chance of seeing or sensing the 'fair folk'.

When I lived in London in the East End, it was pretty rare to meet the folk, but when I did it was often in a park - although occasionally there were some of the more radical ones that you could see standing in the dark corners of clubs and bars. Some seemed happy, others hard and down. The natural harmony of all beings was disrupted by the concrete and brick, pollution and general humanness of it all. The city spirits however were huge (the spirit of a tower block for example) and full of themselves in a quiet way so the faerie model of spirit-diversity works there too, with the humans taking the place of the faerie. We are a nation of gardeners it seems and our love for growing things – in gardens, allotments and even window-boxes adds and feeds to the spirit world around us. But, for me, it was harder and harder to exist there.

Thankfully, I moved to Devon, to a little thatched cottage in the middle of organic farmland, with no immediate human neighbours but plenty of faerie and 'wild spirits'.

When I go walking down the lanes here in Devon I hear the beautiful birdsong, the sheep and cows and then also the chuckles and shouts and conversations from the folk around me. This sounds great eh? Well of course it is, but unfortunately as soon as any of the folk or other spirits know there's a seer around it's like a complaints department has opened shop. Very often they are furious at what we humans have done to our shared world.

It became very difficult when I wanted to dig up some of the garden to grow my veg and the grass beings were saying leave us alone, the hedges were not wanting to be trimmed and cutting down a tree became akin to being a mass murderer. But the faerie way is all about negotiating, bargaining, borrowing and being responsible for your actions as far reaching as they may be. So my first act was to negotiate how much of the large garden was for them and how much for me - I got two thirds!

This respect for other beings' rights isn't just about digging my garden or cutting down a tree, it goes as far as going for walks and especially doing magic or having a ritual. When I was in a coven we often liked to go to beautiful sites in nature to work but we all soon learned that if we didn't ask first, the weather would turn bad or someone would fall over or I would just not be able to concentrate because of the pissed off attitude coming from the spirits and faeries there.

Asking became second nature for us and nine times out of ten it was fine to do what we were proposing (often with the proviso that they could join in). This just seemed common sense and common decency; who would like some strangers coming to their front room and doing what they wanted without asking first when you thought you were going to have a nice quiet night in?

So I walk the land with a sense of deep wonder. There are amazing places full of deep magical joy though sadly they are becoming fewer and fewer. Over the fields from my house there was a old wood which, even though it was a pine forest with regimented rows of trees, had thick undergrowth, ferns, a beautiful river, mushrooms, and other wild plants. There were red deer, roe deer, foxes, badgers, all types of small mammals, birds of all description, and a very strong community of faeries. Then, after one weekend, there wasn't.

One morning I felt a pull, like someone kicking me in the stomach, to the woods and went to investigate. The forest was nearly all gone, the trees in stacks, the undergrowth driven into the ground and the animals all disappeared. Also, there were the folk, some dead, some injured and many displaced with nowhere to go. Fixed faeries need to live in certain places; pine beings without a pine tree to live in will just wither and die. I spent a couple of days negotiating with a nearby forest

(who were at first claiming they had no room for others) and moving the 'refugees' to the new home. I know that these trees were a cash crop and I know all things come to an end but sometimes the mass destruction that deforestation or seabed dredging causes sickens me.

Our heritage in this country is the beauty of the land, not only the beauty we see, but the deep beauty that pervades all life around us. It is important for us to see its worth, not in cash and coin but for the good holistic health of all beings around us. When we acknowledge this beauty and understand its importance then our actions with the land will change. No longer will we cut down those trees because they're in the way, we will look and study them to see what else lives on or with them. We'll hear perhaps of the decline in newts and frogs and build a pond. Everyone can make a difference and bring more of our somewhat lost beauty back into the land. The difference between the energy of a field that has pesticides and fertilizers on compared to one that is organic is immense. I can't say I've seen faeries dancing very often over a 'controlled' field but the organic ones nearby are positively like a free festival at times! The more copses that are left to do what they will, the wilder it all becomes and the more wildlife/ spirit life it will create. These pockets of life will generate, grow and spread.

With the emergence of a counter culture of transition towns, allotments and an understanding of the need for a natural world around us I do have hope (sometimes). The beauty around us with all of its beings in harmony can be such an amazing wellspring of energy, offering communion, and a sense of sacred oneness that it can bring me to tears.

There is a wonderful way of being when going for a walk in nature - I think it's called 'Conscious walking'. Before you start you stand in nature and use each of your five senses, one by one, in turn. For instance if you start with sight, you look as far away as you can and study what you see, then look nearer to yourself and do the same, then nearer still till you are trying to see the end of your nose. Then you do the same with hearing. Then all the others: taste, smell. and touch. When you're finished, start your walk - you will experience a lot more and you may find other senses (your sixth, seventh and even eighth!) starting up as you become much more aware of the beauties of life around you.

I feel refreshed, enlivened and totally fed by going on a walk through the leafy lanes of Devon, super-charged by traipsing across Dartmoor, or held secure and enfolded by spending an hour or two in a wood. This is where I touch divinity, where I can communicate with the gods easily, in a deep and sacred way, knowing and acknowledging my place in the universe and particularly on

this wonderful planet of ours. These are my temples. Sitting in a specially built building cut off from the natural world just doesn't do it for me. As a pagan, I find that sort of thing stifling as if I've cut myself off from the wonders of creation, evolution and my position in it all. The countryside around me is full of beauty, not just of the visual kind. Beauty, for me, goes far deeper than that. The beauty is about the way the land rolls in majestic hills, dotted with copses that pour energy from one to another. A parliament of rooks borrows that energy and takes off in a cloud of caws and high-pitched laughter. How, if you're lucky you see out of that copse a small herd of tentative deer, all grace and awareness and all the time the quiet earth holds it all together in the palm of its hand. How it lifts my heart!

Being a devotee of the god Cernunnos has been an amazing addition to these ways of seeing. I guess anyone who works with him will experience him differently but for me he is the god of the wildness and the father of the Faerie races. He has told me that he looks after all species and the wild places. It seems that he thinks as much about the life of a rabbit as he does to the life of a human. I guess this can be a bit disconcerting sometimes when we have been brought up to believe we are the most important species.

One of the most amazing gifts that I was ever given was being able to occasionally use

his sight. It is called 'the beauty'. With this you look at, say, a tree and you see it at once as an acorn, sapling, tree, furniture, fire, and every possibility instantaneously. But when you use this sight to look at say some abused or poisoned land the possibilities end. There is no 'on and on'; the land has become barren. The same is true for poisoned ponds and trees and other life forms. We need the possibilities of life continuing, so that our life balances with those around us; being part of that rich tapestry, touching those other beings around us in a harmonious way.

In the spirit world, which is in a 'sideways dimension' to our own but in the same space, the spirits of land, air and sea are there in abundance. But I find where we have a wild area or relatively untouched woodland they manifest directly, interacting with us in a way that not only enhances our lives and those around us but actively helps the health of the whole planet. Magical practitioners know that there are certain times of the year when the veils between the worlds are thinner and more of the spirit world and the worlds of the gods and faeries interact with our world (the Land of Iron, as the folk put it). It's an amazing feeling when this happens. All manner of things are able to happen and miracles do occur. In an untouched place (or a place at least that few humans seem to have any influence over), these magical times are a constant and this is what I experience over

the moors, by the sea or in a little known cove. Sure, there is pollution in the air and the daily flotsam of seaweed and cuttlefish bones has old plastic, netting and the occasional wheel, but they don't seem enough to influence the energy of the place. (I try to take a bag with me to try to pick rubbish up along the way and occasionally the 'locals' will give me a gift in return!)

One of the basic tenants of Faerie magic that I was taught is the concept of borrowing. The folk will ask, listen and borrow energy from participating plants, animals, land, fire, water, air etc... to weave their magic. Their rituals, often involving dance, create more energy; the place starts to buzz. After they have finished, they return the energy (with interest) and there is more than enough to go around, to permeate the surroundings. I think this is sometimes what we feel as we come to that beautiful secluded grove in a wood, that left over spillage of magical work that has the flavours not only of the folk but also of all the beings around. For this to happen we need a healthy bio-diverse ecosystem around us for the folk to work with.

So when I see another Tesco built on the site of a little copse that used to sing as I walked past, I feel emptied. They may plant a load of trees in the car park, but that doesn't feed the land or me. That place of magic was a possible temple to me, even if I didn't visit it often. To have the places that call me in my

heart destroyed for the sake of money is an affront to nature, to me and to others like me in our spiritual heritage. It's not just about the destruction of physical beauty for me, I'm not a NIMBY (Not In My Back Yard), It's about all the possibility of the life force that I can touch and work with; all my opportunity to do as the Folk do and create more spiritual power for the whole planet. I see things like the history of oil spills from the Torrey Canyon to Amoco Cadiz to Exxon Valdez and the 2010 spill in the Caribbean and wonder that we never learn....is it the financial cost or the environmental impact that will eventually make us learn? And when we do- will it all be too late for the planet?

When I lived in London I found that celebrating the traditional witches' wheel of the year often mystified me as there were not many of the agricultural or natural references to be had: no first ewe's milk at Imbolc, no may blossom at Beltaine, no harvest to bring in at Lammas. But here in the country it all makes sense; I can feel every festival emerge from the trees and the land around me. The equinoxes and solstices are even more apparent as the whole countryside seems to take on the responsibility of showing and honouring the time of year. This is such a huge blessing, to be able to be part of it rather than trying to find a symbolic reminder of what I feel our ancestors would have felt. And I truly am part of it, actively walking the land

or just standing in my ritual area in my garden observing the leaves changing colour or dancing in the snow and being able to feel what the whole community of plants, animals, faerie and spirits are feeling. This is my temple; this is my spiritual home, my grail and myself. Each place I visit changes through the seasons and yet remains the same at its core, it's like they are all listening to the song of the land at each festival or season and joining in with the song. I do too, being slow and excited at the prospect of new life in the spring, celebrating the time of greatest growth in the summer, dancing with the falling leaves and the great abundance in the autumn and being thoughtful and thankful and careful in the winter.

These are the incredible times when I feel my connection to all those who have gone before. Those ancestors of the land that sing with us still, celebrating birth, life and death in equal measure. For me the ancestors are not just human of course; they are ancestors of the mighty woods that covered the land, the early peoples who honoured the land as I do, the Faerie who have gone to the Summerlands and all the spirits that have been indigenous to this beautiful island of ours.

There is one more thing I would like to share with you, a simple but very deep and connective celebration that I do each year at Samhain, the honouring of the faerie dead. It is called the 'river of light' and it is a very

important commemoration for me. You make a boat, or a few boats, out of paper, decorate them as much as you please and make them as elaborate as you wish. You place in them some food (biscuits are easy) and nice smells, maybe a picture or anything that feels like a connection to the faerie race for you. Then you need a candle, (nightlights are ideal) and you find a stretch of calm river water.(this is the bit I often forget and it sort of goes flat!)

I then sing to the folk, those around me, those to come but mostly to those who have gone on to the Summerlands. Some I would have known, some I would never have met, but the ceremony does not need a personal connection for it to work, just a positive intent. Then set the boats adrift in the river and change your song to one of celebration and joy; I bet that all the folk that around you will start to sing with you. The intent is to send light and life down the river to the sea to the west and the dying sun and the Summerlands, to the Folk and if you have the sight or are deep enough in your ritual you'll start to see that the river is a sea of lights a flotilla of boats and ships of every size all sailing for a common goal. This simple honouring of the departed folk is one of the most simplest actions to take to ensure that the living folk around you will see you and recognize you for the being that you are, one who wants to connect to them and to the land as a whole.

Even though I despair sometimes at what we are doing to our planet, I love my life, I love the land around me and the lands that I visit. I find the sacred in all the myriad of life that is around me in all its forms and I feel blessed by the gods and goddesses and the Ones inbetween for the ability to live here in this time, experiencing the beings and spirits that make up this sacred landscape. And I feel especially blessed by the fact that I am a witch and that I'm a seer.

"Come away, O human child!
To the waters and the wild
With a faery, hand in hand,
For the world's more full of weeping than you can understand."
W.B. Yeats

ST NECTAN'S GLEN

Lud's Church

Gordon MacLellan

Daylight fades, twilight gathers, and night comes quickly to the gorge. Daylight fades and finds me still sitting there on the crumbling, gritstone steps, soaking up the shadows, savouring the stillness.

After all these years, all these visits, being here still feels like the end of a pilgrimage. This is not some momentous, footsore, mountain-climbing, penance-clearing catharsis. This is smaller, simpler, and maybe just as profound in an old-stone-and-tree-roots way.

The drive to get here is part of it. Nothing that special, no great distance, no great drama (unless it is snowy or icy when I can do a lot of the distance sideways). Not far, and these old hills swell roundly above me. Gradbach - "Sandy Stream" apparently, but in the local vernacular, the "Great Bitch"- massive above, the road running down the cleft of Her belly. Bleak hills with rich names, studded with sheep. Not so many sheep now on Axe Edge and Wolf Edge and Tagsclough Hill, but cattle are grazing again. Tough, ancient shapes, heftier and bolder than the nervous sheep. Beyond the farms and the livestock, there is a quiet lasting strength in these hills, the folded, secretive western edge of the White Peak.

The walk from the car is part of the pilgrimage, too. Again, not long. Again, no great drama in this mile along the Bitch's stream. The River Dane. More names, with echoes here of ancient Celtic Goddesses as Mother Danu runs down from the hills to the plain. Is She the "Gradbach", Herself? That would make a convenient storyline while a neat path, waymarked, follows the line of Her brook down the dale to the Black Wood. Or sometimes the "Back Wood". It is easy to get sidetracked into the patterns of names as folded as the hills themselves. The track wobbles in its course,

is muddied with field springs, but again there is no real challenge in the walk to the woods.

Drama? Challenge? Why should there be? The beauty should be challenge enough. The proximity of town and city and motorway to this wild, atmospheric, ancient place should be drama enough. The walk offers another challenge: an exercise in letting go, a processional ceremony discarding thoughts, learning, ideas: recognise them, acknowledge them but don't let them get in the way of the place and the moment. The hill and the cave wait.

For beauty there is, and a challenge too. Ice drops, frozen tears, on thorn twigs of a Midwinter morning. Moonrise over the hills. Snow blowing down the dale. The cool under the trees on a summer's day. Cold water running over rounded stones. A cloud of jackdaws are blown ahead of me down the dale and rise, laughing, in a flowing swirl, up and over the trees ahead.

The woods that wrap the hillside are not "ancient woodland". Knowing what is ahead, I almost feel that they ought to be. Some lingering relict, perhaps. The last outpost of wolf and boar, bear even? Actually these hills might have been just that with Wildboarclough running just a dale or two over to the west. But none of those precious indicator species sprout among the birch, larch and pine. And none of these trees themselves are old heavy-limbed grandparents. Not young, either. More,

a middle-aged wood, a sober crowd of sensible, mature trees. Open spaces, any spaces, are crowded with heather and bilberry, with fallen birch twigs filling up the occasional gaps the shrubs have missed. The path becomes a wide, rutted track, uneven but easy, and takes me up across the hillside towards the pile of Castle Rock.

Just as the setting calls for ancient woodland, so those jewel green glades where the Black Brook meets the Dane on the dale floor speak of jousting lawns, the jingle of a caparisoned horse, pausing, its skirts settling into picturesque folds. A questing knight, helm balanced on saddle-pommel, looks up into hoary, moss-wrapped woods. Or maybe it was Robin Hood and his lot, romantic outlaws in hides and jerkins, shadows sliding across the open space. A wolfshead company gathering, here in the secret spaces, safe spaces, high in the wild hills. Their stories spill out of Nottinghamshire and across the Peaks into these western edges: Longdendale and the Roaches both claim their places in Robin's tales.

Secrecy runs through the history of this place. Here, the boundaries of Derbyshire, Cheshire and Staffordshire meet at Three Shires Head and refuge could be found by slipping quietly from one county into the next if there was no shelter to be found among the dubious button-makers of Flash. Deep dales, wild hills – easy places to hide in. Not

warm, nor comfortable but a good land to withdraw to, to disappear.

Turning all this over, brings me up onto the last path to the Church itself. Lud's Church. That most secret place. An unobtrusive trail, twisting back and cutting up through the heather to the slowly splitting hillside. Another twist, a crack in the rock, twist again, and Lud's Church opens below me, inviting entry with a heavy, geological stillness. A deep cleft in the gritstone, rock hairy-chested with dripping liverworts, well-bearded with moss and tousle-topped with sprouting grasses and holly. The Church is floored with ancient flagstones covered as often with mud as earth, a wallow to squelch through. Deep and deeply hidden, the Church is an unexpected place. We are safe enough down here but its depth proves a grave still for foxes, lambs and even some of the last of the Roaches' wallabies, worried into reckless haste by dogs and welcomed into death by the waiting stone.

I press my hands into the liverworts and feel the thrill of their leathery touch on my palms. Smell the damp, and the silence. That green stillness is like a scent too. It fills the place. Fills my lungs. Breathing here feels like respiration at a geological pace. Nothing of this place hurries. Haste comes with visitors: human or animal. The plants feel as ancient and unhurried as the stone. Being here either slows me down or makes me want to shout,

and to bring sudden sound and movement to the submarine depth. To dance through the Church is to become the small fish that darts across a coral reef while the reef goes on growing slowly, inevitably. A couple of hundred yards, however, and here are the steps out. There is another route, harder, scrambling, sliding, a jumble of tumbled and tumbling stones. But these steps will do. Crumbling. There has been strong rain recently and the old treads spill sand like sawdust down the steps. That is all there is. A short stretch of mystery. No great challenge. No great drama. But why should I need "great" when Lud's Church stands here around me?

Here at the top there are stones to sit on, and birch trees, and toadstools in autumn. A pause with a flask and cake and apples and a chat with unexpected new friends as some sensibly kitted-out walkers tramp through while here I am festive, frivolous and, quite possibly, barefoot with shoes on strings round my neck.

These rocks. The damp, sudden depth of the Church. It never feels bright down there, even when the sun sneaks through the shrouding overgrowth. There used to be a ship's figurehead on a ledge – up there. Long gone, long splintered now but what a thought! The *Swythamley's* Lady bringing salt sea to cold stone. Here there are deep clefts where clay goddesses are still tucked away in the shadows.

Stone, grey and green, running with water. A cleft in the hill so I can step out of haste and into a slower moment.

Church? Lud's Church?

Was it here that Gawain met the Green Knight? The medieval tale of Gawain was probably, carefully, scribed at Dieulacres Abbey near Leek, just down the road. Gawain's journey apparently reflects a passage through these craggy hills. Was this the Chapel in the Green where death waited? I could believe it, standing here in the cold tranquillity of the Church. A young knight, uncertain and fearful, enters. Walking slowly to put his neck, quite literally, on the block. Up there, the Green Knight, in verdant enchantment, waits, axe in hand. Was it here that that one thin line of Gawain's blood for that one indiscretion fell on the hungry stone; his integrity, in the end, breaking spells and bringing release?

Did Gawain's journey follow his own pilgrimage trail? Did he come from the south over the moors by way of Mermaid Pool and the Roaches, by Doxey Pool and the Winking Man? More names, more stories. Or perhaps those are more recent evolutions out of this landscape?

And Lud? Lollards apparently used the Church. Clandestine meetings of early Protestants. More secrecy. Where did they come from? Even when the quarries were full and the Mill was a Mill and not a Youth Hostel were there enough workers here to support a whole religious faction, too big or too dangerous to fit quietly into someone's front room or a barn? Apparently so, and apparently, they were led by Walter de Lud-auk. His granddaughter was killed when a service was raided and was buried by the mouth of the Church. I have looked for her grave but never been sure. I've watched for a forlorn ghost on late nights but she seems to have found her peace and Lud's Church doesn't need human ghosts to feel a haunted place.

More convenient etymology as Walter and his Lollards offer an origin for the gorge's name. Is the name that recent? Or it could it be older? This gorge might have been named for Ludd, Himself, of course. There are so many other ancient deities lingering in the names among the hills, why shouldn't the river god Ludd Llawereint, Ludd of the Silver Hand, and known in various forms across Celtic Britain, put his claim in? Maybe "Church" came after "Chapel" which came after temple….a holy place hidden in the hills of the Great Bitch.

Does it matter? Ludd. Lollards. Gawain, ancient woodland, medieval outlaws. Visiting Lud's Church becomes an exercise in letting go. A pilgrimage with a simple challenge. To be. The drive, the walk, the woods, the hill. They become stations in the practice of being present, of stopping analysis and recollection and appraisal. The stream, the woods, the

stone, the depth, are beautiful, rich and worthy of praise simply for what they are. The challenge is not to examine but simply to be. That should be the starting point. Everything else can follow later, if it is needed at all.

A mixed fall of titmice drops through the trees to forage in the bilberries. Great tits, and blue, and long-taileds, fill the spaces around me and for a moment break the silence with conversation. I am considered, and dismissed. I settle into the stillness, the silence of stone.

Everything else can follow. For now, the twilight and the silence are enough.

IVY & ICE

Places of spirit
and spirits of place:
of Fairy and other folk,
and my Cumbrian bones.

Melissa Harrington

Most spiritual traditions speak of finding sacred knowledge through time apart from humanity in places such deserts and mountain tops. These are wildernesses that have no human distractions, where nature can be felt in its magnificence and enormity, and we are reminded of our own mortality, our tiny moment in the face of eternity.

On a minor level, we find an element of this wonder when we walk out in nature anywhere, and it is not surprising that pilgrimage has remained a spiritual stable throughout history and across many cultures, whereby devotees journey to a sacred destination. It is not surprising that hermits live alone in wild places, that monasteries and temples were often built far from the madding crowd, or that the shaman and the witch were usually attributed to live at the edge of the village, between the world of men and domains of the otherworld.

It is easy to journey through nature and remain aloof, blinded and deafened by our worldly cares. But if we align our conscious minds to the wonder around us, if we meditate into it and leave behind the whirling of the mundane mind, we can open ourselves to the glory of nature, and let it aligns us with the magnitude of the universe. The simple but immensely popular poem by William Henry Davies (1871 – 1940) describes the poverty of life that we live if we do not make these moments:

> What is this life if full of care
>
> We have no time to stand and stare?
>
> No time to stand beneath the boughs

And stare as long as sheep, or cows.
No time to see, when woods we pass,
Where squirrels hide their nuts in grass.
No time to see, in broad daylight,
Streams full of stars, like skies at night.
No time to turn at Beauty's glance,
And watch her feet, how they can dance.
No time to wait till her mouth can
Enrich that smile her eyes began.
A poor life this, if full of care,
We have no time to stand and stare.

Pagans have long held Nature in awe and reverence, and found the Divine therein. At the time of writing this chapter an anonymous quote was circulating on the internet: *"If you take a Bible and put it out in the wind and the rain, soon the paper on which the words are printed will disintegrate and the words will be gone. Our Bible IS the wind and the rain."*

As with any aspect of Paganism, there are almost as many views on how we relate to nature as there are Pagans, so this chapter features my own rather personal point of view. That feels rather intimate for a book chapter, and yet strangely right as our own personal connection to the Divine in Nature is a core belief of Paganism itself.

I was brought up with shallow roots in deep soil, or deep roots in shallow soil, I'm still not sure which! My father's side comes from the North of England with a large number settled in the western Lake District, whilst my mother's is from Ireland. My parents met in the 1960's and lived a peripatetic lifestyle until I was seven, with us living in London and in Bermuda before we settled down to lead the 'good life' in the wilds of western Cumbria.

My parents were so busy building up Cumbrian tourist businesses that us kids were left to our own devices, and much of my time was spent in the company of a big red dog and little white pony, exploring the woods and fells. The pony cost them £25 on its way to the meat market, and was a bargain as it replaced the need to take me for riding lessons, and only ran away with me at whatever pace I had mastered. The dog was a born mother, and when not whelping with illicitly conceived puppies would treat me as her own, and was fine protection. These were happy times, and I think that the early feeling contentment at sharing the wonders of nature with companions of another species has always stayed with me. It has moved into the realm of magical familiars, 'familiar' being a great word to express the bond of a pet who shares one's life, including deeply magical moments.

Time off for my parents was spent with us, either walking to local stone circles and up mountains with my father, or, with my mother, spending days at magical places such as the hidden pools of Stone Star up the Duddon river, swimming underwater following minnow, trout and salmon as they wended

down river, or playing on the sands at the windswept beach of Silecroft.

I first became conscious of elemental beings here, and was drawn into sitting quietly by huge rocks, trees and rivers, exploring the otherworldly presences that felt so close, and developing a 'contact'. It was a time when I was developing psychically, developing skills nurtured by a very psychic Granny who had fled the spiritualists in her early twenties after a few shocking proofs of life after death; a father who read the stars, practised psychism, and played with tarot; the general 70s fascination with Uri Geller; and living in an isolated Victorian gothic home that was inhabited by several kindly ghosts, including a wolfhound that my brother saw independently of me, but we never spoke about till many years later.

This 'Nature contact' goes beyond feeling good in Nature, that wonderful feeling of being at one with the universe, of seeing, smelling, feeling, hearing, and tasting life; of being in humankind's rightful place in harmony with the seasons and the earth. This 'contact' is something that engages the senses we do not use, the senses we have let atrophy in our concrete, material world that has little time or place for such sensitivities. It is the flash on the inward eye that sees a real thing that is not there, the sense of a speech that is not heard, and a knowledge that is given if the recipient has the wherewithal to take it in.

It is contact from another world, the Otherworld, that seems to exist parallel to ours, and that has in fact been clearly written about forever in books of myth and of magic. It is the Otherworld that writers continually access in fantasy films, in which we love a coherent tale, but feel cheated and uncomfortable when the mythic structure is wrong. This is part of the success of Harry Potter. Rowling researched her mythic world very carefully, and her characters and tales are fully coherent with classical mythology, and the folklore of Britain. She set her fantasy alongside it, and we all managed to suspend our disbelief and be swept into her hero's journey as he crashed through the brick wall of the muggle consciousness and into the magical realms beyond.

This contact with the Otherworld is something we develop in magical practice, from first open meditations on the elements, working with the ceremonial magic of the Enochian System which explores the processes of the natural world and creates a ritual map of its patterns. And it was when I was deprived of the natural world, living in a gardenless second floor flat in Camden, London, going to work in advertising in hermetically sealed offices by tube, that I came to Wicca. It appeared there for me when I needed my Nature back, when I needed my seasonal cycle, and I needed that magic and enchantment. That's where my formal magical

path started, and magic led me back to that enchanted world of Nature; calling on the elements was like calling on old friends, and I never looked back.

This lead me on all sorts of adventures, and to finding my soul mate, marrying him and starting a family, at which point, I sought to go back home. I followed a calling that was as strong as that which calls the birds to migrate, and the salmon to leave the deep seas and follow the river home, leaping upstream. Like a frog that must return to its pond to spawn I followed the calling to bring my own kids up in a place that I called home.

I settled in a place of perfect *feng shui*, a house looking out to the sea protected by a dragon hill, where I can walk daily for miles in the hazel woods that lead to the fells that show unsurpassed vistas of pure Lakeland beauty, and I can feel the energies of the earth, wind, rain and nature around me. I feel right doing that, I feel alive and awake. But more than that I can practice my adopted path as I walk in the woods and interact with the energies of the Fey that abound in these western Celtic realms.

Ironically it wasn't my background growing up here that brought me fairy contact. It was after I had become Wiccan and developed my inner eye, and my sense of a two-way communication with the Otherworld, that I developed a dialogue. What brought me into communication with the fairies was the contact I developed when living on the edge of Windsor Great Park, were I walked and biked for years, enjoying that daily contact with the elemental kingdoms, and in awe of the feeling of otherworldly wildness that blows through that place.

It is no wonder that our royal family should adopt Windsor of all places to call their own when claiming ownership of these isles, the magical current there is unlike any other I have ever known. It is pure 'fairy' in the sense of tall, scary, elf-like beings, very like those depicted on medieval tapestries, with easily felt connections to the Otherworld. One path I used to take through the deer park to a hollow oak has a line of blasted oak trees, all dead or partially dead, and a strange cold wind blows through. I called it the 'cold stream' and you can almost feel the spirits ride on the warmest summer day. I have been there at dusk, and worked magic in certain places, but the message I got was to retreat at night, that this was not for human kinds, but for the dance of the folk on the other side.

In coming to live in south Cumbria I felt an easier connection to the Fey of the hazel woods and limestone rock formations because of this Windsor contact. Here it easy to see why the fair(y) people were said to live under the hill, because the limestone outcrops look like castles, and it is easy to get fairy-led in the beautiful woodland until you no longer know your way, but are astonished by the crenellated

structures that rear up in front of you, amongst the places of stillness, and the places where the birds sing so sweetly, and the air smells of wood, bark and frost tinged with the sunlight.

I have developed this contact over the years, and found that I can call upon the Good Folk. Or that they sometimes call upon me if I am in the garden after dusk, and it is one of the nights when the Lords and Ladies ride by. Always there is a cold wind, and sometimes leaves whirl in patterns that suggest the dance of unseen feet. Sometime rings of mushrooms, or even daisies form where there haven't been such rings before. Offerings disappear, and offerings are accepted with a rustle in the bushes and whisper on the wind. I have developed a great respect for this other world, and know when to leave an area that is out of bounds, or when to quietly go alone and be at one. Even as I think of it now, as I write in the quiet depths of the night, there is a sudden bang at my attic window, and a gust of wind and rain rattle the casement, like long nailed fingers tapping to let me know they are there, and to write with respect.

Once, at midsummer, I took my coven up to the fairy hill and did a little working, they were so confident, they loved it. It was a very warm night. As I invited the folk to the edge of the circle, but not over it, the air crackled with frost, and our breath froze in icy puffs. The presence was real and communication achieved, but it shocked me how the coven had no inkling of how firmly I kept the circle closed, and how thoroughly I banished at the end. Maybe I'm little over cautions, but I pay heed to the centuries of folklore about the Good Folk, and would never push the limits of our relationship.

Maybe that's why the dance of the fairies is often depicted at midsummer, when the nights are light and short, and when we humans can dare to cross more easily into their world. At Halloween they offer a very different visage. Yes, it is thrilling, and yes, the veil is thin, and our dancing the hills can be so very invigorating and inspiring, but I'm not sure I would spend the night on one of these Cumbria mounds and return home the same person in the morning.

It's very different working Wicca indoors and out. The sylvan joy of dancing in the woods around a roaring fire on a starlit night speaks of ancient freedoms. And the wonder of working cloaked in the snow on a winter's night when the full moon silvers the frosted trees has no comparison. Nor does looking at branches that rear overhead in stark monochrome, framing the moon that is then drawn by mirror into the cup of the mysteries. At these times the presence of the old ones is always there, and often the fairy host.

I'm not surprised I felt what I felt in Windsor, for England has much folklore of fairies. Maybe I had absorbed this, or maybe

it has this folklore for a reason, for the nature spirits that come with any land are part of that land, representing it, and embodying it.

When I was lucky enough to spend time in Norway I met some trolls. I was walking in the woods. I had not been looking for anything other than the view, but suddenly there was the huge rock hewn face of a Norwegian nature spirit. The hills over there are alive with trolls, it's difficult to go far without encountering a few, seeing the humanoid faces, all huge, almost rear out of the craggy rock. The landscape there is rugged and huge, and thus the trolls. Maybe some part of me knew about trolls in Norwegian folklore, of course it did, but I hadn't expected this, and retuned to my hosts to find they knew the same troll. I learnt of other Norwegian folk, such as the *Hulde*, beautiful women with cow's tails who are pretty mischievous, and the *Nissa* who correlate almost exactly with our own Brownies, and are attached to a homestead, rather than being purely outdoor entities anthropomorphising Nature itself.

Nature spirits are everywhere, bounding out of the landscape and forgotten consciousness of place. In the Greek mountains I felt the presence of Pan, which may be expectable, but in the Catalan mountains I encountered a presence not dissimilar, then heard of legends of a goat headed man.

Some friends once bought a derelict mill to do up near Luisignan in France, it was in a place they felt was steeped in the legend and energy of the water fairy Melusine, and they felt it was imbued with her energy. They loved the languid summers by the millpond's dark depths but they never finished doing up the place, as nature took it back through severe flooding, making in it unviable, as it had always been since the river course changed, long ago, and now it is a ruin that enhances the poignancy that engulfs the place with the sinuous seductive presence by its millpond.

Other friends of mine bought an old farmhouse in Brittany. Mist wraiths used to dance up the door, or through the floors at certain times of year, and once I had a very clear image of figure, as real as you and me, that correlated exactly with a local legend that I had not hitherto heard.

We, as humans, do not always use all six senses, or even listen to our unconscious minds. How often have you ignored a feeling or thought, only to find that you were right, you had had a premonition. How often have you felt yourself being watched by others, seen or unseen? Part of the magical art is to develop our senses, our second sight; to develop our relationship to the Otherworld. Just like the invisible microscopic worlds that are shown on television, or the millions of inhabitants of other countries living in other cultures, in other time zones, they all exist out our sight.

Is it so impossible to believe that there is another world just beyond our consciousness that exists parallel to our own, that we can step into if we know the way?

Part of being a magician is knowing those paths, how to open them, and knowing how to close the doors between. We cannot live between two worlds and hence we use the magic circle, the candle, the trance, the words to get there, and to return.

Folklore is replete with information of lost generations' understanding of nature spirits, elementals and sense of place. We modern pagans are re-envisaging this, and reworking some of the ways to communicate, some of the understanding of other worldly sentient beings. We are reengaging with the archetypal images of the guardian of the portals to other worlds.

We live in interesting times. Paganism re-enchants the disenchanted world, we put talismans on our computers and offer our sacraments to the earth. We bow to the sprits of place and invoke the guardians of the elements to watch over our rites, we use our magic to bring us closer to the natural world, and instead of a holy book we read the wind and the rain, and relate our own lives to the turning of the seasons, and the changing of the tides of the universe with the changes they bring. We align ourselves to the natural world and explore its mystery, and our place within it, rather than believe in any one creator.

When teaching others the Pagan ways I strongly recommend they do a daily practice that acknowledges the elements and the seasons, and that they keep a magical dairy which also notes the seasons and weather, and that they go outside every day if possible. It's very simple but very effective. Daily meditation on the elements will bring a much richer connection when invoking the quarters in ritual, and as the rites change with experience we still need to keep our feet on the ground. Thus when doing Enochian magic, and chanting the Enochian cross, I am still placed in the cross of nature with four elements and spirit protecting me, with my feet on the earth and my spirit reaching for the celestial realm.

Some of my most beautiful magical moments have been simply sitting quietly connected, I have seen such sights as the Aurora Borealis appear as I spoke ritual words looking over the winter silvered hills in Norway, and disappear as I closed the rite. I have had incredibly clement weather offer me windows of opportunity, and enjoyed lightening and thunder accompanying rituals outdoors, or seen the winds blow up to skitter leaves, seas clam and crash, at all at ritually right moments. In those moments, the sense of communion is good for the soul, and seems to be an indicator that we are not alone, and not as separate from the natural world as some might imagine.

As a Pagan and a magician I have come to understand that I am made of the lonely hills and high places of my native soil, where the sea gulls scream over the heather, and curlews can be heard from the rocky tracks that meander through high limestone escarpments, which hold secret caves, and the fossils of sea creatures that once dwelled in the warm seas that covered the Cumbrian coast many millennia ago. I am of the high cartwheel of lakes that formed as the glaciers carved the valleys, leaving drumlins that still sit like fairy hills.

These are my portals to the Otherworld, via communion with the elements, and via contact with the guardians to the Otherworld. Whether the Otherworld is all in my head is immaterial for it has been in the heads of many others before me, and will be in many others that follow, we speak the same language.

This land is far from the ancient oaks of Windsor, and the humid heat of Bermuda. But it is my land, and now it is part of my children's heritage as they walk the dog in special places. And the mixed smell of sea and mountain grass is etched into their memories, as much as the taste of fruit from our garden will for them always be the best. They are easy in their sense of place and belonging, in the transient modern world they have a place from which they come. Where they are going we do not know, but they have roots in a good place, a simply place, a place out of time in some ways, there the clock hands still move a little slower.

And when my time is done I am to be strewn as ashes on my special hill, where the four winds will carry me back towards the sun, and into the thin soil that covers the limestone, to fertilise the quick set hawthorns that glory in bending but not breaking, their branches streaming to the eastern morning sun in the western wind that blows in from the Irish sea. And I will be gone, and I will remain, and I will walk those hills, familiars by my side, on the best days of summer; and come winter I will ride like the wind with the Fair Folk of the Sidhe. And I will remain to look over my loved ones, just as I was looked over, until I choose to journey to the Summerland. This I know, and for this I thank the magical path, and all it has given me.

A life
in the
woods:
protest site paganism

Adrian Harris

"I should not talk so much about myself if there were anybody else whom I knew as well". Thoreau, *Walden or Life in the Woods*.

Over ten years ago I gave a presentation that was to change my life. I spoke about a "somatic knowing" that "is the knowledge of faith, of emotion, of the gut feeling"[1]. I concluded that spiritual experiences in nature give us an embodied knowing that can inspire environmental action. My words spoke of an unexplored landscape and I embarked on a remarkable journey of discovery.

That 1996 paper revealed a broad horizon and it took a PhD to even begin to map out the territory. What I discovered was as profound as I'd hoped and more surprising than I ever imagined.

Academic research can be dust dry, so to create a fleshier appreciation of my work, I'd like to invite you to join me on a pivotal part of my journey. My fieldwork touched the individual threads of many lives, and this story weaves them into a tapestry. This is an autoethnography, a more intimate expression of fieldwork than most, which embraces the researcher's personal experience and reveals a "personal voyage of discovery" (Bruner, 1986)[2].

Autoethnography is an *aesthetic* activity as much as an academic one in that it tells stories that invite the reader "to put themselves in our place" (Ellis and Bochner, 2000)[3]. This is an imaginative retelling in as much as I distil many months at various protest sites into a single narrative. But every

word speaks true: all substantive quotes are as spoken and always in a context that preserves their intent[4].

A new arrival

Field notes:

A few long days ago I was in London phoning the camp from my flat. Now the flat is empty, my unaffordable lease is done and, with my material life in store, I'm on a train going west. It started snowing just as the train left London and the fields all around are now dusted. Not ideal conditions to arrive in! Still, it may delay work on the road. I hope so. When I spoke to Jill on the phone she emphasised how "bloody beautiful" the woods are.

It's snowing pretty steadily as the train arrives at my destination and the bus driver jokes that I'll need skis in the woods. I smile through my mixed feelings: I have the usual slight anxiety at heading into an unknown situation, tempered with a certainty that this is where I need to be right now and all will be well. Why am I so certain? My first thought is that this is in accord with the pattern of my life. Not being here would be a denial of how I identify myself. It's living the life I've created.

Dusk is falling as I get off the bus but within 10 minutes I find myself walking down the rough path towards the camp. A voice hollers out a "Hello!" from the bank above me. "Hi! It's Adrian – I phoned the camp a couple of days ago." At the moment I'm no more than a shadow in the dark, so I want to reassure them that I'm a friend. "Oh, hi! Come on up. There's a gap in the fence over here". A guy who calls himself 'Oak'[5] meets me with a smile and leads me to the fire pit where people sit huddled round the warmth.

"Hi, I'm Adrian. I'm an old mate of Jill's and she was telling how amazing it is here."

"Hi. Good to meet you. Always good to see new people. You staying long?"

"I dunno. Maybe. See how it goes."

"Cool. Have you got a tent or something? You can always sleep in the communal bender if you like."

"I'm OK. I've brought a tent and stuff. Guess I'd better pitch it before it gets too dark." I head off and find a spot to pitch my tent near a tree. It's not exactly sheltered, but it'll provide some protection from the wind. I hope.

Back at the fire, I get chatting to Jan, a young woman of about 20. When I tell her a bit about my understanding of Eco-Paganism she smiles with recognition and says "Oh, I guess I'm an Eco-Pagan then!" I smile with a different kind of recognition as this experience is quite common in Paganism. You don't get converted but just realise there's a name for what you already believe. My problem is that the name 'Pagan' doesn't fit me so well these days. I keep quiet about my doubts as we chat

round the warmth of the fire for fear I might break the spell.

After a few rounds of red wine it's time for bed, so we all crunch through the snow to tents dotted round the camp. The snow is inches deep now and even wearing all the clothes I have I'm cold as I struggle to get some sleep. We must all be crazy.

Next morning is bright and cold, but the fire pit is warm and Oak has made porridge. Joy!

There are a few new faces at breakfast, so I introduce myself.

"You're the guy that's doin' the research on Paganism aren't' you?" says Ben.

"Yeah, that's right. Well, that and helping with the protest. I used to be involved years ago and it felt like time to get my boots dirty again."

Rob thought for a moment and then nodded as he said, "I have a sort of pagan connection to the earth".

"Yeah," said Jan, "that's what Paganism is all about - connection with everything".

Ben shrugged: "It's blatantly all connected. If you can't see that it's just because you're closed down - conditioned".

Ray agreed: "In this day and age it's just taken away from you. Your mind's just filled with so much other stuff - well, crap basically. No-ones really in touch with what they actually are or anything - or *life*".

"Which is why living in a wood is quite good", responded Ben. "Because you get less distractions and you get more of the spirits of the trees - whether or not you believe in fairy nonsense - which, you know, I do!" He laughed.

Ray nodded, and added with a chuckle, "And if you start talking about, you know, the wind and the earth and the fire and the stars people just start laughing at ya".

Field notes:

Alex wrote about the "sense of connectedness" that's common amongst activists (Plows, 1998)[6]. Can we learn that sense of connection? I think so. It's highlighted by the life itself – physical work, the need to keep warm and attend to physical well-being. I'll see what I can learn from people here - and the place!

As we sit and eat supper, Jan asks me for my thoughts on how the body can 'know' something[7].

"Well, basically, we have different ways we can know something. I know in a *conscious* way that Paris is the capital of France. But I also have an emotional, sensual knowing of Paris – the smells of Paris, the taste of Paris, that odd little back street that I couldn't *tell* you how to find but that I could easily walk to. One kind of knowing – the conscious sort – is right here in my head." I tap my head. "The other – that fuzzy, wordless, poetic

knowing – is here in my gut", I say with a gentle touch to my stomach.

"OK. I get that. But does it relate to intuition and the kind of connection I sometimes get with this place?"

"Yeah, totally!" I say, excitedly. "Let me think how to explain it." I ponder for a moment before picking up a couple of forks from a nearby pile and hold them up in front of me. "If you take two tuning forks of the same pitch, and strike just one of them", I say hitting one fork on a log, "the other fork will begin to vibrate in harmony. The two tuning forks are separate but connected. Something similar is happening to us all the time – the deep awareness in our bodies is resonating with the world around us".

"And we can listen to that deep awareness?" Jan asks.

"Sure," I reply. "When we sink our awareness into it we can come into communion with the world. It's probably not practical – or even desirable – to consciously tune in to that awareness all the time. But I reckon that regularly dipping into connection is vital".

Jan smiles as she says, "I think I know the answer already, but how do we dip in?"

"There's lots of ways - ritual, mediation, sex ..." I glance round in mock caution and add "magic mushrooms..."

Rob looks up from his bowl of vegan curry with a grin.

"But that's a much longer conversation!" I say, picking up the plates and heading to the washing up bucket.

Field notes:

Jill came over last night and we sat by the fire to catch up over a cuppa. It's been years since the last big round of road building, and she has a sense that this marks the next turn on the spiral that started at Twyford Down. Jill moved house recently so can't spend much time here now, but she thinks we can win this one. Let's hope so: There are bats, owls, badgers, dormice and toads in these woods.

The Turning

Enchantment

I wake up feeling good: that's one of my last nights in my cold, cramped tent, 'cos I'm building myself a place to live! Most people on site live in a tree house or a bender tent. A tree house would be wonderful, but they are hard to do properly. I read a great quote from an Eco-Pagan explaining that "when you live in a tree it becomes part of you" (Greenwood, 2005)[8]. I'd love that, but I reckon I can build a bender in a few hours: you just make a structure with bent branches and cover it with canvas.

Ray and I are both going to build benders, so Oak is taking the two of us to some nearby woods to cut branches. With that happy thought, I wander down to the communal for

breakfast to find Jan is also in a bright mood, despite piles of washing up.

"You look happy this morning!"

"Yeah, I'm going to plant seeds today. I love doing that." I look vague, wondering why. She gives me a big smile as she explains. "It makes me feel like I'm talking to the Goddess."

I'm still pondering the profundity of Jan's joy as we arrive at the woods where we'll cut the branches we'll use for bender poles. Ray and I both need poles, so Oak shows us what to look for: the poles need to be straight, not too thick and nice and long. It looks easy enough, but it's not: I just can't see the wood for the trees! After a while looking far too hard for the right poles, I begin to get the knack: It needs a particular sensory acuity that feels like I'm relaxing into it and opening myself up to the space. Now I'm looking less and seeing more.

That evening as we sit round the fire I ask if anyone meditates and it turns out that most people do some form of sitting. Rob learnt Vipassana meditation but also uses a less formal approach: "Just spending time out in nature, just listening. Just looking. Not really thinking too much".

"Yeah," says Jo, with a nod. "You just sit there and if you give it a moment, peace - It will just come in. It's like a wash that floods through you".

Adam sits quietly, looking thoughtful, so I ask where he learnt his spiritual understanding. "It's partly about spending time with other beings and partly about being with the land and the trees", he says. He pauses for a moment and adds, "If meditation means doing without thinking, then I do what you might call meditation all the time when I'm with the land".

Sitting outside my new bender watching the waxing moon, I think, "This is my Paganism!" To worship something you have to be separate from it, but I don't feel a need to worship nature. Actually, it's stronger than that: I don't feel it would make sense, because I *am* nature. My Paganism is an expression of a deep love for nature that doesn't try to objectify it. I hear crows squawking in the trees while in the distance the road drones by. The contrast seems poignant: life in place, as part of a sustainable ecology sits next to an oddly pointless series of individual journeys.

Field notes:

Reading 'Walden', Thoreau's book about his time living in the woods. His perception became finely tuned and notes that he smells the arrival of muskrats in the spring. Living here does seem to sharpen the senses: I remember back to when we were cutting bender poles and the way I somehow had to learn to see them. I definitely much more in tune with my environment now: I've been a Pagan for years but before I came here I usually couldn't make more than

an educated guess at which phase the moon was. Now I knew the Moon phase better than I know what day of the week it is!

I wake up and smile as I look at the curve of hornbeam branches that is my new home. The space is motley, more open and fluid than a brick house or even a tent. It has an organic quality inspired by the materials; a dome, shaped purely by the relationship between bent hornbeam and space. It's beautiful, but not much warmer than a tent, so I leap out of my sleeping bag, dress and head out to greet another chill, bright day.

As usual, Lauren is up early. She's a retired school teacher, though you'd never guess from her dreadlocks and rainbow clothes.

"Morning Lauren. How's it going?"

"Oh, fine now I've got my cuppa tea!"

"Are you coming to the Land Blessing on Sunday?"

"Oh, I don't think so" she says with a bit of a frown. "I somehow don't get the whole spirituality thing".

"Ah well. Each to their own". I say with a smile, as Rob wanders over to make himself a cup of tea.

"What about you Rob? Will you joining the Land Blessing?"

"Yeah. I've been at a Beltane festival and Paganism fits in a lot with how I feel about the world."

After supper I get chatting to Rob about his experience of life on site. He's been living on protest sites for a few years, so spends most of his time in the woods. "I find it quite difficult to connect with my spirituality when I'm in an urban environment", he says. "It's only when I get out into nature … and feel the energy flowing through me and I have that connection."

I know just what he means: "Yeah, I've felt that too - especially since I've lived on site."

"It's not that it's there all the time - I get distracted in the mundane shit of my life, like living in a city - but all I need to do is go outside into nature and I can kind of connect and open up those channels again."

We sit and chat while the fire burns low and the inviting darkness crowds around us.

Field notes:

Tonight we talked about our embodied understanding of the site but found that conventional language can't really grasp it. According to old paradigm thinking, the body can't 'know' anything but it's pretty clear now that the mind is more like an ecosystem than a computer: the mind and body are one system, reason needs emotion to function and embodied intuition is a powerful way *of knowing*[9].

The sunlight wakes me. Maybe it's late - or is the sun just stronger now? Time passes strangely on site: days feel short yet looking

back over a week it seems like a fortnight. It reminds me of the old stories about time in Faerieland: humans visit Faerieland for day only to discover that years have passed in the mortal world.

After breakfast, I look round the site for Rob. He told me earlier how he finds it much easier to connect to his spirituality when he's in the woods, and I want to try to find more. I find him sitting in a little grove of beech trees at the end of the site.

"Hi Rob. You got time for a chat?"

"Sure. I'm just sitting."

"I wanted to ask you a bit more about your experience of living in the city".

He frowns. "I find being in the city very very difficult - it drives me a bit mad having to have the filters on, constantly having to block out noise because if not you'll go absolutely insane because there's just so much going on."

He told me how clear this was he left the city to drive down to Climate Camp. When they stopped off in the middle of the countryside the silence was overwhelming:

"It was so goddam quiet it almost hurt. And it was only when you actually started to listen that you realised it wasn't quiet at all but the river was flowing, the wind was in the trees, the birds flying. All of these things were going on which we weren't hearing because we had these filters on. People live their entire lives

in an urban environment and they just don't get that connection with nature".

Rob went on to describe one evening in the woods when a deep sense of connection overwhelmed him.

"The sun was coming though the branches of the trees making a kind of a column of light and these mosquitoes were flying into it. It was November, and because the air was lit by the sunlight it was warmer than the surrounding air, so a sort of convection was going on, and the insects were dancing around in it. This dance was beautiful and there was so much order and beauty to it. It wasn't just a random thing at all. It was utterly poetic".

I nod for him to go on.

"I was just sat watching the sunset, hearing the sounds of the cars in the background and thinking about all the shit that is going in our world, and feeling so sad, so utterly sad. And then I felt like the sun was setting on all life and this one day was the last day and I just started crying, you know... I felt like Gaia was really screaming out through me, saying please help me. I felt so connected, so at one with the Earth that this violence was being done towards me. Not me personally, but me as in life, as in this whole unity which I'm connected with. That strengthened my conviction - I actually said to myself on that day that I would do whatever I could for the rest of my life, whatever the hell I could to

stop this from happening. There's an empowerment and purpose - the ability to get up in the morning and not have to think about what you're doing but just have that energy flowing in your body. I think it's important not to underestimate how powerful that energy is".

Field notes:

To really be in nature - to be nature - we must honour and value our sensory experience: the tastes and smells in the air, the touch of the wind as it caresses the skin, the feel of the ground under our feet as we walk upon it. Instead of a strict boundary between self & the rest of the world, we can embrace a shifting awareness across a kaleidoscope of being. And this new awareness encourages a right relationship with nature. Many of us say that the Earth is Sacred, but we may mean that our relationship with the Earth - and our physicality - is Sacred.

The Land Blessing was beautiful: I nearly wept after Jan's short and simple invocation of the Goddess though it wasn't much more than one line: "Welcome to the Goddess of the Well". Oak suggested that this was because she expressed such a strong belief. That resonates.

Ray wept openly at the end so I did a grounding meditation with him. It seemed to help.

"Are you OK?"

"Yeah. Thanks."

We sit quietly for a while, then he smiles and says: "That was probably the first time I connected properly - realised this bit of land is here and we're actually protecting it and saving it and loving it".

I give him a hug and we walk in silence back to the communal bender. Jan is the only one there so I sit down and asked about the ritual.

"I think that went pretty well. What do you reckon?"

"I've been feeling quite magical being here," Jan replies. "I don't differentiate between what we did in the circle and what I do on a quite regular basis … Just talking to whatever's out there".

Jan had given a beautiful invocation of a local deity, so I ask about her work with the Goddess. She gives me an odd look, like she didn't quite get the question.

"Well, I wouldn't call it work, "she says smiling. "I just like to say hello. Whether it's Her, or something else, or just the land breathing maybe, I don't know, but it's the same kind of feeling. But, I can call Her the Goddess to other people because they understand".

I've never heard it described quite like that. "What do you mean, 'the land breathing'?"

Jan explains: "Well it's all the layers. It's the mushrooms and all the roots, and the trees

intertwining underneath. I mean, in a wood all the trees have joined together and then you've got all these layers of different ecosystems - I think the whole thing makes a complete breathing creature, almost. Which is why, you know, land clearance is so dreadful. That's the whole breathing entity of which we should be a part, a symbiotic part, and we're not. That's where it all goes wrong, horribly wrong, isn't it? That's the Goddess, that's who I try and communicate with, talk to, sense. Yeah, but I felt wonderful when I was calling Her in and I think people understood what I was trying to say".

"Hello?" Calls a voice outside. "Anyone home?" It's a visitor, probably someone from the nearby town who's got up the courage to come and find out what we're all about.

"Thanks Jan" I say with a smile, as I get up to greet our guest.

I wake up with the remains of a dream.

All I can remember is a man saying to me that answers don't come in a single moment. He didn't say any more, but the implication was that solutions emerge over time. It reminds me a dream I had years ago: I met the Green Man in the woods and I asked him if I could record our conversations to take to people outside. The dream ended with me walking out of the wood clutching a cassette tape. Weirdly, that's kinda what I'm doing here.

Mulling over my dream, I wander down to the communal bender for breakfast, where I find Jan reflecting on life on site. She's lived on a site before and was clearly happy to be back. "I feel free here. I'm back to being myself".

Free. Yes, I've felt that myself. A feeling of lightness, sense of openness. It's great to hear other people express that too - It's not just me then! There's certainly something special about this place - a sense that anything is possible.

Lauren and get chatting after lunch and it turns out that she was involved with the Twyford Down campaign of the 1990s. Odd that she hadn't mentioned it before.

Twyford Down was a designated Area of Outstanding Natural Beauty with loads of wildlife, but that didn't stop them building a dual carriageway through it. Lauren used to visit and felt the power of the place.

"Twyford was such a *wonderful* piece of land", she said. "As you stepped onto it you just thought, 'What's happening to me?'"

It was pretty amazing and the protests there kicked off a new direct action movement in the UK. As we sat and reminisced, Lauren unpacked just how important it had been for her. As she spoke, I came to understand lots of things about Lauren that I hadn't grasped before. She'd mentioned that she'd had a breakdown some years go, but not why. Now I found out that Twyford was the catalyst.

"The reason I think I had the breakdown was because it presented the real me to me and I just didn't recognise it or was able to cope with it. And yeah, I couldn't cope with the fact that I knew in my heart of hearts that we'd lose and it would be a motorway one day and ... the madness of it all just really hit me".

In wordless silence the birds sing outside the canvas walls while we sit lost in memories.

Field notes:

There's an unusually strong sense of connection here. Autobiographical accounts of road protest life describe it too: activist Jim Hindle describes how living on the Newbury site "was like being connected to a great river, the source of all life ... and years of separation between us and the Land were falling away like an old skin."[10]

I wake up with a realisation: when I lived in London I used do brief morning rituals to greet the Elements. Why aren't I doing my Elements ritual anymore? I get the answer in a second; 'cos it's all here! Every day I go and collect water, every day I light a fire; I walk on the bare earth and spend most of the day under the open sky. In London I needed to make an effort to stay connected – here it just happens.

As I crawl out of my bender I see Ray emerge from his.

"Morning mate! How's life in a bender?"

"Lovin' it man!" says Ray with a big grin.

We chat as we wander down to the communal bender for breakfast.

"I don't want to live in a house, ever again", he says with a laugh in his voice.

I can relate to that: it feels like I'm in an intimate connection with everything around me because the inside and outside are less defined.

Ray is on one now:

"In a house you're just sealed off from anything that could possibly connect with outside of it you know? Other than probably another box -which is the television. Like you don't realise it until - well I didn't realise until I had the opportunity to live outside in a bender".

The reality of our connection with the world is inescapable here: even in my bender it's very obvious what the weather is like.

I turn and asked Ben if it feels different when he's in the woods.

He give me a mischievous grin: "Does it feel different? No, it feels different when I'm not - when I'm in a box or on a street. That's when it feels different".

While cleaning my teeth tonight I hear a car drive past. I stand on grass, beside a tree in a space lit by the light of the half moon. They sit in a metal box, closed off and closed in. Although we are only separated physically by a short distance, psychologically we occupy different worlds. That evocative phrase from

Rob Greenway that 'civilization is only four days deep' comes back to me, and I suspect it is even more fragile than that: removing just some of the trapping of the 21st Century can profoundly shift our awareness. That powerful phenomenon may be what lies at the heart of the protest movement.

Field notes:

Several factors contribute to the sense of connection people feel here, including meditation, ritual and what ecopsychology calls the wilderness effect. Rob Greenway claims that "both the psychedelic and meditation experiences ... closely parallel" the wilderness effect, and that such awareness seems to have the "capacity to open consciousness to Mind - that is, to the more natural flows of information from nature". There are various aspects to the wilderness effect, but fundamentally it involves feelings of reconnection which Rob unhesitatingly describes as "spiritual" [11]. The wilderness effect is found on long treks in North America, but I think it's happening here too.

It's late in a long day. We've had several visitors from town and got quite bit of work done on the defences. Everyone's gone to bed now, and high time I headed off to my bender.

Suddenly Lauren rushes into the communal bender in a real state. "Thank god you're still up!" She says, breathlessly, and hugs me. "Can you please come with me? I've just seen the Green Man by the compost toilet ..."

What on Earth? Lauren is clearly very freaked out but I can't quite make sense of what she's saying.

"Yeah, OK", I say, trying to sound reassuring. "Let's just go down there together". Lauren is a little calmer now, and together we walk down to the compost toilet.

"There", she said, she pointing out the shape in the trees where she'd seen the Green Man. Whatever spirit Lauren had seen had done its work, and there was now not much more than a vaguely human shape in the trees. We sat and talked about her experience and she explained that the Green Man seemed to have been calling to her. Now that her initial panic had subsided she realised the figure she'd seen wasn't frightening but protective.

"Nothing like that has never really happened before except that night when I sat at Twyford Down. I kind of had it - I call that one of my deep spiritual experiences, sitting there that night when I knew I'd never be back there. I think the Earth is drawing people to protect Herself - a bit like the Rainbow Warriors".

"So you're still not spiritual, huh?" I asked with a grin and she replied with a smile and a hug

Field notes:

When I started my research I thought

that ritual was fundamental in developing our connection to the world. But there's been hardly any ritual here and I've found something even more powerful: the spirit of place.

Changes

My mobile sings. I have a text from an old mate in a Housing Co-op. With a shock I read that they have a vacancy in the house – Can I come for interview? Well, yes … And before I know I'm booked for Wednesday night.

"Looks like I might be offered a place in a housing co-op. Some old mates have a vacancy."

"Oh. Great …" Says Jan in a tone which translates that into "Oh. Shit ..."

Wednesday comes round fast and I find myself on the train to London. As I sit down in this warm, enclosed space I feel odd – slightly shocked somehow. It feels strangely alien: straight lines; hard surfaces; ordered space. I feel shut away. I stare out at the trees and think of my bender.

The train pulls into the station, and here I am, back in London. On the tube I get that

shut in feeling again: I feel enclosed, restricted and less emotionally open. We talk a lot about urban congestion but it's not just roads that are congested – it's psyches.

The interview goes well. Part of me is delighted as it means I'll have a stable base and I can focus on trying to make sense of what's going on. But I don't feel ready to return to a more conventional life and my emotional ties to the Camp mean I'll be leading a double life for a while, spending time living in my new home and my old one.

I got back to Camp late and hoped not to see anyone tonight, but Lauren has caught me by the fire as it sit in a pensive mood. She has that air of wanting to say something important.

"So you're leaving us!" She teases.

"Not really", I say, trying to fudge it. "I'll be here for at least half the time."

"That's good. There's something I wanted to say before you go back to London - something for you to remember when you're there: what was at Twyford Down is living on - it's turned up here. This feeling, this love of the land, is growing so much in people now. And that is what will win through in the end".

I gave her a big hug, and we sat quietly staring at the flames flickering their eternal dance.

Notes

1 Harris, 1996. Sacred Ecology. - 2010.

 Harris, 2010, 'The Power of Place: Protest Site Pagans'. *The European Journal of Ecopsychology*, Vol. 1, issue 1, London.

2 Bruner, 1986, 'Experience and its Expressions', in Turner and Bruner, (eds), *The Anthropology of Experience*, University of Illinois Press, Urbana and Chicago

3 Ellis and Bochner, 2000

4 Aliases are used throughout and two characters - Oak and Ben - combine more than one individual.

5 About a third of the people I met on protest sites used an alias which they referred to as their 'site name'. Typically this was only used while on the site or involved in a protest action.

6 Plows, 1998

7 Although Jan and I could have had this conversation, this section is a fictional device to outline my ideas.

8 Greenwood 2005

9 I explain my model of embodied knowing in more detail in Harris, 2010.

10 Hindle

11 Greenway, 1995. The Wilderness Effect

www.adrianharris.org

3 poems
by Barry Patterson

1. The king who sits upon the water

In town, in Woolworth's

10am, not too crowded

Pepsi-brite colours

Cheap pop tunes

In plastic packets

Smiles in the aisles

Of the popcorn, head tube reality.

Beneath your feet

Scuffed beige floor tiles

Shoe rubbed by happy shoppers

Beneath *them,* concrete foundations

Laid in the fifties

By poorly paid Irishmen & local lads

Who could still remember fighting in the war.

Even lower, a few broken bricks

Blackened, blooded

Haunted by the shocked voices

Of the maimed, the trapped

The burned, the dying:

Prayers, curses, sudden warnings

Explosions in falling darkness.

Beneath this smoky tide,

What you might call mud – not clay, silt

From the reedside lakebed.

Waters turning, snipe drumming

Dragon-wing, beetle bright

Reed warbler hiding place

For the hunter in his canoe.

Wind rush rustle settles

Three for the price of one, forgotten

Eddy, current, wave-lap

Mud smell, suddenly unclouded sun

A deep breath, a sudden move

Another explosion!

A whirl of wings -

Thousands of them darken the sky.

The people have taken oaks

From the Wild Wood -

Cut free, uprooted, tooled

& awkwardly at first

Replanted in the mud,

In rows – an avenue

Upon the water.

Track it down

From the red sandstone hill

With its springs & its scrub

Out from the bank

Out over wave-lap

Like a bird watchers walkway-

Wedding road for the Lord of the Land.

Circumnambulating

Coventry's circular market

Comparing the prices of

Tomatoes, potatoes, chillis –

Way back, below…

Crannog! Thatched hall,

Smoke slowly drifting.

So I sing my song

Unthreatened by the gold

Around their necks

& the creak of dark, blooded leather

Then they bang the handles

Of knives upon the table

Of the king who sits upon the water.

Originally published in my collection "Nature Mystic" Heaventree Press, 2008, ISBN978-1-906038-29-8

TYNE PLOVER

2. Ballad of the Tyne Plover

We flew down the valley of ancient memory over the great gleaming river

Where salmon ran & men bent over oars, adjusted sails to centurion wind

Where the green bank was home & work for the multitude of the unseen

& the bridging point was a struggle between names & named for life-start.

The eye-window gave shine to the nucleus of the city's stony history shouting

Words at clouds, at birds, to newcomers in the port riding the tidal heave;

Words of love & fight, of song & celebration; musical words of resistance & pride

& wove the story, gave it the power to imprison or set free the human heart.

We watched them fight! Year after bloody year; for fields, for fun, for treasure

Make-work for the hardy, for the hearty to kick ball, throw arrow or spear

Make us fly even higher up, above the smoke of burning, the melodies of drinking

& market haggle & the horn blast of industry with the great iron cranes, ship weaving.

We saw them clear the forest, shore up the marshy bank,
drain the black mud slacks

Take the hill-tops for homes, carve whirls of points &
rippled rings on stones

Take shelter in over hanging once-sand rock, to light fire,
guard the flock

& dance beneath the moon to celebrate the land-life that
they felt beyond believing.

We saw it all, we are the host that passes over their heads
in year-wide shadow waves

A thousand rejoicing the flight of season, from hill-fell
to the coast's rocky carrs

A thousand wing-eyes, eye-wings, bearing witness to the
cycle of valley years

From the ice mountain to the pelican raft upon the river;
from nut gather to rivet beat.

Deep wind voice from the hill side has shown us how far
the spiral root goes down

That jungled river delta, voice of croaks; the fall of the
non-tree in the unheard forest

That first footprint of the ancestral animal that walked
the primal shade, made voice

Barely audible echo over Northumberland, over Wallsend
& Hebburn down in mine tunnel heat.

We fly the land, we see & hear all; watch them build their
empires, roads, cemetery walls

WHERE ARE THE WILD PLACES?

Watch the secret memory wave that's slow to build but slowly rises & breaks in their dreams;

Watch the delicate conurban lichen spread & gently recede as time passes over us all;

But we're wind riders, we gather every song; surf the wave of analepsis down to the final sea.

Down to the dark North Sea of storm & freezing wind, coast-man's larder of life-risk

Who eats away at the land, soaks flats, gives vent to voice in caves to lead us on

Who has seen & remembers more than we can ever say, back to the first green verses;

Her stony bed hairy with weed, complete within herself whose heart we never see.

& so we descend to the coast-green refuge our forebears first found so long ago

To crouch & play on our pipes the songs & the tunes of the remembered remembering land

To crouch & listen to the dwindling voice-number of our people, to wonder

At the vastness of it all & the deep magic of each note-detail within the songs of life

3. We met first in the north

Old king man that sleeps upon the hill stood, rode his horse over the field like a shade that grows with the tide of night

Peewits leapt into the low light; weeping, crying, falling all around him in voice cycles of fear & mournfulness

Oh stone king, thorn man, you watch us living in the comings & goings of our life circles always arriving departing

As fast as rainbows over sea storm swing, always a'wing buzz of insects in sun summer voices raised in delight & sadness

Golden dolerite is your bed, a kissed of stones your nest looking north south east west we met first in the north

I bowed to you before I set forth, to seek to sing the songs of life written as rings on grey stone up the nap of the purple hill

You remained & waited still, watched as if frozen like the longstone finger figure darkly pointing at the sky

The miles rolled by; Chatton, Wandylaw; moor & curlew cry my company family not just cells

Ancestral winds at my back can tell the larger circle into which my smaller circle seems to have fallen

Voice raised & swollen with song, eye bright with rain ray light descent strong nuclear love

All that I am I offer, I give, I lay before the sacred land hand root rock pattern

Where seas force rush & the stones it would flatten make circles of
water & myriad forms of life celebration thrive

Caught into the braided song, alive with fins, arms, waving threads &
eyes that follow the sun

All of this shared circle, all of it, in the song, the wide eyed song that
the earth in my body has finally released

& as the song ended geese flew overhead, the wind changed & it
began to rain, good & grey on the ground

We returned to the hill, the ghost could not be found; bones in a urn
long gone to soil & dreaming sleep

Anne hip deep in barley follows the tramlines towards the golden
church bell horizon of Kelsoe Hill

Heart love hand root skill of the stone man dreaming holds us in the
evening air

No passing shadow bird in hall there; rather the glowing embers of
an living home hearth

That knows no stranger anywhere on the earth & dreams that the
voices of the living beating heart round

Weave themselves wildly into perfect sound, colour, light, ray, shade
–something never still.

Originally published in the collection "Nature Mystic" by Barry Patterson,

Museum or Mausoleum –
A Pagan at play in
King Solomon's House

Mogg Morgan

Once upon a time Manchester Museum gave a party for the return of the Lindow Man otherwise known as "Pete Marsh". For those who know not of what I speak, Pete Marsh is a well-preserved Iron Age corpse discovered on Friday 1st August 1984 by a peat cutter on Lindow Moss, near Manchester. Pete is currently displayed in the London's British Museum. The history and possible provenance of this body is told in two excellent books[1] Lindow Moss is just a stone's throw from Alderley Edge, one of the legendary resting places of King Arthur and his knights and a place much beloved of local pagans[2]

The return of Lindow Man to his former stamping ground coincides with a widespread reappraisal of the manner in which museums curate human remains and indeed all their religious artefacts and assemblages. Like many museums, Manchester is undergoing a radical refit and indeed rethink about how these things should be presented to the public. Part of this is about trying to accommodate changes in the way the public wish to engage with their collections. This also coincides with a noticeable growth in a pagan sensibility.

I am a member of a special focus group known as *HAD: Honouring the Ancient Dead,* which brings together various pagans with an interest in the ancient past. I'm quite happy to self-identify as a Pagan although I know that for many the term can be a problem. This might surprise some who know me as a senior member of the Golden Dawn Occult Society and indeed as a long-standing Hermetic magician obsessed with, amongst other things, Ancient Egypt. But for me the term 'Pagan' originates in the world

of classical Egyptian magick. The best way to define 'Paganism' is by reference to a pre-Abrahamic Egyptian religion – but that's another story!

Over the last few years HAD's focus group of 'pagan theologians' has successfully lobbied, along with others, for museums to adopt a less reductionist and more respectful approach to their 'wonderful things'. One of the upshots of this was the idea that those with a mind for it, could, in an unobtrusive way, make small, appropriate offerings to the illustrious ancestor on the other side of the glass case.

With the above in mind I posted a request to my local Pagan internet forum to see if I could elicit some ideas on the mechanics of how this could be done. The first response reminded me how controversial such concepts can be, even amongst Pagans.

Also immediately someone said that the only thing we should be doing is placing an offering box so that more money could be raised for the museum's work. It was a disappointing reaction from my own community – to say the least. After all, it's not as if museums are not already going to be asking for money. It's almost as if Pagans have so internalized their marginal status they find it hard to even imagine what they would do if they were given the chance. It's the whole 'fear of freedom' thing, or is it 'fear of flying'?

But there again as Marx said (Karl that is not Groucho – although my editor says it could just as easily have been the other!) – money is the ultimate fetish object. And my own proposal re the mechanics would be some sort of great pot or cauldron, filled with water, into which people could, if they were so minded, drop those talismanic coins, and indeed other small metallic objects. Some might say that all that water in a museum might be a management nightmare but there again galleries often do have fountains and water features? This is what I mean by the *mechanics of ritual*. Pagan temples of the past would have had some sort of delineation in the kinds of offerings people could make – hence the standard offering in an ancient Egyptian temple was a loaf of bread, some beer or some linen.

Actually these kinds of impromptu offerings in museums are more common than one thinks. The British Museum's colossal sculpture of Kephra, personification of the rising sun and therefore the ultimate image of "becoming" has in the past been the focus of blood offerings. And my correspondent Justin M who is researching the connections between religion, ritual and the arts writes of "how people leave offerings of coins at the statues of Ganesh at the Metropolitan Museum of Art in New York City" (The "Met"). "Personally," he adds " I've always felt that the Met is a temple!"

In the absence of "rule governed creativity" one could end up with the 'trash altars' once seen at St Nechtan's Glen in Cornwall. People arrive here and are moved by the number of previous offerings to make their own dedication. You know the feeling, if you are unprepared to make such an offering then you rummage around looking for a suitable token that often turns out to be trash. This could be a problem in a museum.

Hence one needs to address the issue of the mechanics of offerings. Pagans, with a growing knowledge their own history; do have some relevant information – something that might actually be useful. So for example my offering cauldron, is not just manageable, it does also have resonance with the object – by reason of offering into water – the Lindow man was also an offering into water – and indeed offerings of valuables things into water is part of the Iron Age context. It is also a coin – a fetish for us, also so for Iron Age people. It is also money, so handy for the museum. The growing heap of junk offerings currently to be seen at St Nechtan's Glen would be a problem for museums. But there again, I visited the Shrine of our Lady of Mallieha on the island of Malta and found it full of neatly wrapped baby clothes – the intent was obvious and the effect was very moving but also well managed. For me this all resonates with the wishing well tradition. It involved me despite the fact I was a lay, i.e. non-Christian, visitor to the shrine.

Some may already be shouting (I hope so) saying "but what about the ordinary visitor – why should they be made to do this!?* Well no one is being made to do anything – it's just an option – hopefully subtle and unobtrusive. But there again, I suspect that even the accidental pilgrim to a museum, or sacred site *enjoys* being there. There is room for both the tourist and the pilgrim – as much today as in the classical world.

One of the first mass-produced tourist souvenirs, certainly since classical times, would be those medieval pilgrims' badges. Some of the most popular shrines sold over 100,000 of these naïve and crude knickknacks. These medieval equivalents of the tacky "Kiss Me Quick' hat", are now prized objects in the museum [3]

Recently I went to a Pagan handfasting at Rollright Stones on the Oxfordshire/ Warwickshire border. The "normal" visitors who came in were smiling not frowning – surely that's OK – people smile – they enjoy that we are being Pagans – right?

My offering cauldron is just an example, an idea of what it's about, this mechanics of ritual thing. Call it experiential archaeology if it makes it easier. I'm hoping others will have more ideas about how this can be done in an inclusive and interesting manner. For example, what about that cauldron, how does it look,

should it be an existing artifact from the storage rooms or could local artists and craftsman be enlisted to come up with designs? Hold on there – could it be that we Pagans might actually have projects that could draw others into creativity – I think so.

Which all made me think about museums and what are they for? I work and study in Oxford, and now and again I lead a tour of its 'Hermetic' campus. "Hermetic" in this context means the ancient Pagan doctrine, a synthesis of Babylonian, Greek & Egyptian wisdom. This is often encoded into its neo-classical buildings. Thus the central area around Oxford's Bodleian Library is said by some to be laid out on Hermetic principles. Here for instance is a bijou science museum designed by Christopher Wren as a house for the magus Elias Ashmole. In the recent renovation the curators unearthed in the basement his original alchemical laboratory and a name for the collection as King Solomon's House.

Museum or Mausoleum ?

The surrealist Marcel Duchamp felt that museums are where art goes to die. For him ther were too insular and exclusive. For him art was a shamanic activity that should be everywhere, on the street, on the sides of buildings, etc. There is a great affinity between Surrealism, Paganism and magick. But perhaps the beat in the museum is just lacking in that tribal vibe?

But there again for those with a more melancholic disposition, the sepulchral nature of the museum can be very evocative. Kurt Schwitters is hardly a household name but he was an artist/shaman who thought of the museum as "cathedrals of erotic misery". He no doubt related to them as the old style "Cabinet of Curiosities", what he called *Wunderkammer*, "archives of the time and space". In his vision the museum is a "space for mysticism, sexuality and autobiography in the production of art and architecture".

And that is quite close to the original meaning of 'museum' as a 'house of the muses'. The name 'Solomon's House' derives from Sir Francis Bacon's book *The New Atlantis*. In origin a museum is a collection of people and things arranged to inspire and invoke memories. Culture is memory, is it not?

Elias Ashmole stipulated that the large collection of objects assembled by himself and earlier collectors such as John Tradescant should be displayed in a purpose built building adjacent to the Bodleian Library. It duly opened in 1683, 70 years before London's British Museum opened its doors and became one of Europe's first new museums since ancient (Pagan) times.

Elias Ashmole (1617-1692) is a remarkable figures from history who rise from relatively humble origins to become seen as the most knowledgeable man in England. He founded the scholarly Royal Society and was

a keen "antiquary", the precursor to the modern disciple of archaeology and intellectual history. He was also a Magus in the Renaissance mould and through his collecting and experimentation is one of the most important links between us and magical knowledge of our ancient Pagan past.

Society and academics have spent a great deal of time disenchanting things such as museums. They have been so successful in this that all of us need reminding of what these institutions and indeed enterprises were originally for. Take for example Egyptology, set in motion by Renaissance Hermeticism and later by the "Egyptomania" of a Romantic age. In modern times it has become a fairly dry discipline, emptied of its original magick. It's a good of example of throwing out the baby with the bath-water!

Which brings me to the topic of Psychogeography which I'd though must be a Pagan thing although in truth it was defined in 1955 by Marxist thinker Guy Debord as "the study of the precise laws and specific effects of the geographical environment, consciously organized or not, on the emotions and behavior of individuals." But, there again, I suspect there are some affinities between Paganism and Marxism. Wherever it originated, psycho-geography lends itself to Pagan practice, which is often focused on spirit of place and how this has an emotional impact. My own term for this would be "The Erotic Landscape. "

If you fancy a bit of psycho-geography then you could do worse than London's Lincoln's Inn Fields – the largest public square in London. Laid out in the 17th century it has a footprint identical to the great pyramid at Giza!

On its north side is the mysterious John Soanes museum. It was here that I was first introduced to some very strange ideas beside the sarcophagus of Egyptian King Sety I. It set my foot on a path that began in the imaginal temple of Sety I and continues to this day with my immersion in the "Setian" mythos – the Egyptian god after whom King Sethos was named.

John Soanes' museum is some kind of palace or playground of Hermetic fantasy. In the mysterious basement lies Sety's sarcophagus, hewn from translucent alabaster, its sides engraved with *The Book of Gates* (not to be confused with *The Book of the Dead*). *The Book of Gates* is a much more coherent magical book and one that was a guide to me on my journey. The inner side of the sarcophagus presents an image of the Star Goddess Nuit, embracing the mummy as it lay in the coffin: "Oh my mother Nuit, spread yourself over me, so that I may become one of the imperishable stars that are in you, and I shall not die."

John Soanes was an interesting and enigmatic character. He was a leading 18th

century Freemason – and a rarity among masons, a real hands-on architect. The museum is his former domestic residence as well as teaching collection of antiquities, displayed for the benefit of his architectural students. This is the cabinet to end all curiosity, at its heart lay many priceless artifacts. This is a worthy enough object for a Pagan pilgrimage.

The British Museum's recent "History of the World in 100 Objects" is essentially an exercise in psycho-geography. Though originally a hit radio show presented by the museum director Neil Macgregor it is now available in book form from British Museum Press. Ten years ago the museum was described as "broke and dowdy", unable to excite people in the same way as for example the then recently opened Tate Modern. In the last decade its fortunes have been reversed by this new but also old approach.

So for example Tim Brennan, received a major Arts Council award to work on a British Museum project. Trained in both fine art and history, Brennan uses history as his creative medium. During a residency at the National Maritime Museum he became interested in the 16th-century mathematician and astrologer John Dee. 'Dee' he says, 'was entangled in a lot of esoteric, occult, alchemical ideas that the Enlightenment would have dismissed as non-scientific. And yet his papers and artifacts were some of the founding works of the BM's collection.'[4]

Brennan devised walks through the museum, exploring the relation between 'official' knowledge and esoteric specialisms. His walks didn't rely on information but on quotations (Biblical or even pop songs). Over the route they create connections. 'Every image from the past that is not recognized by the present as one of its own concerns threatens to disappear irretrievably,' said the philosopher Walter Benjamin.[5]

There is obviously something in the air, with museums, sometimes reluctantly, preparing for a reintroduction of enchantment. None of which detracts from the work of academic gnomes slaving away over a hot keyboard in some subterranean office. We Pagans *as the followers of hermetic traditions as well as modern citizens* who set the whole in motion, and it just might be that we have *'mummy truths to tell, whereat the living mock; Thought not for sober ear, For maybe all that hear, Should laugh and weep an hour upon the clock.'* (W B Yeats, "All Soul's Night"

1 *The Life and Death of a Druid Prince* by Anne Ross and Don Robins and *The Bog People* by P V Glob

2 see Maxine Sanders' recent biography "Fire Child"

3 B. Spencer, *Pilgrim souvenirs and secular badges*, Medieval Finds from Excavations in London, Stationery Office, 1998.

4 Tom Brennan quoted by Rachel Campbell-Johnston, *The Times*, August 07, 2002.

5 Rachel Campbell-Johnston, *The Times*, August 07, 2002.

Hills of the ancestors, townscapes of artisans

Jenny Blain

For the last ten years, or thereabouts, I've been working on papers looking at how people and place interact and the meanings developed there. Much of this has been about the ways that Pagans inscribe sacredness in landscape (or does landscape inscribe sacredness in them?). But this developed in association with another passion: the hills and towns of my recent ancestors and why they 'matter' to me.

These thoughts provoke a series of seen and heard representations to me. Not only do the memories of places matter, but how these memories are given. And so, immediately, there are two, which both relate to my childhood in Dundee, and both hold much wider appeal beyond my associations with place.

The landscapes of Angus, painted by James McIntosh Patrick, matter to me. Not because they are copied and re-copied in people's living rooms and over the Internet, and hence are all that many people know about this countryside, but that he was a family friend and I grew up with his name as a component of family discourse and family identity. 'Pat', my mother called him. There is an 'Angus-ness' inherent in the quality of light and in the detail of composition, which means the images are instantly recognisable wherever they are found. In pursuit of my 'Blain' ancestors from the other side of Scotland, I walked into a bed-and-breakfast in Stranraer and said, 'That's a McIntosh Patrick' of a picture on the wall. Which it was.

The poetry my father recited included verses which still make my heart pause and my imagination fly to the braes of Angus: not least those of Violet Jacob, on *The Wild Geese*. Again, the impact is not only that of the poetry, but of knowing the landscapes that the poet summons. I will use those words to pace this chapter.

But the landscapes are more than history and more than personal memory. They are living, now, and have their own 'placeness' which impacts on the tourist, traveller, viewer or seeker.

My crafting of this paper was interrupted, and subsequently framed, by a family, and personal, event: the death and funeral of my eldest brother, Peter Blain, in August 2010. My family has a diverse and diffused attitude towards religion. Peter had followed a journey from agnostic, through Presbyterian, Anglican to Catholic. He died, therefore, in the Catholic faith, a lay member of the Augustinian Friars. A week before he died, though, he was talking with me on our ancestral links, and expressed great pleasure that I had found, in Dundee, an Irish Catholic connection from which our mother was descended. I had planned a trip North to Dundee and Angus to see what could be found, but his death resulted in a postponement followed by a swift visit encapsulating scenes of my childhood, of his two decades previously, and of those 'ancestors' in the landscape of whom we had knowledge. The journey given through this chapter expresses not the chronological experiences of my own journey, which began

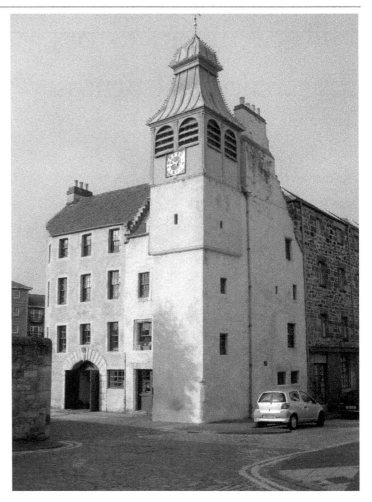

in Angus, but, moving north, follows the verses of Jacob's poem. I start, then, on the shores of the Forth.

The Leith connection

> *'O tell me what was on yer road, ye roarin' norlan' Wind,*
>
> *As ye cam' blawin' frae the land that's niver frae my mind?*
>
> *My feet they traivel England, but I'm dee'in for the north.'*

LEITH, RESTORATION OF THE OLD NORTH LEITH MANSE

"My man, I heard the siller tides rin up the Firth o' Forth."

The docks of Leith have seen much: ships, war, occupation, cooperation, internal debate, and an uneasy relationship with Edinburgh which has its roots in the different forms of governance and autonomy inherent in the old burgh rights of Scotland. Until the 19th century, Leith, though the chief port of Scotland and key to the economy of the capital, had no status enabling control of imports or exports: goods had to be imported by an Edinburgh merchant, sold within Edinburgh possibly to Leith merchants, before resale to those people who wished to buy. Some Leith merchants had clearance to import, though. An advertisement in the Edinburgh Advertiser of 21 February 1772 announces oranges from Seville, brought in by a Leith captain in 1772. 'Seville oranges, in the greatest perfection for marmalade, also China oranges and lemons, imported in the Venus, Thomas Philp master, from St. Lucar, to be sold in chests or half chests, by Charles Cowan merchant in Leith. The vessel has had a quick passage, and the fruits are in excellent order, and will be sold at a very moderate price.' They are likely to have graced the tables of the more wealthy merchants or craftspeople in Leith and Edinburgh.

The Shore of Leith was home to many seafarers and craftspeople, tailors, carpenters, merchants, porters, from a variety of backgrounds but mostly within a general location ranging from artisans to labourers. The social class designations were not the same as today's. A craft master could employ journeymen, and take on apprentices, but an area such as Leith was in a different situation from a Royal Burgh such as Edinburgh. On the Shore today, some buildings survive from the 17th Century and earlier. Many, though, are later. Across the Water of Leith, the river which itself occasioned the port, are buildings restored from the manse and tower of St Ninian's Kirk, originating in the middle ages, renovated in 1736, and finally supplanted by the new North Leith Parish Kirk built in 1816. The 18th Century restoration has been lovingly itself restored, by the firm of architects now occupying part of these premises.

My ancestor James Philp was a ship carpenter, also described as shipwright, around the turn of the 19th Century. He will have apprenticed somewhere, but in which yard we do not know, or even if this was in Leith or elsewhere. Dundee, St Andrews, Dunfermline, Kirkcaldy are all possibilities. James, though, married Mary Bell in 1799, she being the daughter of Alexander Bell, Deacon of Wrights in Queensferry, likely to be another maker or repairer of the ships that sailed the silver tides of Forth.

Their son John Philip[7] was also a ship carpenter, as was his older brother, another James. They will have worked in the shipyards

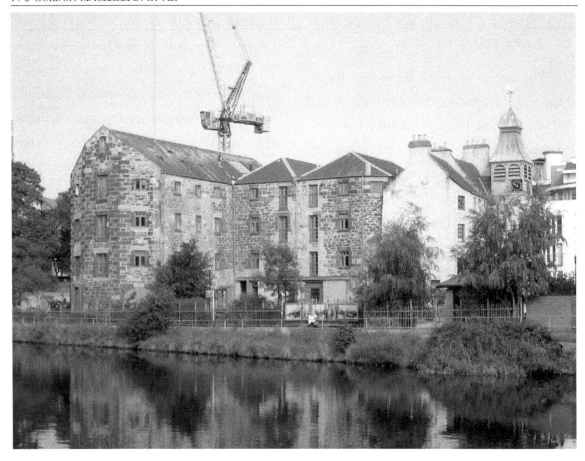

of Leith, part of the growing industrialisation of the port in its endeavour to retain its prominence and compete with the rising ports of the West Coast. As far as the Philip brothers were concerned, though, it did not succeed: first James, then John, left for Greenock, and their families are documented there. Both died young, James possibly at sea, John in an epidemic of cholera, the scourge of the growing cities of Scotland of the earlier 19th Century.

John Philip's wife, Catharine Renton, was herself an inheritor of the silver tides. Though she was born inland, in Newbattle, south of Edinburgh, her father's family was from the East Lothian districts of Gladsmuir and Tranent. Her people were farm workers and blacksmiths through the 18th Century, around the coastal village on Longniddry. Their landscapes included the then destroyed Longniddry Castle, slighted in 1548 in protest against its owner's support for the 'rough wooing' of the little Queen Mary, and the newer but now ruined Redhouse Castle, both Douglas strongholds in their time. John Knox

LEITH, THE RESTORATION OF THE THE NORTH LEITH MANSE AND OTHER BUILDINGS, TAKEN FROM ACROSS THE WATER OF LEITH.

has an association with the area and is said to have preached in a chapel nearby the town.

It was Leith, though, which became a point of contact, where the lines of Renton and Philip in my father's family met.

Walking around Leith, for me, is a journey of changing perceptions. From the Shore, I walked over a bridge of the Water of Leith, and then down by the water, until returning through North Leith by the old churchyard and new building sites, then the St Ninian's reconstructed manse. What this means to me is very hard to describe. The many photographs only catch parts of it. The landscape of Leith has been changing for centuries and is changing today. But for this one descendant of Leith ship carpenters, it resonates powerfully. I talked with a friend, a shamanic practitioner there, about seeing with 'different' eyes, seeing the present overlaid by pasts and peoples, buildings and waterways holding a different course. In my hours of walking in Leith, crossing the river, I could sense echoes of these pasts, with the sounds of traffic gone but the cries of the seagulls remaining, ancestors of those who now wheeled overhead.

The silver (*siller*) tides, though, may have many interpretations. For me, they are not only pretty white water, on moonlight glinting on waves, but connect with another sources of meanings that resound through Scottish folklore and music, as well as the materiality of Scotland's being and substance of her people. Fish. *Herring*: the silver darlings. The siller tides may be the herring fished from the Forth, springing their own sets of music and poetry. The shoals of herring were not only sought by fishers going outwith the firth, but within it; and they and other fish and seafood were the grounds of folklore, worry and wisdom through the years. Concerns about the fish stocks and the fisheries are not something new. In the first statistical account of Scotland, the entry for Crail, a small Fife fishing town, bemoans a decrease in the herring over the 18th century. The account, from the 1790s, blames overfishing in the Forth, and catches made in the North Sea for destruction of the once-plentiful silver shoals.

They are remembered still in song. *Caller ou*, frae the Forth – oysters or other seafood; *Caller herrin* – I grew up singing Lady Nairn's words, 'Wha'll buy my caller herrin, they're bonny fish, and halesome fairin … new caught frae the Forth'.

The shoals of herring, and the riches of the estuaries and the sea *beyont* are not only part of the folklore and mythology of Scotland's east coast, but of my being and upbringing. They and their seas are part of my landscape.

The Fife connection

"Aye, Wind, I ken them weel eneuch, and fine they fa' an' rise,

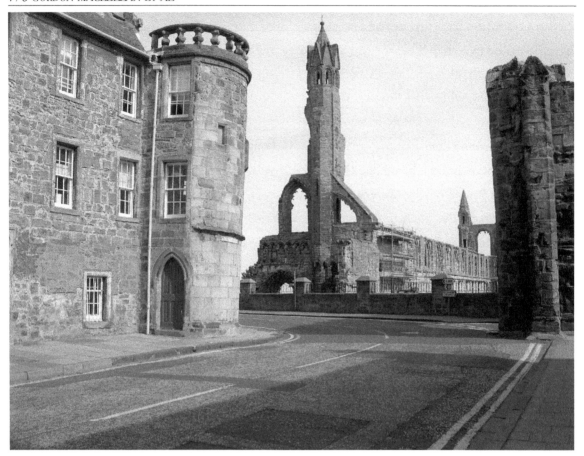

And fain I'd feel the creepin' mist on yonder shore that lies,
But tell me, ere ye passed them by, what saw ye on the way?"
"My man, I rocked the rovin' gulls that sail abune the Tay."

A journey from the south shores of Forth to the Tay can take many paths, philosophical, metaphorical, or physical over the roads. Today's main route is a motorway from the Forth Bridge to Perth. There are, though, others. The northern shores of Forth include the yards of Rosyth and Kirkcaldy, via Burntisland and Wemyss, and the coast road runs further through the seaport towns of Buckhaven, Leven, Largo, Pittenweem, Anstruther and Crail: further exploration up the coast leads to St Andrews, the ecclesiastical heart of Scotland through the middle ages and the early modern period.

A spiritual journey through eastern Scotland cannot exclude St Andrews. The sense of history there has its own connection with my brother's life. Near the end of the second world war, he was conscripted, and was in training when the war ended; he then

ST ANDREWS, FROM THE TOWN TO THE CATHEDRAL

spent some time in the army in Germany. But the outcome of this conscription was that he was placed to take advantage of the special two-year degree studentships offered to army personnel, and so headed for St Andrews for a studentship in history and geography, the first of the family to be at 'a university' rather than the technical colleges where his uncles – and indeed later his two brothers – studied – a lack of Latin in secondary school education denying many people of that time, or earlier, entry to the privileged portals.

Peter and St Andrews became, for me as a tiny child, a recurring legend. There were stories of place and people. Peter, now back in Dundee, would drive my parents and me to where he had been a student, and I grew up with tales of the castle and its bottle dungeon (or oubliette), and of Cardinal David Beaton being hung from the walls - 'by aye hon an aye fit' the tales, somewhat ahistorically, related. (Beaton was killed within his own castle's walls in 1546, and his body indeed displayed upon them for the people to see, but not in the shape of a St Andrew's cross.) St Andrews was where much of Scotland's earlier history and politics were determined, and for the young child in Dundee, my brother was part of this, merged with Kate Kennedy processions which at one point made their way to Dundee, whose university was a child of St Andrews.

At St Andrews on my journey, two women from New Zealand were perturbed by Scottish pound notes – were they legal tender elsewhere? When I reassured them, we swapped cameras and took each other's photographs, so that I have a memento, myself in the graveyard against silhouetted skeletal ruins of the cathedral. My walk though St Andrews, from a car park near the small local museum through town and university to the castle and the cathedral, brought a sense that every footfall echoed with history, from the far distant of the old carved stones in the cathedral museum, to building of St Rule's Tower, of the cathedral itself, the castle, the houses in the town, restoration of part of the cathedral in the 19th century, and the newer stones in the graveyard, which may hold some of my ancestors, family of a Janet Birston whose parents were married there in the 18th century, before she herself married Robert Philp in nearby Leuchars and raised their own family in nearby Dairsie where Robert was a wright in a village named Middlefoodie. Dairsie holds not much trace of them, though some of its cottages, along the main road, may date to this period. But every mile of the way, for me today, resonates with what I've heard, learnt, investigated and indeed imagined, with the links that seem to difficult to find, so tenuous, the scraps of paper and register pages (now digitised) that give bare-bones information at best.

From St Andrews I drove via Dairsie to Falkland, the small town which I'd last seen when driving my parents there when I was around 19. I could remember much of the layout of the palace, perhaps better described as the hunting lodge of the Stewart monarchs. The mother of my best childhood friend was from a Falkland family, so that for the small child in Dundee, looking across the Tay to the hills of Fife, 'Falkland' was part of the story of the land, of the legend and of my being. And, in passing through the chapel in

DUNDEE FROM THE LAW, LOOKING ACROSS THE TAY TO FIFE

Falkland Palace, I saw that the bible on the lectern was turned to a passage from the Book of Wisdom, which had been spoken at my brother Peter's funeral just a few days before (and selected by him, when he had planned the funeral in the knowledge that he had not long to live).

Ayont the Tay

"But saw ye naething, leein' Wind, afore ye cam' to Fife?
There's muckle lyin' 'yont the Tay that's mair to me nor life."
"My man, I swept the Angus braes ye hae'na trod for years."

O Wind, forgi'e a hameless loon that canna see for tears!"

The road to Dundee, for me, was through the Carse of Gowrie, where I stayed at a small hotel, noting the pictures on the walls, several prints from McIntosh Patrick. Other times, other journeys, have been over the bridges from Fife to Dundee, by train as a child in the compartments on the old trains, later driving over the road bridge of the 1960s, a road on stilts, initially a toll bridge, which carries the A92 from Newport to central Dundee. Before the road bridge, though, transport was often by the ferry from Dundee to Newport, a trip that my father and I took several times just for the sake of going by ferry: a way to entertain a small child who was fascinated by the boat, its size, its decks, the piers and even the lifebelts on the railings.

After my brother's funeral, I drove to the Carse of Gowrie and the next day up into Angus. Two days later, I was in Dundee, in a hotel at the foot of a road I used to know well, Dalgleish Road running from the Eastern Necropolis on the Arbroath Road south to the road to Broughty Ferry. I went first to the waterside, in the low evening sun, to watch the Tay, and the next day visited the small and very run down church where I was, on one or two occasions only, at Sunday school when aged around five; and then walked around the street of Broughty Ferry, rediscovering places where I used to go as a child when a visit to the ferry was a family occasion; and, after lunch with a cousin, finding where to buy McIntosh Patrick prints. That evening I went into Dundee, and to the top of the Law, Dundee's best vantage point, a volcanic cone giving views over the entire city, spending time gazing over the Tay to Fife, east to Broughty Ferry and Broughty Castle where I'd earlier seen the local museum, north to the Sidlaw Hills and west to Perthshire; and watched as the sun sank towards Schiehallion, the pointed peak over forty miles to the west.

Central Dundee next day was for me a connection with buildings, scenes, the quality of the late summer light, and foregrounded my other research of the past within the present, the past re-configured, the past that echoes as we walk through city streets as over farmlands or by cairns. In St Andrews, bolstered by histories, connections and indeed memories, I can still be a tourist. In Dundee, the emotional resonance is too great for that, although in some part the Dundee of my childhood is not the Dundee that presents itself to today's visitor.

In Dundee, the destruction of the memories of pasts, through the gutting of the city in the 1960s, left a gap, a hole in the feeling of the city centre that – at least it seems to me – may have contributed to the exodus of people in the mid to late 20th century. Dundonians know about 'The Overgate' and those I've spoken to (of several generations)

maintain that the built replacements for the late mediaeval streets were 'soulless' and something to be avoided. Indeed, in my memory several of the shops in this modernist shopping centre remained unoccupied, and others unprofitable. Today's 'Overgait' is a later build, from 2000, when the '60s modernist 'improvement' was torn down and replaced by – to me – something rather more in keeping with the city and with the City Churches which it frames.

So, the shopping centre of my remembering – and of the outrage of my parents and their friends, in the Dundee of the 1950s and 60s – lasted less than forty years. The destruction of its creation, though, removed four hundred years of history and archaeology, and though the present complex is interesting and in keeping, the sense of loss remains. The '60s construction did not only remove 'broken down houses' but scooped a depth of foundation for the new build that wrecked remains from prehistory through mediaeval and early modern periods. Anything of the ancient past was gone: and the documented outskirts of the mediaeval royal burgh, together with the still-present shop fronts and elevations of the 17th and 18th Centuries, or even the 19th Century 'improvements', had now no trace.

The discussions I heard, as a child, related to these destructions; these discussions were then rejected in the name of progress, but

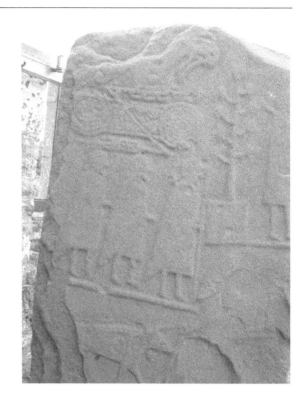

now the effects of the destruction are lamented by all I have spoken to within Dundee.

So much for history: in my journey I visited the areas which I knew best, both the centre and the lands of Craigie, which I knew as the streets in which I lived, off Old Craigie Road, up through a quarried area, and to the 'swanney ponds' of Stobsmuir, south by the High School playing fields at Dalnacraig and to the Arbroath Road, and east, over Old Craigie Road, to the Eastern Necropolis where owls lived. Notices on the ponds warned not to not touch the water, because of excessive growth of bue-green algae, and the whole visit was touched by the strange quality of the late-

PART OF THE EASSIE PICTISH STONE

summer light, the blazing sun which threw hard shadows behind every building, the late-evening sun which slanted through every street turning stone to a rich gold. And despite the algae, the swans were still on the ponds.

The Angus braes

To me, Angus beyond Dundee meant day trips with parents, to Forfar, Clova, Monikie or on the coast to Barry, Carnoustie and Arbroath. The Pictish stones of Aberlemno, and the so-called 'picts houses' (souterrains) of Tealing, Ardestie and Carlungie are part of the memories I carry. On my visit for my brother, time in Angus was limited. After reaching the

hotel on the Carse after his funeral in Lancashire, I began by driving to Forfar and to the priory at Restenneth. It had been associated with Jedburgh Abbey, an Augustinian foundation, from the 12th century, although the priory's antecedents went back further, possibly by 400 years or more; my visit was spur of the moment, and the link with Augustinian canons surprised me. In the mist of the morning, the day after my brother's funeral, the place held depths of history that I thought he would have

RESTENNETH PRIORY IN ITS LANDSCAPE

appreciated, and the scenery around was, on that trip, my first encounter with the remembered shapes of fields and hedges.

Forfar held a small museum, with a 'street' showing shopfronts for various trades of the early 19th century. For me, though, the Angus Folk Museum at Glamis held attractions, in memory of being there many years before, and in the fascination of artefacts many of which would have been very familiar to my people who worked on the land and in the small hamlets and towns of lowland Scotland; with now the added farm museum where I spent time hearing the stories of the curator, who had started as the 'boy' on a plough team and lived in bothies of Angus farms. And, while I could not easily see the carved stone in the grounds of the old manse in Glamis, nearby Eassie held another stone, which I had not seen before.

In the drive north, and in Dundee itself, I was partly following one Thomas Lynch, grandfather of my mother, from an Irish family but born in Dundee, orphaned early, and sent out by the Dundee parish council to be boarded in Kirkton of Auchterhouse, becoming a farm worker at an early age, marrying, leaving re-appearing in Glasgow, an unskilled labourer in a variety of jobs, though apparently quite literate. This Thomas Lynch was the link to the Irish Catholic immigrants in Dundee, which had given my brother pleasure in discussion, when I visited him a

week before his death. His later partner, another of the Dundee Irish community, had her being within a strong community of interlinked families, Connely, Cranley, Cassidy, giving some stability and some history with, one assumes, its own memories as part of this Irish influx of the early 19th century; but she died young, having given birth to my grandfather and his sister, and so left none of these memories to her children's children. Thomas, orphaned very young, had seemingly none of this, so that the braes of Angus, the ploughed field, the bothy and the plough team may for a time have been both family and history; and somewhere along the way he had picked up a store of poetry and literature that did become a family inheritance.

From Glamis and Kirriemuir, I drove by Meigle and Alyth by backroads and hillroads to and through the braes of Airlie, through places with names which in my childhood had a particular resonance as they pointed the way to the remote and unknown, the high hills, the foothills of the Grampians, a boundary between the known scenes of the lowlands and the Angus fields and the lands of romance, mythology and Jacobitism, the mysterious Highlands. As with everything else on my journey of memory, they held also other meaning, but always now unprovable or undocumentable, the stories of ancestors

who were maybe there, maybe not, the unfindable ones.

And so, here my written journey or even partial journal ends. This account does not focus on one place or time, but on many. It has pointed to the meanings created in and by an individual – me – by the juxtaposition of circumstance and memory, and it reflects some of the pilgrimage I made after my brother's death in August 2010. Yet it is not an account of that journey, but has followed the verses of the poem that my father used to read, a half-century ago now, in our house in Dundee.

There is an exception. The last verse of the poem reads:

"And far abune the Angus straths I saw the wild geese flee,

A lang, lang skein o' beatin' wings, wi' their heids towards the sea,
And aye their cryin' voices trailed ahint them on the air—"

"O Wind, hae maircy, haud yer whisht, for I daurna listen mair!

The wild geese were part of my growing-up in Dundee. They flew east in the autumn evenings, from the Carse of Gowrie out towards the flats of the Tay estuary shores, and to Montrose basin. Sunset skies streaked with red were streaked also with the great

THE 'FARM' PART OF THE LOCAL HISTORY MUSEUM AT GLAMIS

skeins one upon another, trailing their 'V' wings, hundreds or even thousands of greylag and pinkfooted geese, their calls filling the sound-scape as their 'V' wings filled the sky-scape; and the small child in Dundee, the *me* of yesterday, read stories from Ireland, Scotland and Scandinavia where the Wild Geese played key parts. Today there are still geese on Montrose basin, and on the fields of the Carse west of Dundee and the flat Angus fields to the east, and they still fly, but not as I remember. The land changes, the world changes, and I have not seen the great skeins on any visit for many years. There were a few geese, a small 'V' shape over the Forth, the last time I drove over Soutra towards Edinburgh, others seen on journeys in Fife and Angus, indeed others further south, but never now the expectation that the geese would be *there* and that their calls were an intrinsic part of the evening and the coming of winter.

But, for me the calls of the skeins are still in the landscape, as is my brother's memory, and as are all those who were my ancestors, working on the land and on the sea, shaping wood, stone, wool, creating, raising their children and preparing the produce of field and net. Today I am an anthropologist looking at how people look at landscape. Can anyone be in landscape without its holding meaning of some sort, whether banal, commonsense, mysterious or wondrous? Can

any landscape, cityscape, taskscape hold only one set of meanings?

For me, the scenes of this story, the Angus braes, Dundee and the Tay, the hills and towns of Fife, the Forth, Leith, Edinburgh, hold their particular appeals and enchantments. These are not all pretty, but include the sweat and blood of workers on docks and in farms, and the dangers faced by fishers at sea and their wives in childbirth. Tales, poems, experiences shape how I now see, and my seeing creates yet other layers of meaning. Ancestors, geese, herrings, field crops of oats or turnip, people howking potatoes, weaving cloth or churning butter, carving Pictish symbols, creating poems or crafting ships' prows, all these are there today, though we may not see them with physical eyes. And each of us who seeks will find some of them, though who and what we find will be different.

Notes

1 "The Wild Geese" by Violet Jacob Jacob, V: "Songs of Angus", John Murray, London, 1915 or on-line: http://www.gutenberg.org/ebooks/17933

Other versions are available on-line but often alter original language to make the work more "accessible"

2 In Scottish records until the late 19th century there is little consistency in spellings. The older version is 'Philp', particularly in Fife, but in the early 19th century it becomes Philip and indeed Philips and Phillips.

Smoke and mirrors

Stephen Grasso

All cities have magic. You just have to find it. For some, London is a mechanistic urban grind. A compassionless engine powered by seven million dreary and disillusioned lives that trudge back and forth across the City in their tremendous rush hour waves. Spilling out of holes in the ground each morning to labour at deskbound servitude or whatever menial task has been allotted, moving paper around for unknown masters, tinkering with abstract systems, selling anonymous product, keeping the machine well greased and oiled. Whatever you can do to keep the slow trickle of funds coming in. Whatever you can do to stay afloat.

Counting off the hours with cups of tea and cigarette breaks, we make it through the day until the silent bell rings and it's out again into tumultuous streets to fight the last desperate battle of the day. Tramping over the corpses of neighbours, co-workers, future partners, ex-lovers. It doesn't matter who they are. Through the commuter glaze, all heart and personality are boiled out, reduced down, distilled away in a perfect alchemy of intent. All that matters is your destination. Nothing else is real. With invisible machete you hack through a forest of meaningless bodies moving in space. Your space. It's best not to think of them as people. We bare our fangs and claws, and rend our way through the crowds. Those who fall behind, the weak, elderly or infirm, will be torn to pieces by berserker salesmen and maenads from accounts. Try to ignore them as they crunch underfoot. Doesn't matter, needn't be.

When you're a Londoner, the daily gauntlet of roaming tourists, charity muggers and free paper vendors becomes a background static. Possessed by an atavistic cruelty bubbling up from the back brain, you no longer even see them as individual people anymore, just a white noise of interference and delay. Fleeting mayflies to be crushed against the oncoming

horror of your concrete overcoat. It's the law of the jungle down here in the London heavy.

Like water down the drain, you flow along with the current of bodies, down the old Masonic channels in the manner that has been preordained by your rulers and betters. Now that the City is done with you for the day, you can disappear down the plughole again back to whatever hovel you crawled out of, and you do. Scurrying down below into an underworld of brutal florescent lights and clinical white tiled walls, disembodied voices and corridors that seem to go on forever. On entering this domain, you must leave something of yourself behind, and as a half-person begin your descent into a very British purgatory.

Time works differently down here. Nothing is fixed and nothing is certain. Two minutes can extend or contract in any direction, as you stand in perpetuity on the platform waiting for your salvation. Implicit rules and unexplained codes govern permitted behaviour. No talking to strangers, no eye contact, stand on the right, keep your head down. At every angle you are assaulted by enigmatic hoardings, offering mysterious products and services that may not exist in the world above, or perhaps pertain to some parallel London that shares an underworld with the one to which you belong.

Tin worms burrow through the darkness at measured intervals ferrying flesh and bones around an ancient maze. At peak hours the underworld becomes a frenzied night of Pan. Here in London's dreamtime, the sickness of the City is inescapable. Fear, futility and frustration growl beneath a thin membrane of civility and threaten to burst through in vivid paroxysm. There is no deliverance in this place. No sunlight ever reaches here. Carriages arrive and peel back their doors to reveal a grotesque mass of bodies pressed close to one another in immodest physical intimacy. It's individual constituents rendered sexless and neutered, in close embrace yet utterly apart. Hundreds packed together in an obscene collage of limbs, and sweat, and longing, but entirely divided, infinite miles from one another. It is a perfect glyph of the City. A dense Lovecraftian shamble that you must join.

The tunnels of the underground trace a boorish path through boneyards, plague pits and thwarted resting places for the dead. The air is thick with spirits down here. London is built on two thousand years of corpses, the sedimentary remains of the dead piled atop one another like a ghoulish layer cake of fossilised lives and forgotten cities that once were. On the tube, you are never far away from a skull or a rib or a thighbone. Spirits abound on the London Underground. Dead Roman centurions trying to puzzle out the implications of the East London Line extension. Regency swells unwittingly trapped

BARBICAN GRIME

forever on the Circle Line, unable to breach its magical barrier. Victims of blitz, and fire and homemade bomb howl through the endless tunnels, snared in their death rattle, nothing left of them but a scream in the dark. Lonely suicides pack the platforms of their demise, hoping for a fleeting glimpse of the loved ones they left behind. A thick soup of spirits caught in the gap and pleading for blessed release. But to the Londoner, these old ghosts are just another nuisance trying to take up more of your valuable time. "Sorry mate, got somewhere else I need to be." Keep on walking. It's somebody else's problem, but somebody else never comes.

London divides us by its sheer size and geography. You do not have enough time for even those closest to you, and you find yourself rationing out your affections like whiskey during wartime. The scale of the city is so immense that it fractures our relationships, but so densely populated that friction and opposition are inevitable. We keep our distance from one another, because it's the only way we know how to claw back any space for ourselves. We pretend we can't hear deafening cries for help and studiously avoid

desperate glances that try to pierce our armour. Secure in our portable shells we make uncomfortable contracts with our conscience and cultivate a necessary callousness for the faceless shambling zombie hoards that fill every street. Every day is the same. This is London. We are the dead.

All cities have magic. You just have to find it. This vision of London is a spell. A tawdry confidence trick built on misdirection and silver patter. Hoodwinked by City glamours and West End theatrics, we only see what we're told to see, but spells are made to be broken.

Scrape beneath the surface of any urban landscape and you hear the distant echo. Drift the streets with no intent but to commune with the spirits of place, and another vision of the city gradually comes into focus. Bloody fingernails prize up concrete paving stones to reveal a richly textured fabric of living tissue. Teeming with life and variety, forgotten, flooding awareness in an oil slick of sense impressions.

In the earliest creation stories of London, Brutus the Trojan was caught in a storm on his voyages from Troy, and amid the wreckage of his ship was witness to a vision of the Goddess Diana, the virgin huntress of The Moon. Radiant on the waters like so many incarnations of Our Lady from the Stella Maris to the Virgin Caridad del Cobre, each appearing to those in distress at sea. Diana

saved his life, and told him to build her a temple at the place where he struck land. He founded a city and dedicated it to her, Luan-Dun, the city of The Moon, and built her sacred temple upon the hill where St Paul's Cathedral now stands. Its pulsing lunar orbs like the ripe nipples of Our Lady, and its whispering gallery shot through with spirit. The dub echoes of history bleed through and its traditions continue undaunted. Until as late as the 18th century a mysterious ritual was perpetuated in the Cathedral called the Blowing of the Stag. The head of a deer was carried on a processional route around the church and then placed on the high altar, while the Sheriffs and huntsmen of London's great surrounding forests would sound their horns at the four quarters.

London partakes of the nature of its mother. The Moon is both radiant and treacherous. Often obscured by cloud, it looms into view upon occasion offering a glimpse of the infinite. Moonlight and music and love and romance are all on offer, and we stare transfixed by the possibilities and potential. Moonstruck, our gaze is held by the promise of London, its cold hard paving slabs reflect the gold majesty of the Sun and we're taken in by its glamour. The city is akin to a hall of mirrors, it offers all you can imagine, but its tableaux can be deceptive and distorted.

West towards Fleet Street is Ludgate Hill, and a crossroads that marks one of the seven

gates to the city. Like something out of Revelation, London has seven old gates. The gatehouses long torn down, the site of several gates are marked by a crossroads that traces the intersection of their entrance way and the course of the Roman wall that demarcated the original settlement. Any magician with half a clue knows that any crossroads functions as an entry point still, and with the right connections, can unlock the city gates and gain entrance to the mythic spaces of the city. Each gateway is ruled by its own specific powers and opens onto a different variant of London. Ludgate is solar in nature and ruled by Old King Lud, a monarch and protector of London who ruled around 60BC and from whom, according to one etymology, the name of London may be derived. Originally known as Trinovantum, or New Troy after Brutus the Trojan, King Lud renamed the City Caer Lud, or Lud's Town. A pub called The Old King Lud used to stand on Ludgate Hill, now closed down and converted into a chain restaurant, its facade still bears incongruous effigies of the forgotten king crowning its windows. Plaster statues of Old King Lud and his two sons, commissioned by King Henry III to adorn the old Lud-Gate that still stood during his reign, now reside in the church yard of St Dunstans in the West on Fleet Street. Just another London eviction.

Trace the ghost of the Roman Wall eastwards and it erupts into physical manifestation, its brickwork unveiled by falling German bombs. Lost fragments of ancient London excavated by shell and shrapnel. The site of Cripplegate obliterated during the war and replaced with the concrete wasteland of the Barbican complex. Knock on the Cripplegate and it opens to the dead. Maimed ghosts and mutilated souls endlessly follow the thread of coloured lines painted on the ground, an inadvertent spirit trap that amps up the toxicity of the brutalist estate. The chasm of London Wall cuts through the haunted desolation and its disembodied traffic settles at Moorgate, a medieval gateway that was not a part of the original Roman edifice. Moorgate is the backdoor of the city, an escape hatch for a quick getaway or a secret entrance by which undesirables may slip in unnoticed to carry out their shady deeds.

The Moorfields were one of the last remaining areas of open land around the City of London. The now-subterranean Walbrook River bubbled up from the Moorfields and flowed towards the Thames, giving the area its marshy liquid character. After the Great Fire of 1666, those made destitute and impoverished by the blaze settled within the Moorfields on the outskirts of the city, and the area became known as a haunt of prostitutes, outlaws and deviants. Today it houses some of the shabbier office spaces of the financial district, cheaper rents off the beaten track. When it comes to its Stews and

Rookeries, the City has a long memory. Dreary concrete rules, and the iron steps of Moorgate tube are weathered by the heavy footfall of generations bred to open letters, answer phones and enter numbers in the new feudalism of financial services serfdom.

Moorgate maintains its position as the borderland, and in these liminal spaces magic can be seized. In the short stretch between the crossroads of London Wall and Ropemaker Street, there are three layers of boundary. The echo of the original city wall, the jaunty silver gargoyles that mark out the territory of the Corporation of London, and the shadowy "Ring of Steel" - a cordon of security and surveillance fortifications that encircle the city, narrowed roads, concrete barriers, checkpoints, sentry boxes and a sprawling network of CCTV coverage. Which is the real wall? Where does London begin and end, and whose measurements should we trust? The space between these shifting palisades belongs to no-one, and it's in these flickering territories that the mirror between worlds is at its thinnest.

To the right of the Moorgate crossroads is the birthplace of John Keats, the lodging house where the sensory flush of English Romanticism drew an infant breath. To the left is Bedlam, the second location for the notorious Bethlehem Hospital. The original Bedlam was constructed in 1247 at the location now occupied by Liverpool Street Station, and relocated to the Moorfields in 1675. Patients were manacled and chained to the walls, brutalised by their captors, beaten, degraded and frequently locked away for life. For the cost of a penny, gloaters could take a tour of the cells and laugh at the freaks. Today, following another relocation, the centuries of misery and suffering that took place at the asylum are commemorated with a blue plaque above a branch of Pret-a-manger. City workers unwittingly sup their skinny Bedlam-mochas and bite into Bedlam breakfast croissants, oblivious to the history of cruelty that pervades the psychic fabric of the site.

Just north of the crossroads is Bunhill Fields, originally a Saxon burial ground, its modern name is a corruption of its historic appellation "The Bone Hill". In the mid-16th century, more than a thousand cartloads of human bones were removed from the overcrowded charnel house of St Paul's Cathedral and deposited at the site - a thin layer of soil spread over the fragmented remains to form a new gruesome point of elevation in the landscape. A century later, the site was used as a mass burial ground for victims of the plague, and later became a popular cemetery for dissenters and religious non-conformists. William Blake and his wife Catherine are interred upon the Bone Hill, their exact resting place is lost, but there is a memorial stone in the boneyard. Barely recognised for his work during his lifetime,

the shrine now overflows with flowers, potted plants, and coins in small denominations. Devotional offerings left regularly at the well-tended grave by admirers of Blake's visionary magic.

Yet perhaps the most striking element of the Bone Hill are its trees. Avenues of tall, spindly London Planes that claw at the sky like bony tendrils, mighty oaks and sycamores with roots that run deep through the ancient hill of bones, and sparsely scattered willows that seem to bend and weep for the departed like daughters of Our Lady of the Cemetery. It is a true bone orchard, under the patronage of Gran Bwa, the grandfather spirit of the forest who rules the island below the sea where the dead reside. At dusk, after libations of black coffee have been poured to the earth, it is as if the trees themselves are possessed by the ancestors. Great branches vivified by the wind, stark presences made of twisted bark, creaking figures of wood silhouetted against the night sky. The London dead make their voices heard to the living and speak of older cities subtly embedded behind the pulse and charge of our familiar streets.

Step south of the Moorgate crossroads and you enter the City proper. Trace the course of the buried Walbrook as she floods invisibly towards the Thames and you can almost feel her coursing beneath your feet, the true lifeblood of the city. London's undine, shackled underground and all but forgotten like her imprisoned sisters. The daughters of the Thames, sunk under concrete and tarmac, wiped from the life of the city like victims of a Mafia hit. The Walbrook, the Fleet, the Tyburn, the Efra, the Ravensbourne. Brutalised mermaids buried alive, scorned and clapped in iron. But blessed water is an irresistible force, and though it may be bound and culverted, where there is a river, it will always remain. Press your ear close to certain grills and grates in the city and you can hear the siren song of the Walbrook. A bitter, plaintive lament echoing upwards from the gloomy sewers of her rotten dungeon. Seductive, beckoning, the rhythm of her waters entices any who can hear it to her embrace. At the sound of her voice, it is hard not to stop in your tracks, try to kick up the curb, rip up the streets to free the nymph cast in concrete.

Cut down Great Swan Lane, hang a left, and again down Mason's Lane and you spill out into the courtyard of the Guildhall. London mythology claims this as the ancient location of Brutus the Trojan's royal palace. On his arrival at these shores, Brutus was challenged by two great British giants named Gog and Magog. The origins of these beings are ambiguous, as they appear widely in both Biblical and Islamic tradition, often portrayed as ancient ancestors of mankind that have been bound and might one day break free. According to the British legend, the Roman

emperor Diocletian had 33 wicked daughters who murdered their husbands and were sent into exile. Led by a sister called Alba, the women took to the sea, where they were eventually shipwrecked and washed up on a land that they named Albion, after the daughter Alba.

Here they coupled with demons and gave birth to a race of giants, of whom Gog and Magog were the descendants. When Brutus showed up, he had all of this to contend with before he could settle and build the city and temple prophesied by Diana. Together with the Cornish hero Corineus, he fought a war and subdued the remaining giants of Albion, renaming the land Britain, after himself. Gog and Magog are sometimes conflated into a single being called Gogmagog, the largest and most ferocious of the giants, who was defeated by Corineus in a wrestling match and thrown off a cliff at Plymouth. Another legend claims that Gog and Magog were taken captive by Brutus and chained to the gates of his palace at the site of the Guildhall.

The subtext of the Gog and Magog stories are resonant of witchcraft. The notion of Alba and her wicked sisters copulating with demons to produce an elder race of giants is highly suggestive of a similar tale in the Book of Enoch. Excluded from the Biblical cannon by all but the Ethiopan Orthodox Church, the Book of Enoch recounts the erotic coupling between the daughters of Cain and

a group of fallen angels known as the Watchers, Elohim or Grigori. These beings are alleged to have taught mankind the arts of writing, blacksmithing, sorcery, herblore, astrology, mirrors, cosmetics and the courses of the Moon. All the tricks of the trade. The offspring produced by this lovemaking between witch and devil was a race of giants known as the Nephilim, which are described in the Book of Genesis as "the heroes of old, the men of renown".

Today we tend to think of giants as monstrous beings of exceptional size, but it's a term that occurs in many mythologies and often does not refer to physical size at all. In many traditions, such as the Norse tales of the Jotunn, the giants are more akin to untamed forces of nature that dominated the earth in wilder times, but were subjugated by a younger group of deities. In these mythic narratives, there is an implicit threat that the chained Elder Gods may one day slip their bonds and wreak their havoc. That is not dead that can eternal lie.

Such stories tend to function as parables of magic. In this light, Gog and Magog might be considered the fierce, terrible spirit of the land itself. When you peel back all the layers of history, strip away all the old variant cities, and pare London back to its core - it is Gog and Magog that remain. Raging, dreadful land wights that existed here before even the first mud huts were built on London soil. The

courtyard of the Guildhall is flooded with this grizzly sense of pregnant expectation. As if something old and big is trying to force itself into the contemporary moment. Gog and Magog chomping at the bit, rattling the gates, tearing at their chains. Too big to fit in your head, all you see is an immense cross-section of a thing. The shape and dimensions of what you are looking at are unfathomable. It could be a fragment of elbow or the lobe of an ear, but even that is too much. All you can comprehend is the pressing in of something.

Carved wooden statues of the giants Gog and Magog are kept in the Guildhall and paraded through the city following the annual election of a new Lord Mayor. The earliest version of these carvings were destroyed during the Great Fire, their replacements lasted over 200 years before being wrecked in the Blitz, with the current statues presented to the Guildhall by a wealthy Alderman in 1953. England's ancient giants displayed by the ruling power like the spoils of war. Wooden voodoo dolls painted in garish colours and designed to humiliate and belittle their subject. The magic of the Old Boys is petty and mean-

spirited. Sorcery as imagined by a snide public school boy in short trousers. Terribly brave and confident about tormenting the lions when they are bound, sedated and muzzled. But what would happen if the manacles slipped?

Dwell on these streets for as long as you like, but eventually the force of gravity will draw you towards the crossroads at Bank. The fat ugly spider's web at the centre of the city. The Bank of England squats at Threadneedle Street like an ominous fortress. Its oppressively high windowless walls provoke an air of occupation. The grim battlements of a subjugating power that has prepared itself to defend against inevitable siege. Every so often it has to. Blood runs red on Throgmorton, and Lothbury knows slaughter. The stone ziggurat has huge iron doors on each side like Biblical seals, inscribed with symbols of Masonic significance. Rampant lions with serpent tails guard twin keys and keep watch. A gold statue of Shakespeare's Ariel surmounts the structure - broadcasting the dark magus Prospero's colonial domination of the airy mystery of commerce. Opposite on Prince's Street is the building where the first ever postmark was struck, and on nearby King William Street is the Church of St Mary Woolnoth, designed by Hawksmoor and incorporating a relief of Mercury on the outside wall – winged helmet

like the golden age Flash and Caduceus staff in hand.

Every crossroads is a place of power, sacred to Mercury, Legba and Eshu, and the Bank is best considered a spell etched in stone at the central crossroads of the Old City. An enchanted monolith that both physically consolidates and functions as a living repository of financial power – a black art wielded with such deftness and agility that we have forgotten that it was ever a spell. The most potent enchantment is that which embeds itself so thoroughly into our frame of reference that we can no longer imagine life without it. The Bank is the Old Boy's Pentacle, writ large. It dominates the landscape, but its labyrinthine underground vaults are reported to contain more space than the overground mass of the NatWest Tower, now renamed Tower 42, for decades the tallest building in the city. The area was allegedly a former red light district known as Gropecunt Lane, and the etymology of "threadneedle" is thought to be a euphemism for the activity most associated with the locale. It is perhaps then ironic that it would later become so closely associated with such a different breed of fucker.

A political cartoon by James Gillray, published in 1797, popularly characterised the Bank as "The Old Lady of Threadneedle Street". It personified the financial institution as an old dame with a dress made of pound

notes, being roughly manhandled by a predatory caricature of the then prime minister William Pitt the Younger. The image has since become a recurrent motif of political satire concerning the Bank. The ancestral wealth of the land endlessly pillaged and exploited by a succession of nefarious suitors. Nothing much changes in a bad house. The Old Lady of Threadneedle Street still on her knees, forced to turn tricks at gunpoint. Her weary body the property of an exclusive members club with tastes that run to the cruel and unusual. Attack-dog youths with slicked-back hair stride purposefully around the square mile beneath over-sized umbrellas emblazoned with corporate sigils. Astral parasols to ward off not just the rain and strain of nature, but other more abstract vexations such as personal responsibility or a sense of human decency. The Old Lady's degradation prolonged for centuries, now amplified to a fever pitch as her bones are picked clean in one final, gruesome feeding frenzy. A ruinous scene, but if you let these people into your house…

City adepts trade in cryptic thaumaturgy, charting esoteric fluctuations and manipulating arcane instruments to pillage and exploit without limit. Wicked magi peer greedily from the upper levels of dreadful, impossible towers. Steep Lovecraftian angles and diabolical geometry dominate the skyline, making a mockery of the landscape. Dabbling in the blood of the ancestors to line offensively-tailored pinstripe pockets. Each year, the meaning of value itself is further abstracted. No longer based on grain, no longer based on gold. It is taken further away from anything you can touch or hold in your palm. Pure number, pure idea, with nothing to underpin it. Economies of debt and hypothetical assets. A shadow-play of increasingly abstruse financial instruments that masks a crude snatch-and-grab. Desecrating the dead, ravaging the land, and selling out the unborn for temporal profit. But this is not the only game in town.

Other Societies hold sway. Our blessed dead are on the march. Cemetery Barons bow to no earthly authority, and by their mystery entrenched positions may be upturned. The wheel rotates and kings are made pauper. The pauper is made king. Ghede dances the banda through the Mansion House and the Royal Exchange. Step in time. Chim-chim-cheroo. The Man in the Black Hat shakes the palace and transgresses the iron doors of the Bank. In 1836, the Governor of the Bank of England received an anonymous letter from a mysterious personage claiming to have access to the bullion vaults. The letter writer offered to demonstrate this claim by meeting a party from the Bank deep in the vaults at an hour of their choosing. At midnight, the intruder revealed himself as a sewerman who had found a disused tunnel that led directly into the Bank, and speculated that the labyrinthine

complex may yet harbor further forgotten openings. No matter how much iron, how many cameras, or how many guns are brought to bear, the law of entropy will win out. All things tend towards a shambles. There is always a potential for change.

Something in the land seethes with fury and demands to be given voice. The crossroads territory in front of the Bank frequently serves as a theatre for this protest. Impromptu soundsystems and carnival performance. African drums refixed with dubstep bass shudder and masked MCs chatting vitriol and hope. Long-forgotten magic, buried centuries-deep, winds its way up from the soil of history. Neglected spirits, shoved down into the recesses of ancestral memory, claw their way out of tombstone retirement to have their say. Ye Olde English Egungun take to the streets, given shape and form by accidental mummers barely aware of the dead mounting their heads. Teenage guisers responding to some nameless call and instinctively taking on the apparel of Jack-in-the-green, the raggedy man, the soot-faced chimney sweep, the hobby horse. Old ghosts of England that will not be put to rest when there's work to be done. Enacting a drama on the front steps of the Bank, a chilling satire that cuts to the core, gets inside your head and doesn't let up. Like the scathing street theatre of the Ghede who march on All Soul's Day in Haiti. Resplendent in top hat and tails,

poking fun at the aristocracy, mocking crooked politicians and lampooning corrupt power structures. Their comedy and clowning has a bitter edge and stings with the knowing grin of death itself, taunting would-be masters of the universe with the cold facts of their own impermanence and the impending final kiss goodnight. You next.

You are done for the day. Turn your back on the City. Step onto London Bridge, and exhale. Once you get a few steps onto the bridge, something lifts. It's like leaving occupied territory, passing through the final checkpoint and letting something go. Perhaps there's some truth to the folk belief that evil spirits are unable to cross running water. Old Boys afraid of getting their feet wet. London Bridge is an idea that exists beyond the physical structure. Like something from the Platonic world of forms, the archetypal London Bridge endures through the centuries even though its material expression may be set fire to by Boudica, smashed by Danes, blown down by a tornado, or sold to gullible Americans and reassembled in Arizona. In a perpetual condition of falling down, the bridge occupies a space between worlds.

The human traffic on the bridge is unforgiving. TS Eliot's unreal city. A relentless twice-daily march of the living dead, back and forth from train station to work and back again. The trick is to never fall into step. Break the hypnotists gaze. Snap out of the dismal

rhythm and claim a space. Here, where the city intersects with the ancient Thames, all wicked enchantments are undone and we confront the one irrefutable fact of London. Outside of time. Her grey waters pulse a sinuous path below and bring life and freshness in her wake. The Moon and The River are the principle powers of the city, and all other would-be claimants are usurpers to that role. Presumptuous johnny-come-latelys trying to muscle in on a witch's patch. Stop at the centre of London Bridge beneath a Full Moon, and the shock of this old magic wakes you from the cold brick torpor of the homeward trudge. Black water and dangerous currents coursing below, amplifying the light of the Moon. Pale rays shimmer on the river. Caught in an ethereal feedback loop between two titanic forces, there is nothing to be done but give yourself over to this wild magic. The back recess of your skull seems to open like a flower at her silent bidding. Sleeping dragons shift and stumble in their slumber.

The eastern skyline is dominated by Tower Bridge, a steampunk memorial to faded empire. The relic of an unsustainable vision of Britain built on slavery and industrial exploitation. Dark satanic mills and the horrors of the Middle Passage. Its majestic turrets a wistful reminder of the long-vanished glorious dream of England that was always illusory and concealed a hideous crawling underbelly. In the distance, the blinking

Sauronic eye of the Canary Wharf tower gazes over its dominion. A pyramid-headed alien sentinel charged with overseeing the subjugation of south London.

Up ahead at the end of the bridge is the skeletal frame of The Shard, still under construction, but due to be the tallest building in Europe. The architectural plans depict it as some manner of enormous technofetish inquisitor's hood or dunce's cap, overwhelming the Borough with its grotesque scale. It signals the intention of the city to spread its wings into territory that it has traditionally shunned. Only a matter of time before the whole terrain of urban residential London is consumed. – but for now, south London remains our rebel patch.

At the southern end of London Bridge is a busy crossroads that marks the site of the old Stone Gateway, the doorway to south London where the Old Boys used to display the skulls of their enemies as a grisly deterrent. The decapitated heads of traitors were dipped in tar to preserve them for longer, and stuck on pikes above the gatehouse, up to thirty at a time. The Scottish hero William Wallace, Watt Tyler, leader of the 1381 Peasants' Revolt, Jack Cade and his conspirators who led a similar rebellion in 1450, and St Thomas Moore who coined the term "Utopia" all ended up with their heads on the wall. The practice of dressing the southern gate with rotting human skulls lasted for 355 years, and

was finally discontinued in 1660 with the Restoration of King Charles II. A busy crossroads produces something of a vortex for local spirits, the churn of activity across time exerting an irresistible magnetism for roaming ghosts. The spectral disembodied heads of our London rebels, heroes of the resistance and traitors only to the rule of the Black Iron Prison, still congregate around the site of the Southern Gateway, muttering words of insurrection like foul-mouthed Cherubim.

South London has always lured in sorcerers and witches. John Dee had a house at Mortlake on the south bank in Richmond - where he amassed the greatest library in England. He died at Mortlake around 1608 but his gravestone is lost. Mortlake is also the home to the interred ashes of that other great English magician Tommy Cooper. The 19th century occult society, the Hermetic Order of the Golden Dawn - whose members included Aleister Crowley, Arthur Machen, WB Yeats and Florence Farr - has strong south London connections. It's founder member, SL MacGregor Mathers, worked as assistant librarian and ultimately curator of the Horniman Museum in Forest Hill. The museum's bizarre assortment of tasteless taxidermy, Voodoo altars and exotic musical instruments was the collection of wealthy tea importer Frederick Horniman, whose daughter Annie Horniman was a member of the Golden Dawn and bankrolled many of

the order's activities. William Blake received his angelic visions at Peckham Rye. The artist and magician Austin Osman Spare was a long-term resident of south London, making his home around the Borough, Brixton and the Walworth Road. Having become estranged from the mainstream art world and the attentions of the Royal Society, he displayed his art mostly in pubs near where he lived, painting portraits of locals for beer money.

Push out further south to Elephant and Castle, Brixton and Lewisham, and catch traces of Voodoo and obeah operating beneath the radar. Spiritual temples behind closed doors, root doctors working out of low-rent pubs, churches where Sunday services culminate in spirit possession, fly-by-night market stalls selling seven day candles and 'keep away evil' floorwash, rebel soundsystems holding space.

The stretch of land from Camberwell, all the way out as far as Croydon, was once a dense forest known as the Great North Wood. The area's prehistory is reflected in local place names such as Norwood and Forest Hill. Isolated patches of the once great forest remain, such as the adjoining Dulwich Woods and Sydenham Hill Woods, and the woodlands of Beaulieu Heights in South Norwood.

Norwood is gypsy territory. The area's long relationship with the Romany people remembered in place names such as Gipsy Hill and Romany Road. South Norwood Hill itself

was once known as "Beggar's Hill", and such was the gypsy's fame in the area that a pantomime called "The Norwood Gypsies" was staged in Covent Garden in 1777.

In the diary entry of Samuel Pepys dated 11 August 1668, he records that his wife and her friends Mercer and Deb had their fortunes told by the Norwood gypsies. The most famous of the fortune tellers at Norwood was Margaret Finch, regarded locally as the Queen of the Gypsies, who died on 24 October 1740 at the venerable age of 108. After traveling the whole of England, she settled at the lower end of Gipsy Hill and was visited in great numbers by people from all walks of life who sought out her clairvoyant powers.

Finch was buried in the cemetery of Beckenham Parish Church in a deep square box. In life she had adopted the habit of sitting on the ground with her knees drawn up to her chin - and became so atrophied in this position that she could no longer extend herself or be extended, and had to be buried in this doubled-up pose. She was succeeded by her niece, Old Bridget, who took on the mantle of Queen of the Gypsies until her own death in 1768. Bridget's own niece Margaret was the next to hold the title, and another of Finch's descendants, a Mrs Cooper, was still telling fortunes at Beulah Spa during the 19th century.

From the late 18th century onwards, however, there was a concentrated effort by the authorities to stamp out the gypsy presence in south east London. In 1797, the police arrested 30 men, women and children under the Vagrancy Act; and in 1802, the Society for the Suppression of Vice brought charges against the Norwood fortune tellers. But the main social change that drove the gypsies out of the area were the Enclosures Acts instituted during the period, which literally sold out the ground from under them. An isolated camp of gypsies lingered in the still wild Dulwich Woods for a while longer, and, as late as 1808, a hermit called Matthews the Hairyman occupied a cave in the same woods, but a work of malefic magic had begun that would eradicate such characters from the landscape with grave finality.

The Enclosures Acts, the bulk of which were passed between 1750 and 1860, amounted to an unscrupulous landgrab by the aristocracy in which land formerly considered "common", the wild public spaces belonging to all but owned by none, was fenced off for the private benefit of wealthy landowners. Traditional rights such as mowing meadows for hay or grazing livestock on the land were removed, as was the right to make use of natural resources within the landscape such as wood and water. It spelled the end of the Great North Wood and much of England's once extensive forest land, and terminally compromised those that sought to make their home in these free spaces. A whole class of

people were dispossessed of the land they had used to sustain themselves and their families, as the ancient occupation of subsistence farming became untenable. Marxist commentators identify the Enclosures Acts as the mechanism by which a disenfranchised landless peasant class was forced to participate in the capitalist system, maneuvered into a predicament where they had no option but to seek work in the cities and in the factories of the newly industrial north.

Over the course of a few generations, the entire frame of reference by which we relate to the landscape had been undermined. The wild green portioned off and divided up among those who had no right to embezzle it. It was taken by force, and the apparatus of the state used to create legislation after the fact that justified what was effectively class robbery. An anonymous protest poem from the 17th century bemoaned:

> *They hang the man, and flog the woman,*
> *That steals the goose from off the common;*
> *But let the greater villain loose,*
> *That steals the common from the goose.*

The wicked enchantment of the enclosures was a direct assault on the notion of common space. It worked to reframe our culture's relationship with the land itself, so that every scrap of territory became the property of a landowner. If you can successfully destabilise a person's sense of their right to simply exist as an animal in the jungle, it becomes an easy task to reposition them as functional units within a new frame of reference that solely exists to create capital.

In this way, we are nudged further away from the condition of experiencing our natural environment in a way that is anywhere akin to how a crow or a fox or a cat might inhabit it. Our instincts of animal kinship with nature are increasingly eroded as we are taught that there is no forest, no jungle or Garden of Eden. No primal landscape left for us to inhabit. The land no longer simply is. No scrap of turf exists only for its own sake, and our very presence on the planet as physical objects in space is ultimately subject to the sufferance of those shadowy personages that we are told own that space.

When this lie is sold, the scaffolding is put in place to create more subtle and conceptual variations of serfdom that annex the roots of being. Once you have been persuaded that every inch of ground beneath your feet is the private property of another, a fundamental disconnect with nature is established. Old Boys rub their hands together and salivate over the prospect. Nature is terminally othered. Framed as an inanimate resource owned by someone else, and theirs to pillage and exploit at will. Over the course of a few generations we are increasingly separated from the landscape itself, the course of the seasons, and any sense of our ancestors and the continuity of being. Recast as isolated

units of flesh divorced from nature, little brains set in walking meat, we're herded through a hall of mirrors constructed to produce wealth. Continually subject to a sophisticated onslaught of word and image, prodded around like nodding dogs, toiling in cubicles, scraping out whatever pleasures we can before an abrupt cremation. Stark confrontation with the mysteries of wild creation is not even a distant memory, and magic is just a fairy story sold back to us in multiplex cinemas.

Yet Gran Bwa endures. The predicament of the Old Boys is to be perpetually working against the grain of things in order to sustain a profitable yet artificial illusion. It is a clever spell. A tawdry confidence trick built on misdirection and silver patter - but spells are made to be broken. The only real fact to be had is our animal existence in a sensory landscape. Deep in the woods, this is brought more clearly into focus. A profusion of verdant limbs coil and snake in a lavish tangle of form. The spidery irregularity of their branches claw at something within. Horse Chestnut gives rude flower and Hawthorn draws blood. Green hues and mossy textures abound. A living canvas of olive and russet, black and citrine. Soundscape of avian assembly and insect striving. Scent of sap and trampled grass. Sudden thunder of sensation as dulled senses stir and wrap around ripe stimuli. Intoxicated and inflamed with

thwarted longing, we drink in the world through the sacred openings in our body. In this moment there is no separation. We are the forest. Our thick-set roots coil through the ancestral dead and the eager exploratory tips of our senses press out like keen budding shoots. Washed clear of the grind and glamour of the city, a full sight of our miraculous circumference slopes into view for an instant. All of nature in our blood, awake and aware beneath a blazing life-giving Sun.

But it is not enough to beat a retreat. Too much is at stake to make like Matthews the Hairyman and flee into a leafy hole. This embodied awareness must be made to flourish in the sink estate and urban waste. If magic is to be more than parlour trick and novelty turn, something has to be brought back. This same sensory communion with place must be cultivated in regions that are the least conducive to it. It is an easy task to slip into visionary reverie in untamed spaces, but can you do it in Croydon on a Saturday night? Can you do it on the Tube in rush hour?

The imperative of magic is to reshape our experience of each moment as it comes into being. Magic throws off the shackles of deceitful illusion and penetrates through to the raw pulsation of existence that underlies such imposed narrative. This visionary awareness understands that no territory is profane. If the primal forest is a sacred terrain, its mystery must underpin all else. There is

nowhere that the jungle is not. Neglect a London garden through the spring and the true face of the landscape boldly asserts itself. Leave a city to its own devices for even a short time and it starts to revert to what it fundamentally is and always will be. Gran Bwa is the process of growth through time, and the fleshy human branches of this tree of being, subject to the tides and seasons of life, are no less participants in this process than the wild flowers that push up in April and are gone by July. Whatever else we build upon the foundation of this baseline reality, does not change where we are. If there was ever a fall from the Biblical Garden of Eden, it was caused by our willingness to forget this primeval condition, and is sustained by our complicity in burying the potency of its memory. Nobody ever went anywhere else. There is nowhere else to go.

So the task for a witch is to grasp the magic of the city and become one with its living ecology. Understand its curves and contours, the sacred hills and buried rivers, that may have become obfuscated over time but are nonetheless there. Stand strong at the crossroads and hear the churn of spectral traffic. Fathom the mirror between worlds and soak up the echoes of history. The sediment of lives and times that thrived and died in the place where you are standing. Learn the network of improvised Poteau Mitans erected throughout the city and how to access the specific powers they tap. Trace the boundaries and markers, the walls both vanished and ephemeral, and occupy the spaces that evade any map. Take the underworld journey in full awareness of its Hadean premise and the fractured ghosts that howl below in striplight purgatory. Pay attention to the chatter of damaged phantoms delivering garbled cut-up broadcasts from the city's unconscious netherworld. Come to recognise the imbalances and toxicity that corrupts healthy growth and study how to treat wounds and administer to infection.

Make ambassadorial visits to the boneyards of your patch and strike up alliances with the local dead. Hear the opinions and grievances of the skeleton court, and provide a medium for their cobwebbed voices to be heard above ground. Feel the Moon and her tidal currents as viscerally as if you were at sea. Inhabit the storm and savour the chill wind and cold drizzle of your town as if it were the stroke of a lover. Take frequent sojourns in the wild corners of the city, be it surviving forest or neglected scrubland, and step back into concrete conurbation refreshed and reminded of where it is you live. Embrace the Sun in its daily rising and yearly circuit, and let the cells of your body be nourished by its cosmic battery. Come to full awareness of your being as a marvelous animal within space and time. A double-headed trident of living tissue with two upper appendages to

grasp and shape all things, and a conscious orb bestowed with five rich senses to embrace and intake the world. Two lower limbs to traverse the face of the earth according to your will, and a magical organ to create new life and share delight.

While shady consortia may conspire to diminish this wholeness of being, entangling newly-fledged branches with reams of poisonous narrative and constricting our full expression to an exploitable spectrum of awareness and behaviour, such risky ploys can't hold up forever. It's a fragile house of cards. No matter how secure the vaults of your bank, there is always the opening that you haven't thought of, the secret tunnel that you never knew was there. The grass always grows. You remain subject to Gran Bwa, and however well crafted your subterfuge or how many generations have been brought within the thrall of your legerdemain, the Wanton Green plays a longer game. While there is the Green, there will be its witches and magicians, and the opportunity remains to cast another, better spell. Magic is a force of liberty. It topples ill-built towers and causes great forests of ideas to grow in their place. It creates meaning within each moment, and can undo wicked spells and shatter duplicitous enchantments like brittle glass.

Break the hypnotist's gaze. All cities have magic. You just have to find it.

Out of America: between this world and the next[1]

Maria van Daalen

When we at last left the parking place in front of the cemetery, it was almost deserted. My brother, who was driving, kept telling me all the way back to Amsterdam what a good family thing it had been, while the children in the back were being noisy, and his wife put her head now and then between us with an odd remark, mostly concerning my stepmother. I was sitting in the front seat, 'shotgun', as I had recently been taught, in Iowa, by my young lover, and it felt like shotgun, because I was the eldest of the six, because I had to watch, had guided them into the two rows: my own sister before me, before her our very young stepsister, at the other side my own two brothers, and behind them and align with me, the much younger stepbrother who is the only one taller than I am; I overlooked the scene quickly in the warm sunshine and made the slightest gesture with my right hand; we took a firm grip of the six handles, and lifted the coffin.

Not one of the things I have wanted to tell seem to stay in place; everything is shifting all the time; my brother's son, Laurence, whose verbal skills with all of his eight years already outdo mine, walks silently up to me, puts his hand into mine, gives me a quick glance through his eyelashes, hangs his head demurely, lips somewhat pursed as if tasting an onspoken 'thank-you-for-what-you-said-about-grandpa'. Some months before, when in the morning he finds out that I am leaving his parent's home that day, and that none of his promises to me can keep me another night, he takes a stand at the bottom of the stairs, looks up to me on the second floor

1 Read at the Short Story Conference, Cedar Falls, Iowa (USA), June 1996

('Laurence! You have to go now! Your mother...'), sighs, and pronounces carefully his last bid: 'Do you want to marry me?' But we agreed that it was maybe not the right day yet, and now we walk in silence across the cemetery, at the head of the family, the sun shining happily upon the flowers and the crosses, the stones grinding beneath our feet. He is the only living one I ever dedicated a poem to, when he was two years old, I called him Dionysos, and now he leads me to the exit, solemnly, the guiding of souls.

I close my eyes and I open them, and there I am, with Hans and Rudolf, on the train, running into Germany. It runs past the Loreley, along the River Rhine. I am dragged ever deeper into a story where I don't want to go; the afternoon fades, Hans and Rudolf are already drinking, 'Don't you be unhappy, girl, this time we really have got you a handsome dark man, he is sure to be at the conference'. I am dead tired and I try to smile, I try very hard to be the nice, smiling Secretary of the Dutch PEN-Board. I am not offended, of course not, I used to be Dutch, I know them, they are barely eight years older than I am and I do not belong here.

'Let's have a walk through the streets at night.' The narrow medieval streets are deserted; cobblestones, we call them 'children's head's', my high heels make a strange sound, Hans and Rudolf want another drink, and yet another. 'White wine, but you should try it, girl, this region, it is unsurpassed.' They enter the hotel at midnight, we enter the hotel I was going to say, but when I am in my room I can't even think of sleep. I don't want to take my leather jacket off. I stalk restlessly around in the room, then I decide to go down again. Maybe a drink. If I close my eyes I have to close the coffin again. I need to go outside.

There is no outside in Heidelberg at midnight. The man at the front desk is sorry for me and tries not to show it; yes, there is a discotheque, yes, one, it is open till three o'clock, you just step outside, then to the right, you walk straight down the road. 'A taxi? No no, not needed, certainly ...'

It would be murder in Amsterdam, to send a woman out on the streets like this, I feel how my tears inside turn to rage, and I walk, out of the door, my back straightened; men, my goodness, idiots, but I have got time till 9:30am, breakfast.

I head into the night, into the main street of Headquarters, a narrow valley between the 2000 feet high, wooded hills, hills invisible but for the blocking out of stars. All is dark, all, really, what a city, only one discotheque sign, shining, 'Billy Blue', whatever that may mean. In front of the entrance is one man, standing. I slow down my pace and glance quickly. He is black. ('Is he black', M., who is an African-American, will ask me later, much later. 'Or is he black black black?' I didn't know you could do that with language.) So I ask him in

German if he is leaving, and he answers in American English, cautiously, that he is. His voice sounds like sixty, not like the forty-odd that his face shows; a voice with cracks all over; earthenware that has been broken and mended so often that it has become impossible to make out the original design. He embodies caution: he is waiting for me: to make the next move, to shift grounds, to answer. A smile covers only the lower part of his face, from the jaw up till the cheekbones; in his eyes the question is death. I feel very comfortable. I have death all over me already. Let's have death tonight.

Within seconds we walk further down the street, ever deeper into history, more cobblestones, a fountain, 18th century houses, 17th century houses, chatting happily: about Vietnam, about Desert Storm, about the necessity of carrying a nine millimetre to protect yourself. There is no one about in Heidelberg, but somewhere at a corner one other streetsign is lighted, and we enter another catacomb, with drowning sounds and ever shifting colored lights, and this time I'll have a drink. Didn't my house-owner tell me, helpful, on the phone from his Californian home, 'Kiddo, get yourself a nice blonde-haired, blue-eyed...'. I try for a moment to picture his face when I will tell the story, the essential part is to tell the story, the timing, the elongating, the quickening; the seducing.

I enter the lobby somewhat after three and casually hold out my hand at the desk; the waiter stares, stares past me, does he notice death? He grabs behind him and offers me the key as if it burns. I don't remember the elevator, nor how we got in; I remember a yelling, or crying, or both, at some time; something that resounds at the same level as death, I was laying flat, my head backwards over the rim of the bed, a scene from Fassbinder's "Die Ehe der Maria Braun".

Three hours before breakfast I enter the darkness; when I open my eyes it is 9am and he has left me one of the three pairs of trousers that he was wearing. I can barely squeeze an arm into one of the legs.

Downstairs, Rudolf and Hans are waiting, sitting across from each other, leaving me the only seat at the head of the table. They are already having coffee, they glance at each other before I am seated, they look condescendingly at me, 'Well, girl.' 'Thank you', I reply, 'It was perfect', and when I start telling the story in its barest outlines, I see the unbelief rising in their eyes, they look at each other, no, she is telling a story, because ... She is a writer, so are we, she is lying. I am the secretary, I smile sweetly. We go together to the conference and I take notes. We have lunch, and I listen smiling to their jokes about women. We go back to the conference, there is a war going on, West Germans versus former East Germans, and I take notes. We

have dinner and we enter the lobby of the hotel.

'There has been a call for you', says the girl behind the desk, and hands me a pile of fluttering notes. 'Bobby', they say, spelled out in different ways, whether the writer was from Morocco, speaking German and trying to understand American English, or from Tunisia, or just German. Hans and Rudolf exchange glances behind my back. Thank you, my dears. I don't want to sleep. I can't. At midnight I run down the stairs again, with my glass slippers, but what is outside waiting doesn't turn into a pumpkin. It is a red limousine with a veteran at the steering wheel, here is death for you, the ferryman rows me across the river, drives me full speed to eternity. Fortyeight hours after flying into Schiphol Airport, Amsterdam, from Iowa City, US, to Europe, I am in America again; the shop is open 24 hours, and the Lexington, bar, dancing and bowlinghall, is noisy, is full of a hundred warriors in their early twenties, American and African-American and German, all behaving feverishly happy, like in West-Berlin before the perestrojka, all keeping European distances, so that the place seems to be far more crowded than an all-American bar can be. We are in the wrong place because we have the wrong age. They call him softly 'cat daddy', the other word that is coined, for me, and that I only am told directly days afterward, is 'stallion'; so much for gender,

odd, it adds to the nightmarish quality of the otherwise so familiar American surroundings. Maybe the only one who is wrong is me.

'Let's go buy flowers', says Bobby. After half an hour stalking around, amidst all-American wealth of food, I walk out with popcorn and Pepsi and a bunch of white flowers and one rose, the colour of which in Dutch would be said to be: black. I'm sure I've never seen a rose that colour before, in this reality. But I know the black tulip, a rarity, the flower that was an obsession in many a 17th century life, the flower that ruined lives and finances of buyers and sellers alike. I put my flowers somewhere in my room, forget later on to water them, forget later on also to take them with me, though it can scarcely be the lack of sleep, it doesn't seem to hinder me, I'm on an island of nothingness in the ocean, amidst the turmoil, I'm located on one of the Western Isles, the region of the apple trees, where the king comes to life again; as long as I do not close my eyes he cannot die.

In the daytime I watch the conference, the fights, the arguments, I'm the observer in a time of war; I take notes. At night the world turns, and I am allowed to visit the enchanted castle that only is a cairn of stones near a circle of dancing stones. Who enters the circle looses his soul and one of the stones comes to life.

For three days and three nights the world does not end. Let's dance. I close my eyes and

I open them, and I stare at the white tablecloth in front of me, at the glass pepper and salt containers, at the goldrimmed cups and saucers for coffee, at my glass with ice tea and a slice of lemon. I stare, and slowly the table begins to revolve, it is revolving, I decide that at my right hand the Mad Hatter has left the table, while left and halfway behind my back the White Rabbit nervously plucks at his gloves, watches his watch, and mutters; the table revolves, and I lift my glass with ice tea and take a sip, slowly; with every next sip the slice of lemon floats deeper under the surface, every next mouthful tastes more sour than the one before, but it is a sour taste that matches the growing bitterness in the depth of the glass, it is a sour that is near to sweetness. And I empty it, and I start shrinking, shrinking, into my wordings, into a sigh at the end of the sentence. There is no one about.

Standing at the crossroads

And what comes next? A lot of *The Wanton Green* is reflective and celebratory but any of our authors are actively engaged with working for change in all sorts of ways. We offered space for a few final words, issuing an invitation:

But the environmental challenges that face us are (may be?) fierce and immediate. So does the wind whisper to you of action and danger or does the breeze simply blow as it always has, careless of the way we humans stamp across the world? Do those ancestral voices or the muses bound up in the halls of museums sing in ancient choirs of past crises and the endurance of stones or speak of arming and action and a struggle ahead…

In no particular order….

And next …
In some the anticipation is revealed as trembling
But the cold panic of fear is now all gone
Our eyes are wide open, but our breath is slowing
Hearts gently pounding as our feet have done
On the sweet soil of this land, the days of our living
Now sitting in the fallen leaves, one by one
We wait in this silence, more dreaming than thinking
Watching the rising of the perfect golden sun
Feeling the pulse of our tribe now accepting
The die cast by the gods we've depended upon –
And as the shining waters approach the first weary feet
We sing songs of devotion, of thanksgiving, of merry meet
Emma Restall Orr

'what next'...?

"We walk a lonely path, but upon it we encounter many facets of ourselves returning to the Source. The best advice I was given by my own mentor for a successful quest was as follows: never cease to question, always listen to the wind, your heart and to those with whom your soul dances; seek the companie of angels; aspire to grace; live each day with meaning and purpose; counsel the self in all matters; but finally, and best of all - follow the directive of the 'Master Therion' - *invoke often, inflame yourself with prayer!*"

Shani Oates

Afterword

The circle turns and the folk awaken from their long sleep and begin to remember the ways of their ancestors. Once again they hear the voices of the gods and goddesses in the wild places, in the barren places, crossing thresholds unseen by the eyes of man. Woden speaks in the wind howling through the branches of the forest, Freyja dances barefoot through the wild flowers of a sunlit English meadow, mighty Thunnor rides his chariot through the great storm clouds and Frey again welcomes the wanderer deep into the heart of the grove. The gods, the land and the folk are one, in learning to respect and care for the one then we learn how to respect and care for the all.

Runic John

What next? Sense the wisdom of the body: Not just the skin-bound self - though that has juicy wisdom - but the deep body as it ripples out across the pool of life.

Adrian Harris

So, what has this path taught me about moving into the future? It has taught me that dancing redefines death and destruction. It has taken me to places where I would have predicted meltdown and shown me my capacity for courage and calm. It has compelled me to continue to celebrate life and beauty, to relish being alive and active and to respond fully to this green springing, cycling world. It girds me to live passionately connected to a planet whose life I fear is doomed. It strengthens me to face the destruction, to argue against it, to paint visions and tell stories that fall on deaf ears. It tells me to keep my balance and be prepared to move.

Susan Cross

The river swells in the evening – I hear it plashing against the jetty and the voices begin to murmur;

"…yes, once the water here was so clean we could drink from any stream or river…

….now it is black and many living things die or it is red and all creatures suffer…"

"What do you mean amoeba in the water? Is that a kind of bacteria?…."

They sing:

You are the people of the ***prophecies;***
You are the ***people*** of the prophecies
You ***are*** the people of the prophecies

Ask yourself – who else would it be?
Time to wake up!
Lou Hart

And the stone said, "Why bother? Why worry? Relax, give yourself back to the passion of the mountain growing…."

And I said, "And you will crush me, grind my bones to pulp in the strata of the hills and I will lose myself in the long slow life of stone"

And the stone said, "Everything returns. Everything comes back to stone in the end."

And I said, "But this time, I am living the short life of flesh, of tree and fish, insect, flower, bird and beast. And in this world I give myself to that story and to the richness of it. And I will fight for that, work to the ends of my bones for the patterns of these short flashing lives to have the freedom to grow and change and brighten the world with the wonder of their passion.

And the stone said, "Then we wait. All returns to stone in the end and a space will wait for you in a cave in the hills when all this is over."

Gordon MacLellan

Meet the authors

Jenny Blain

I was born in Dundee, grew up reading mythology and interested in anthropology, studied at Napier in Edinburgh, then at Dalhousie University in Halifax, Nova Scotia. I returned to Britain at the millennium, now run the Master of Research programme in Social Sciences at Sheffield Hallam University. As a practitioner/academic, my books include *Nine Worlds of Seid-Magic* on north European shamanistic practice, and *Sacred Sites, Contested Rites/Rights*, with Robert Wallis, on pagan interactions with prehistoric landscapes. Currently my focus is partly on Thornborough Henges in North Yorkshire, partly on the 'British reburial issue', and increasingly on how people – including myself – do 'family history' in contexts of lowland Scotland, and what this means spiritually and emotionally to us.

Susan Cross

Susan Cross has always been fascinated by the relationship between people and place and has spent almost all her professional life exploring this. She works with heritage and countryside sites in the UK and Ireland, helping people to share their stories and significances. This has always involved listening carefully to anyone and anything with something to say about the site and a belief that our connections with our environment are of profound, multi-faceted importance. She is also a poet. About a decade ago she has realised that she has probably always been some kind of animist mystic and since then has endeavoured to make that a more conscious, clearer and brighter part of her life. Susan can be contacted on susan@telltale.co.uk

Woody Fox

My name is Woody Fox and I've been a witch since my 1st initiation 34 years ago. I work with the Faerie races and the spirit world, (my totem is the beautiful Fox), and for the last 12 years have also been a devotee of the Horned God Cernunnos. I earn my money from illustrating children's books and making willow sculptures. I live in Devon in a little thatched house, up a dirt track with my lovely partner Drew, two cats and a whole court of independent Faeries.

Stephen Grasso

Stephen Grasso was born in Newcastle and lives in South London. He writes about the occult, African Diaspora magico-religious traditions, music and culture. His work has been published in Strange Attractor Journal 4, Abraxas, Dreamflesh, Generation Hex,

Devoted and XVI. He has a blog at :
cleanlivingindifficultcircumstances.blogspot.com
and is a regular contributor at
liminalnation.org. He buys a lot of records
and can move between worlds.

Susan Greenwood

From a very early age Susan liked snakes and
earthworms. This interest led her to explore
magic at the bottom of the garden, and then
later in a witchcraft coven. After completing
an undergraduate degree she decided that she
wanted to find out more about magical
practices, this led to a PhD in anthropology
and three academic books: *Magic, Witchcraft
and the Otherworld* (Berg 2000), *The Nature of
Magic* (Berg 2005), *The Anthropology of Magic*
(Berg 2009). She has also written *The
Encyclopedia of Witchcraft and Magic* (Lorenz
2001 and other editions). Susan has taught
courses on religion and magic at various
universities, including the anthropology of
religion at Goldsmiths, University of London,
and Shamanic Consciousness and Altered
States of Consciousness at the University of
Sussex, where she is past Senior Visiting
Research Fellow. She is now writing a magical
methodology with the aid of a dragon and
still likes snakes and earthworms.

Melissa and Rufus Harrington

Melissa is a Wiccan High Priestess who played
a key role in revival of the OTO in Britain in
the mid 1990s, while managing London Pagan
Federation. She is now the District Manager

of the Pagan Federation in the North West. Her main focus in life is raising their young family in the countryside of Cumbria. Here she still practices magic, and trains a few initiates in Wicca and the Western Mystery tradition, but much of her personal focus is on a gentle connection to the seasons, to Nature and to the deep beat of the earth's heart. Melissa was awarded a Ph.D for her research on men and Wicca, and continues to write on Paganism and magic for academic and Pagan publishers.

Rufus is a Wiccan High Priest and initiate of the Western Mysteries who has spent many years studying Elizabethan magic. He

has reconstructed the rituals of that era's most famous mage, Dr John Dee, using Dee's original manuscripts, and related documents. A renowned expert on Elizabethan magic he is the founder of the Enochian Magical Order *The Temple of Flame.* He is a Consultant Cognitive Behavioural Psychotherapist, with practices in London and the North of England, and an ex-Vice President of the Pagan Federation,

Melissa and Rufus have been practicing the Craft for over twenty years, successfully hiving off daughter covens in Britain and Scandinavia. They are particularly interested in the revival of Pagan religion, the psychodynamics of ritual and the technology of magic, and enjoy experimenting with creating innovative rituals for groups of two to two hundred people of various paths, in various countries, that aim to achieve gnosis, ecstasy and enlightenment via techniques as varied as meditation and fire-walking. At the time of publishing this book they have started to put some of their training papers on the internet at templeofthephoenix.co.uk

Lou Hart

Lou is a witch of long standing (non-Wiccan tradition). She is also a multi instrumentalist and singer and has worked extensively with altered-states induced by drums or chant. Lou was one of the illustrators for Wood and Water and co founded Queer Pagan Camp in 1998 and has been a member of various bands

(Pearl Divers, Ministry of Marriage) and drumming groups (Wildskin). She has facilitated trance dances and lead groups of trance drummers and was a member of Mad Shamans. Lou has written articles (such as 'magic is a many gendered thing') and reviews for pagan magazines including the Pink Pumpkin, Pagan Dawn, Pentacle and Ashé. She has also lead various ritual training groups and is a queer activist.

Adrian Harris

I'm a researcher, counsellor and workshop facilitator with a passionate curiosity about the wisdom of the body and the healing power of nature. I've been active in road protest campaigns, notably Twyford Down, the M11, Priory Park ('Camp Bling') and Oxleas Wood. Roads were built in the first two cases, but Oxleas Wood and Priory Park remain. The

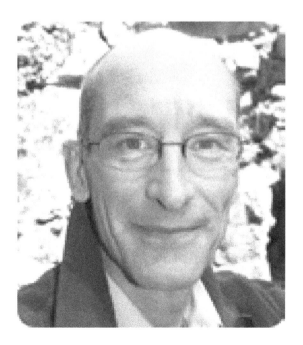

relationship between spirituality and ecology led me to Paganism and inspired me to found the Dragon Environmental Network (1990). My PhD thesis explores 'embodied knowing' and I have adapted sections - including 'A Life in the Woods' - for publication. www.adrianharris.org

Maria van Daalen

Maria is one of the Netherlands' leading poets with her work translated into English, Italian, and other languages. She teaches Creative Writing and Dutch, and reads poems at conferences and festivals around the world. In 2007, she was initiated as a Mambo Asogwe in the tradition of Haitian Vodou in Port-au-Prince, Haiti. In Vodou, everything in this universe is known to be linked, in all times and places: plant and animal and stone-fire-air-water and all humans and all angels and stars and the ancestors... much like the old Web of Wyrd. Her mystical poetry is full with these relations: "In the beginning was the word and the word was grass". Or: "And somewhere, going to seed, blossoming, / a new garden / and fresh earth" and "How infinite is potentiality, art / and nature unfolding in waves of bolder // design and art, than art itself can hold..." Find out more about Maria and her work at http://www.mariavandaalen.nl/hoofd/poetry_hoofd.html

Jan Fries

Jan lives in Frankfurt near the Taunus Mountains. He is a musician, artist and magician. He is the author of several well known books including: *Visual Magick: A manual of freestyle shamanism*; *Helrunar: a manual of Rune magick* and *Cauldron of the Gods: a manual of Celtic magick*.

Greg Humphries

Greg Humphries is a contemporary artist living in Cornwall. He works with communities, helping them adapt to the challenges faced by Peak Oil and Climate Change and is never happier than in the woods working a pole lathe, or with his hands in a willow crab pot. His activities are detailed in an ongoing blog at:

greghumphries.wordpress.com

and views communication and the passing on of information as crucial to his artistic practice. His research has led him to communities in the Arctic, the Amazon, the Sinai desert and deepest darkest Cornwall; for which he counts himself extremely lucky and privileged.

Gordon MacLellan

as "Creeping Toad", Gordon MacLellan is one of Britain's leading environmental educators. He works with groups to find ways of celebrating the relationships between people and the places where they live, work and play. An animist pagan, Gordon's work is an

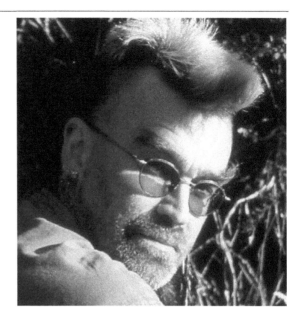

expression of his own passionate relationship with his environment. Fulfilment in that work is to help other people find their own ways of expressing their feelings for the world around us through whatever language of faith or imagery is appropriate to them.

Also a writer, storyteller and puppeteer in his own right, Gordon works both nationally and internationally with recent projects in South Africa, USA and the Republic of Ireland. Gordon's books include *Talking to the Earth*, *Sacred Animals* and *Celebrating Nature* (all with Capall Bann), *StarMatter* and *the Piatkus Guide to Shamanism*

Ffi: www.creepingtoad.org.uk

Runic John

Runic John lives in the wild Northern hills of England. At the age of 11 he was called by his ancestors "to make the ways of his forefathers

with the environment can be explored, examined and enriched through creativity, having fun and immersing ourselves in nature. Sarah has been known to fall in rivers. She completed MA Art As Environment in 2006 and continues to pursue research interests in participatory arts practice, imaginative rationality and embodied thought.

Mogg Morgan

MMM is a senior occultist, author, publisher, commentator, theologian, historian, lecturer, teacher and researcher. Following his earlier experiences with Kenneth Grant's Typhonian OTO he has continued his own journey into the Pagan/Kemetic tradition. He shares his vision through a series of books including *Tankhem: Meditations on Seth Magick, The Bull of Ombos, Supernatural Assault in Ancient Egypt* and *The Wheel of the Year in Ancient Egypt*.

Shani Oates

Shani Oates lives in Derbyshire (UK) where she is a devoted practitioner of the true art, a mystic, a pilgrim, artist, professional photographer and holistic therapist. She is also a life-long student and researcher of theology, philosophy and anthropology intrinsic to all praxes that engage the Mysteries proper. Providing valuable resources for her lectures at both Moots and Esoteric Conferences, these disciplines serve to enrich her role and duties as the Maid of the Clan of Tubal Cain (see www.clanoftubalcain.org.uk). As an

live twice", a calling that set him upon the Heathen path and a task he has followed for the last 33 years. He is a Seidrman, Galdrman and Wodens Gothi and runs cutting edge experiential workshops on seidr, galdr and Heathenry, which he makes accessible, dynamic and relevant to our everyday lives. He is the author of "The Book of Seidr: The Native English and Northern European Shamanic Tradition".

Sarah Males

Sarah Males is a freelance artist and workshop leader with a particular focus on creative engagement with place. This practice is driven by a deeply held suspicion that our connection

author her published works are included within 'Hecate: Her Sacred Fires' by Avalonia Press and other various popular pagan, folklore and occult publications for over a decade, including The Cauldron, Pendragon, The White Dragon, The Pentacle, The Hedge Wytch and The Wytch's Standard. The second 2010 edition of Abraxas Occult Journal features her most recent contribution on the Mysteries. Her debut book, *Tubelo's Green Fire* was launched through Mandrake of Oxford in April 2010 and she is now busy working on her second book that continues to explore and explain the deeper aspects and histories of her Craft.

Emma Restall Orr

Emma Restall Orr is an animist, priest, poet, teacher and philosopher, working within the British Druid tradition. Joint Chief of The British Druid Order for 9 years, she left to found The Druid Network in 2002, her focus now being mainly on the work of Honouring the Ancient Dead and the natural burial ground she runs in Warwickshire. Her recently published books include *Kissing The Hag: The Dark Goddess and the Unacceptable Nature of Being* (OBooks 2008), *Living With Honour: A Pagan Ethics* (OBooks 2008), *The Apple And The Thorn* (Thoth 2007) and *Living Druidry: Magical Spirituality for the Wild Soul* (Piatkus 2004).

Barry Patterson

I'm a writer, musician & storyteller living in Coventry, in the United Kingdom. I work in places like schools & museums a lot but also in the great outdoors. One of the themes which runs through much of my work is that of our relationship awith the land through the special places in which we find ourselves: the places where we live, work & celebrate. I grew up in the North East & my love of that region inspired two of my contributions here. My book, *The Art of Conversation with the Genius Loci* was published in October 2005 by Capall Bann Books. A pamphlet of 24 poems, *Nature Mystic* was published by the Heaventree Press in May 2008.

Contact me via my web pages:

http://www.redsandstonehill.net

http://www.songandstory.co.uk

Julian Vayne

Julian began doing group ritual within a progressive Alexandrian coven at the tender age of 15. His first co-authored book was released when he was just 22. His writing appears in both popular and academic journals and his most recent works include; *Pharmakon: Drugs and the Imagination, Now That's What I Call Chaos Magick* (with Greg Humphries) and *Magick Works*. Currently resident in the South-West of England, Julian's name is most often connected with the style of occultism known as chaos magick. He is a frequent speaker at esoteric conferences and teaches on-line in

the Department for Liminality, Shamanism & Daemonology at arcanoriumcollege.com.

Robert J Wallis

In this volume I stand as both a scholar and a Heathen, an identity I have always been upfront and honest about in my published work. Following the 'reflexive turn' in the humanities and social sciences, I acknowledge that my being a Heathen impacts upon my scholarly work, and vice versa, and that rather than compromising scholarly integrity or what used to be called misleadingly 'objectivity', this standpoint lends its own nuance to my professional and private life. My writing as a scholar engages with indigenous and prehistoric visual and material culture, particularly in animic communities with shamans; and the re-presentation of the past in the present, especially by contemporary pagans and neo-shamans. My books include *Shamans / neo-Shamans: Ecstasy, Alternative Archaeologies and Contemporary Pagans* (Routledge 2003), and *Sacred Sites, Contested Rites/Rights: Pagan Engagements with Archaeological Monuments* (with Jenny Blain, Sussex Academic Press 2007). I'm currently working on a book examining the discursive interface between shamanism and art from prehistory to the present. As a Heathen, I co-authored *Galdrbok: Practical Heathen Runecraft, Shamanism and Magic* (Wykeham Press 2005) and I continue to write books, articles and give talks and lectures on this and related topics.

Photo credits

With thanks to our artists in their various media

Cover: Damian Hughes

Frontispiece: Marlo Broekmans

Chapter 4: A Heathen in place: Robert Wallis

Chapter 5: Wild, wild water: Janitzio cemetery: Galdina Duran Munoz, St Nectan's Glen: Anthony Cox, all others Lou Hart

Chapter 6: Facing the waves: Gordon MacLellan

Chapter 7: Dragon waters of place: Susan Greenwood

Chapter 10: Places of power: Jan Fries, page from the notebook of Alexander Thom

Chapter 11: Natural magic is art: Greg Humphries

Chapter 13: Because we have no imagination: Susan Cross. "Knowth Rock Art" by Peter Phillipson

Chapter 14: The Crossroads of Perception: Shani Oates, "Munlochy" by Gordon Maclellan

Chapter 15: Woody Fox, "Offerings at St Necktan's Glen" by Michael Clarke

Chapter 16: Lud's Church: Gordon Mclellen, "Ivy & Ice" by Gordon Maclellan

Chapter 18: A life in the woods: protest site paganism, Adrian Harris

Chapter 19: We first met in the north, Barry Patterson

Chapter 21: Hills of the ancestors, townscapes of artisans, Jenny Blain

Chapter 22: Smoke and Mirrors: Stephen Grasso, "Barbican Grime" & "The London Stone" by the author.

Chapter 23: America: Maria van Daalen , "Theatre des Fleurs" by Marlo Broekmans

Lightning Source UK Ltd.
Milton Keynes UK
UKHW031029131220
374972UK00012B/813